Almost at the foot of St Isaac's, on a square enclosed on two sides by calm, clear-cut, majestic buildings of the Admiralty and the Synod and Senate and washed on the third by the regal Neva, stands the monument set up by Catherine II to Peter the Great: *Petro Primo Catharina Secunda*. If anybody happens to be near it on a foul autumn evening, when the sky turned to chaos comes close to the earth and fills it with its commotion, the river constricted in granite groans and tosses, sudden gusts of wind set street-lamps swinging and their juddering light makes the surrounding buildings quiver — he should take a look in a moment like that at the Bronze Horseman, at that fire transformed to copper with sharply-drawn, powerful forms. What a force he will sense — a passionate, impetuous force summoning to the unknown. What a great sweeping gesture, evoking the alarmed question: what's to come, what's ahead? Victory or failure and death? The Bronze Horseman is the spirit of Petersburg.

Nikolai Antsiferov,
The Soul of Petersburg, 1922

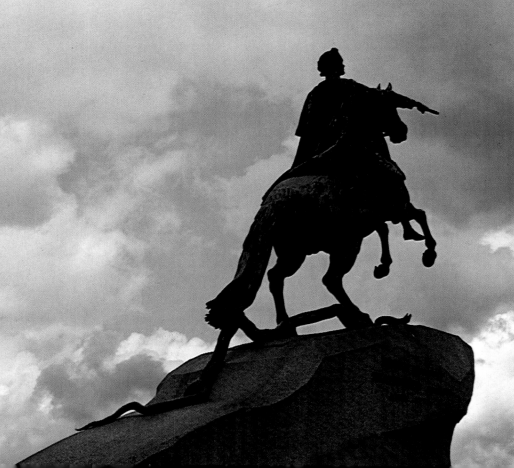

Saint Petersburg

*Founded
on 27 May 1703*

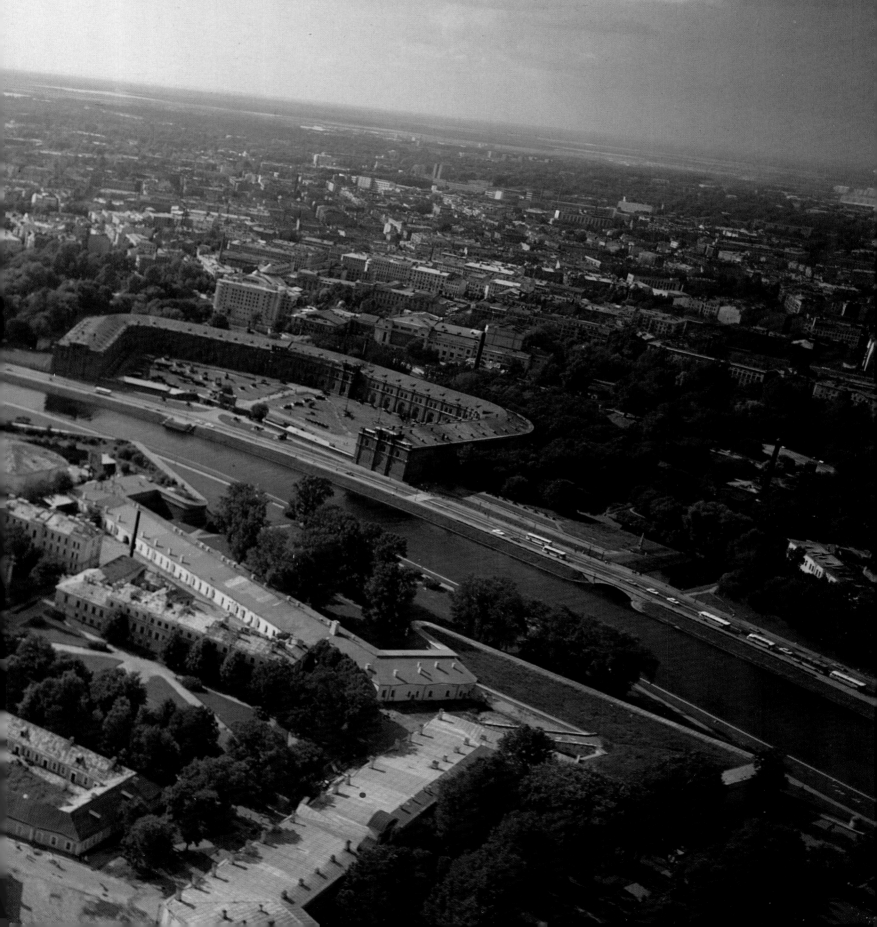

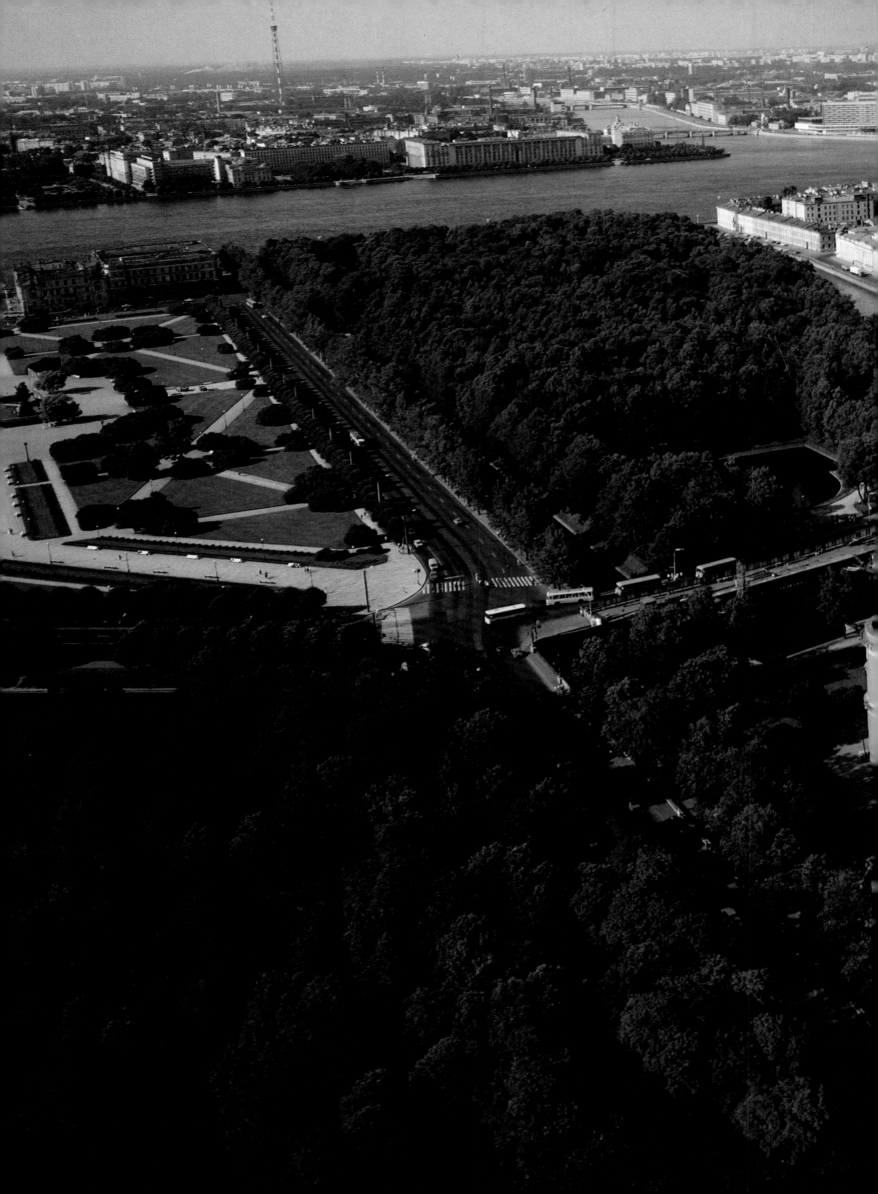

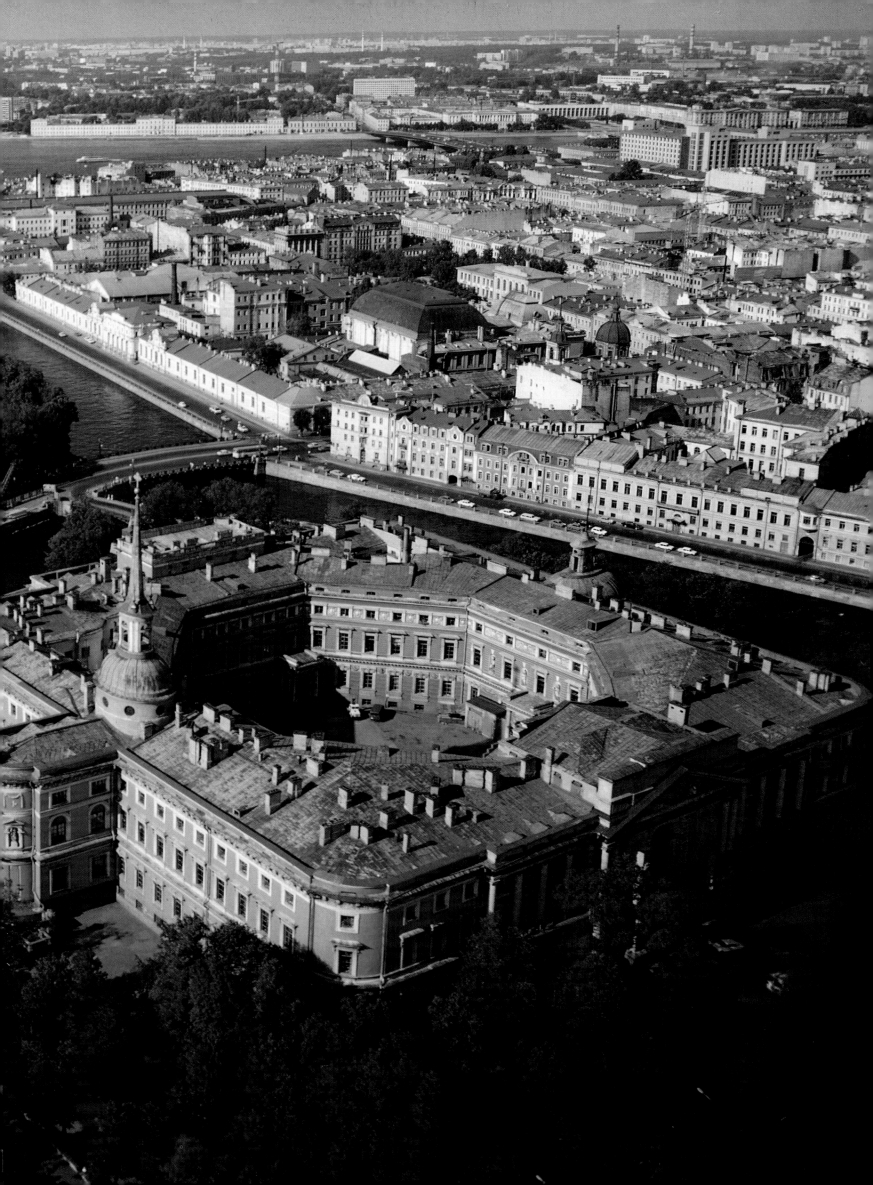

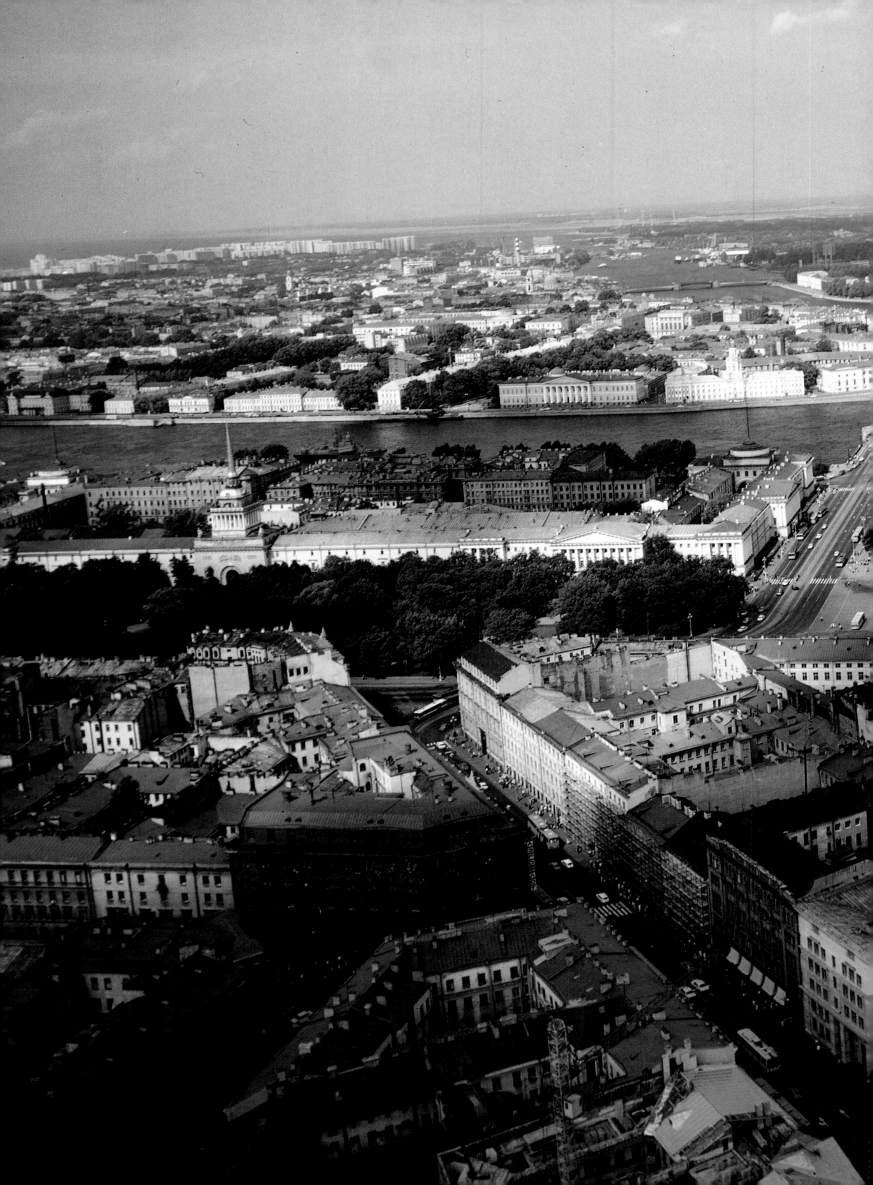

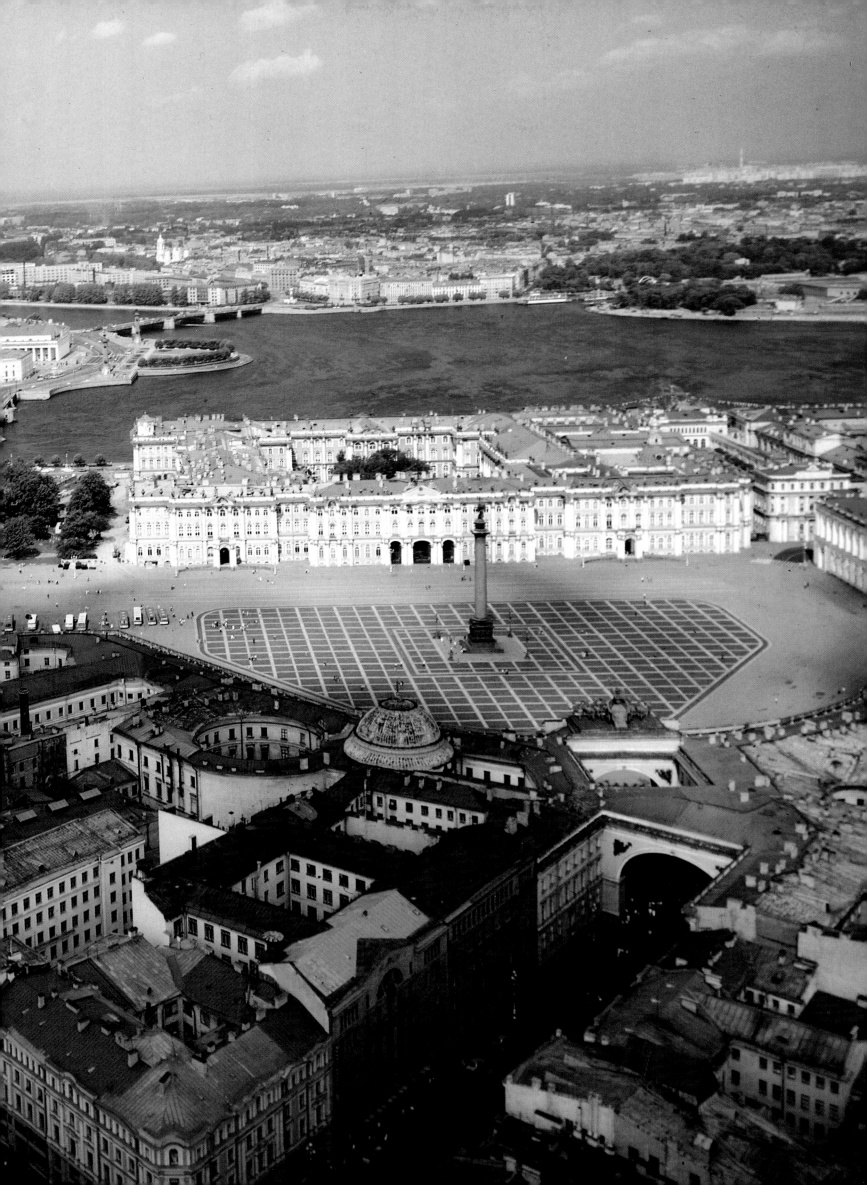

SAINT PETERSBURG

In 2003 St Petersburg will be three hundred years old. Compared with the hoary stones of Paris, Kiev or Cologne, the city on the Neva really does seem a youngster. There is nothing ancient about it; it never knew the Middle Ages.

It did not just appear — it was conceived by Peter the Great as "a window to Europe", as the capital of a "young Russia".

It was constructed according to a rational plan; its architects, as a rule, designed not simply buildings, but whole ensembles; the streets were wide and straight, the squares unusually spacious. But there are few cities in the world so "fantastical" (Dostoyevsky), irrational, uneasy and inexplicable, grand and mysterious, so full of great shades and memories, as St Petersburg at less than three hundred years old.

Following its foundation in 1703, it was the capital for a little over two centuries (1712 — 1918). St Petersburg has come to share the distinctive and proud lot of "second cities" around the world, such as Florence, Munich, New York or Seville, which, while yielding precedence to the capital, have preserved their fame and importance even after losing their official status.

But St Petersburg has one important peculiarity: not only was it a capital — it was built as a capital. This is the source of the sweep and grandeur which has caused such delight, the source too of the austere officialism, even coldness which has so often been cursed.

Indeed, there were many whom the city delighted, calling it the Venice of the North, the Northern Palmyra. It inspired perhaps the best of Pushkin's verses. The city gave birth to its own literature, its own mythology, and, of course, its own art. Yet the culture associated with St Petersburg always contained and still contains within it a certain uneasiness. Admiration for the city was tinged with a hint of sadness. Its "austere, elegant appearance" (Pushkin) impresses with its stern refinement, but not with its warmth. It does not gladden the heart, does not promise cosiness, but generously gratifies the human passion for beauty and harmony. A particular, peculiar city!

The observer with an inclination to seek out in St Petersburg the face of its past will easily come upon views which recall the different pages in its history to life. But to do so requires imagination and a certain degree of knowledge.

As they appear today the streets and squares of central St Petersburg, its embankments, bridges, monuments and famous palaces are reminders primarily of the last decades of the eighteenth century and of the nineteenth. The elegant, finely-planned ensembles, colonnades in the opulent Baroque or more austere Classical style, bronze sculptures on granite façades, the five- or six-storey buildings along Nevsky Prospekt and the agglomerations of tenement houses in the less stylish areas, where one cannot help but remember Dostoyevsky — this is a far cry from the St Petersburg which Peter I dreamt of and which — during his own reign and the years which followed — at least in part reflected his dreams. That city, the "Petrine" one, was squat and low. The first stone buildings seemed smaller still on the banks of the wide river, and only the rare towers topped with spires and the flagstaffs with their flags fluttering in the Baltic wind relieved the monotonous look of the capital on the Neva. To some extent this scene recreated the appearance of Peter's beloved Holland, although the majestic Neva and the already-foreseeable future scale of the city belonged to another world and another time. In addition, Peter, who dreamt too of Italy, proposed constructing a large number of canals like in Venice; and Domenico Trezzini, the architect who constructed the most important projects in the young capital, was an Italian by birth. It was not for nothing that the term "Petrine Baroque" was later coined to define the unusual architecture of the first quarter of the eighteenth century, in which simple-planned buildings were enlivened by not over-rich Baroque decoration. Such were the SS Peter and Paul Cathedral in the fortress of the same name — the starting place for the construction of the city, the building of the Twelve Collegia or ministries, and the first dwelling-houses. The buildings were created in brick, plastered and painted different colours; even in the time of the Baroque and Classical styles they were not, as, say, in Paris, made of stone or given the colour of stone. Yellow, azure, turquoise and terracotta façades, rhythmically divided by white

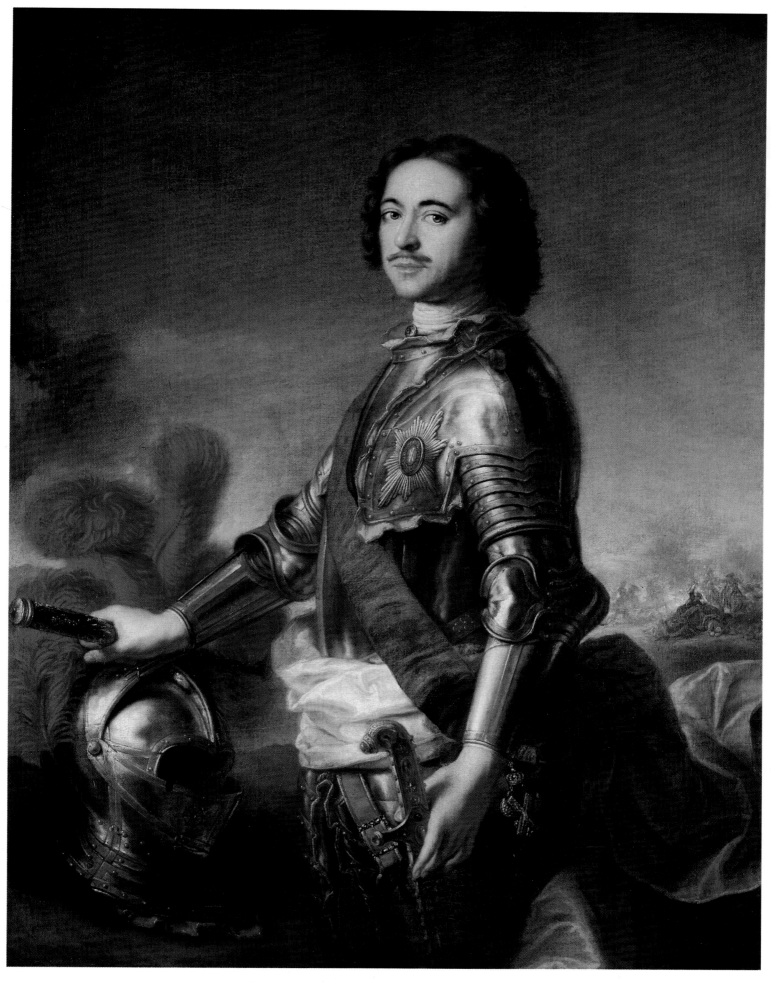

PORTRAIT OF PETER THE GREAT. 1717
By Jean-Marc Nattier

columns and pilasters with dark-ochre, and sometimes even gilded, capitals, endow St Petersburg with an absolutely distinctive range of colours and bring life to streets that do not see the sun that often, being more accustomed to gloom, rain and fog.

Peter himself never saw dreams come true, but the Emperor's idea of the appearance of the city was brought into life by architects who began working to his commission. The three component parts of St Petersburg were the Peter and Paul Fortress on Zayachy (Hare) Island, Vasilyevsky (Basil's) Island to the right of the main channel of the Neva, and the Moscow Side (with the enormous shipyard of the Admiralty, which gave it its second name) on the left bank. Three radial streets extending south and west of the Admiralty — chief among them, the "Nevsky perspective road" — became the most important thoroughfares in the city. The city turned its face to the immense, chilly river, still not crossed by bridges. Ships from various corners of the globe sailed high up the Neva, their masts and flags adding, as it were, to the number of towers and spires on the banks...

The heart of the city has, in essence, remained the same. As before slender spires pierce the grey sky; the same trident of main streets still cuts across the city. But much had already begun to change in the first decades after Peter's death. The dryish manner of Domenico Trezzini was succeeded by the opulent fantasy of Francesco Bartolommeo Rastrelli. The grand splendour of the Baroque decoration used on the incomparable Winter Palace — the royal residence on the bank of the Neva, and on the palaces built for Count Mikhail Vorontsov on Sadovaya Street and Count Sergei Stroganov on Nevsky Prospekt together with the refined elegance of Smolny Cathedral gave the city a hitherto unknown stylishness and the true lustre of a capital. Incidentally, these were more like a sprinkling of magical dust, precious insertions into the map of the city, rather than component parts of architectural ensembles.

The turn of the nineteenth century became to a significant degree a turning point for the appearance of the city. Classicism with its striving after triumphal monumentalism, strict architectonics and the ensemble gave the city back the unity Peter had conceived. Adrian Zakharov's reconstruction of the Admiralty with a spire raising the gilded sailing-ship weather-vane to a height of seventy-two metres — a building full of dignity and true grandeur — determined, as it were, the scale and

MONUMENT TO
PETER THE GREA
1821—22.
By Andrei Martynov

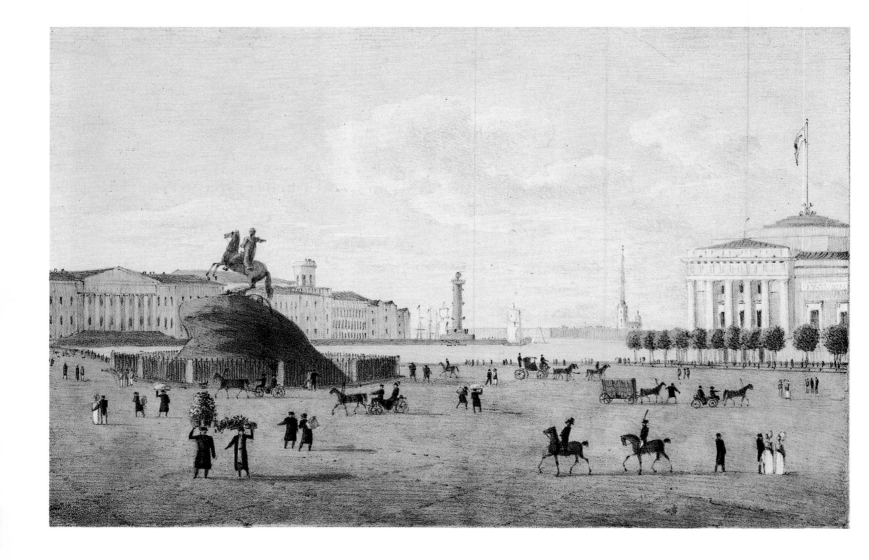

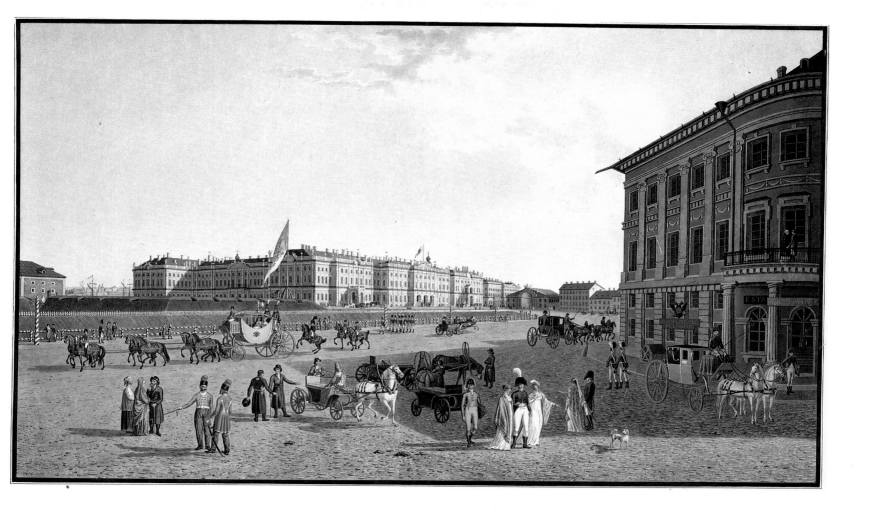

VIEW OF PALACE
SQUARE AND THE
WINTER PALACE
FROM NEVSKY
PROSPEKT. 1804.
By Benjamin
Patersson

sweep of construction in the capital. With a semicircle of buildings joined by a tremendous arch Carlo Rossi closed off the square in front of the Winter Palace. He created the ensembles on Mikhailovskaya, Alexandrinskaya and Senatskaya Squares to give the centre of the city a regal completeness. Earlier still, Andrey Voronikhin had erected the Cathedral of Our Lady of Kazan with its open colonnades facing Nevsky Prospekt. St Isaac's Cathedral — the tallest building in the city — and the Alexander Column in front of the Winter Palace, both the creations of Auguste Montferrand, to a large extent summed up the construction work of the nineteenth century. Over the course of the century a wonderful capital had appeared, created in one breath, so to speak; a spacious and harmonious city, surprising the visitor with its rare unity and majestic calm.

Bronze tsars and generals stand rigid on their granite pediments, frozen too is Etienne Maurice Falconet's celebrated "Bronze Horseman", that monument to an emperor who "made Russia rear up" (Pushkin). The city is populated and animated by superb works of sculpture, the icing on the cake of the architectural ensembles. The gilded spires echo each other — the SS Peter and Paul Cathedral and St Isaac's, the Admiralty and St Michael's (Engineers') Castle. Stone embankments with architecturally surprising landings adorn the Neva. Finally, in place of the single pontoon bridge, huge drawbridges appear.

Since the middle of the last century the look of the city has altered little. The countless apartment houses (among which there are many architectural masterpieces, although still more are utterly mediocre), the elegant, and not ineffective, architecture of the style that has become known as eclectic, and even the cultivated and exquisite refinement of the brilliant St Petersburg *art nouveau* could no longer principally change the face of the city, but only made St Petersburg more heterogeneous and interesting.

But not a single excursus into the history of the city's architecture can replace the visual impression of that divine unity of buildings and ensembles constructed at different times, that harmony of stones and water, that "indivisible dissimilarity" which make Nevsky Prospekt and the Petrograd Side, Kolomna and the Summer Gardens, and many other places in St Petersburg both unlike each other and at the same time intrinsically part of the city.

There is the city celebrated by Pushkin in his verse — the "beauty and wonder of the northern lands" — which can amaze a person standing in its very centre, on Palace Bridge, say. From there

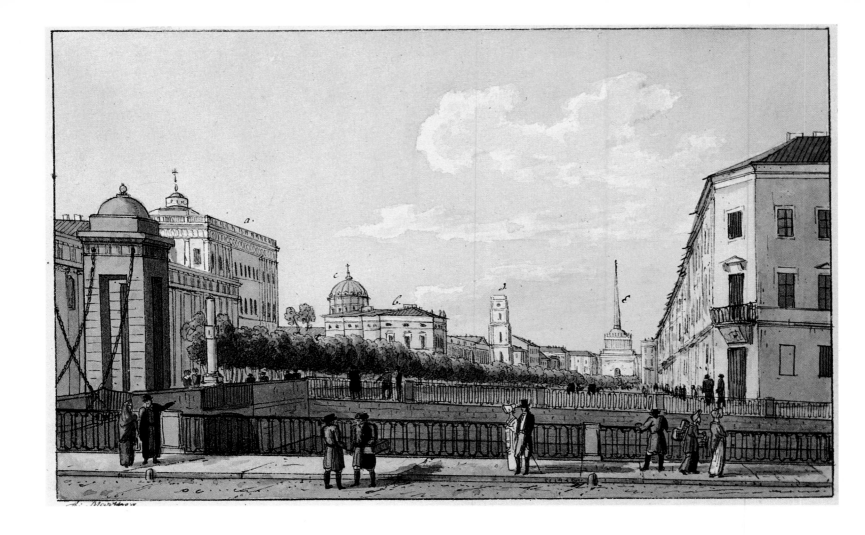

you can see the elegant pavilions of the Admiralty and the row of buildings that make up the Hermitage from the Winter Palace to the Winter Canal (across which Giacomo Quarenghi threw an arch inimitable in its stern finesse), the steep bridges over the canals, the Peter and Paul Fortress and the Spit of Vasilyevsky Island, where the majestic building of the Exchange stands flanked by the mighty Rostral Columns.

There is amazing Nevsky Prospekt — "St Petersburg's common line of communication... Almighty Nevsky Prospekt..." (Gogol) — in which you can read the history of the city and discern its changeable face. The street is straight and wide, every now and again revealing views of enchantingly beautiful ensembles — the Mikhailovsky Palace or the Alexandrinsky Theatre, so utterly harmonious that at times they seem to be stage decorations. Nevsky is crossed by two small rivers and a canal, their unexpected sharp turns pleasantly relieving the undeviating straightness of the street. And if you turn to walk along one of their narrow embankments, you find yourself in a completely different world, a world of quiet, narrow water, hanging trees and indispensable little bridges, sometimes decorated with eccentric sculptures, old lamps and railings. You can follow them to the Neva, but if you go deeper into the city, you find yourself in quiet districts which have little attraction, but possess their own lyricism nonetheless — perhaps in Kolomna, the sad back-of-beyond as far as St Petersburg is concerned, home to the heroes of Gogol, Pushkin and Dostoyevsky.

On Vasilyevsky Island, right on the bank of the Neva, two ancient stone sphinxes brought from Egypt stand rigidly. Spreading out behind the façades of the "Academy of the Three Most Noble Arts" is the most "geometric" part of the city, regularly laid out for canals that after only a few years were filled in to become streets yet are still known as "lines" and distinguished only by numbers.

Scarcely inferior to Nevsky is Kamennoostrovsky Prospekt which runs through the whole Petrograd Side district so as to become airborne on the most beautiful of the city's bridges — Trinity Bridge decorated in a deliberate, even excessive display of refinement with railings and lamps in the purest *art nouveau* style, a bridge on which even the masts supporting the wires for the trams have been designed with an especial neurotic subtlety.

And further, on the opposite bank, is the tremendous esplanade of the Field of Mars and the green massif of the Summer Gardens with their legendary railing, perhaps the most beautiful in the world.

VIEW OF NEVSKY PROSPEKT FROM ANICHKOV BRIDGE. 1800s. By Andrei Martynov

12

Every city has a historical and moral drama of its own. The beauty of St Petersburg, celebrated by many poets, delights the eye, but rarely warms the heart. The antithesis between Muscovite patriarchal cosiness and the cool elegance of St Petersburg has become a truism, but there is undoubtedly a grain of truth in such a view of things. A strange "poetry of bureaucracy" (are there any other cities like this in the world?) found sublime artistic expression in St Petersburg. Order, pedantry, raised to the level of an aesthetic category, introduced a particular, oppressive logic into its architecture. The city is hardly likely to produce surprises: there is not a single hillock, not one gully, and there are but few crooked sreets. St Petersburg was born to become the capital of a vast empire. Its life, brief by historical standards, has been rich in political tragedies. Here the Russian history of modern times was determined. The streets ran red with the blood of rulers and their subjects. It was here that the revolution took place which shook the world — probably the greatest social drama of the century. Happily, misfortunes, although they age a city, at times also bring it an especial, wise kind of beauty and fill its streets with memories which evoke whole chains of associations.

It is only natural that such a city should have produced its own legends, its own mythology. The streets seem peopled not only by the ghosts of great writers, but by their characters as well, characters who simply could not exist, nor even appear in any other city — the creations of Pushkin and Gogol, Dostoyevsky and Blok. They were born of the very atmosphere of the city, where "everything is deceit, everything a dream, nothing what it seems" (Gogol), where the traditional Russian character entered into dramatic conflict with a capital conceived by Peter in the European manner. And in the icy setting of St Petersburg human passions grew especially ardent and poignant. Penetrating through the "window to Europe" which Peter I had cut out, the Hoffmannesque grotesque of the world beyond took on a unique Russian individuality in Petersburg culture.

Dostoyevsky wrote that Russian man "had already acquired the capacity to become most Russian only when he was at his most European". Possibly, precisely here, in St Petersburg, Russian architecture and urbanism, having come directly into contact with the western cultural tradition and made it an integral part of the city's intellectual and artistic life, created something wholly original, the like of which will scarcely be found — a great city on the frontier of West and East, a city attractive to the Russian and the Western European alike and for both of them something surprising, "fantastical".

So much has already been written about how beautiful St Petersburg is. Its celebrated white nights which do not permit "the shadow of night onto the golden skies" (Pushkin), when the city is transformed into an utterly unreal spectacle; the hoar-frost which covers the granite of the columns in dimly glittering silver when the temperature rises in winter; the rains and mists of autumn which so become the city — all of these have been described many times by the best writers in Russia.

An astonishing city — capable of making even its tragedies a source of poetic revelation! The devastating flood of 1824 was a considerable part of the inspiration behind Pushkin's poem *The Bronze Horseman*; even the 900-day siege during World War II evoked no small number of verses and paintings. Indeed, the whole dramatic history of St Petersburg, which has experienced not only the bloody toppling of regimes, not only periods of social stagnation, but even the loss of its own name, has invariably and consistently been perceived through the mirror of art. And that is how St Petersburg was conceived — to be the visible expression of the New Russia, the touchstone of taste, harmony, reason… of all that which the busy pedestrian always senses, walking — even for the hundredth time — through the streets of St Petersburg.

Mikhail Guerman

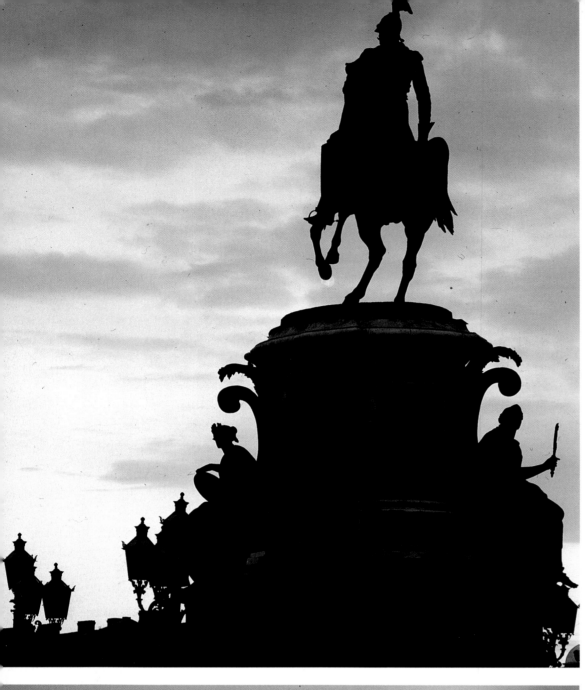

...Nowhere did the white nights gain such control over minds, become so full of meaning, so saturated with poetry, as there in Petersburg, there by the waters of the Neva. I think that Peter himself, when he founded his Petersburg in May, was enchanted by one such white night, something unknown in the central part of Russia.

Alexander Benois,
My Memoirs, 1934

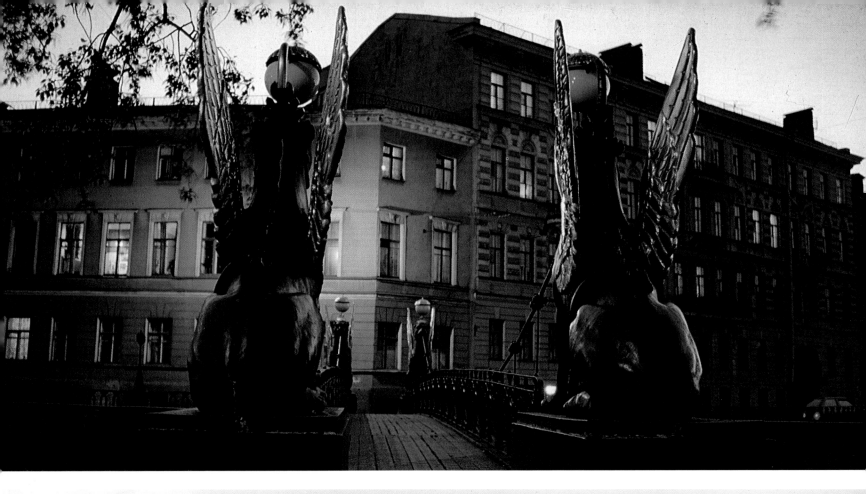

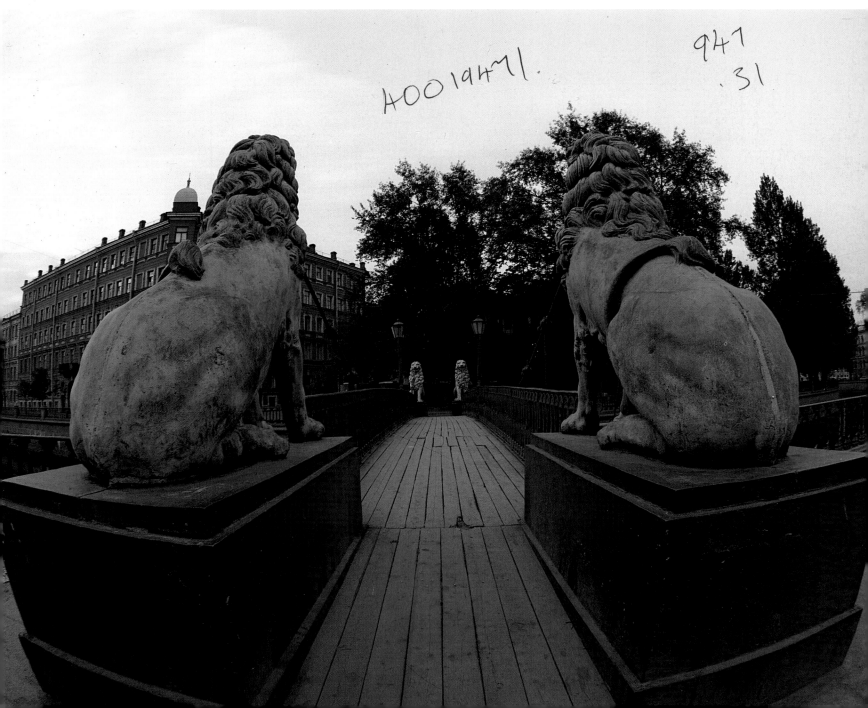

HOO194~1.

947
.31

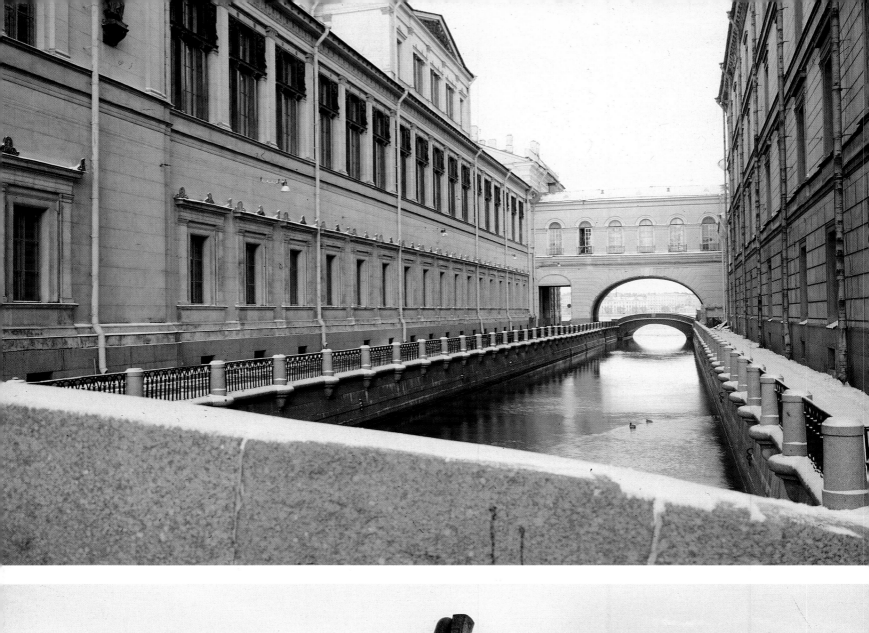

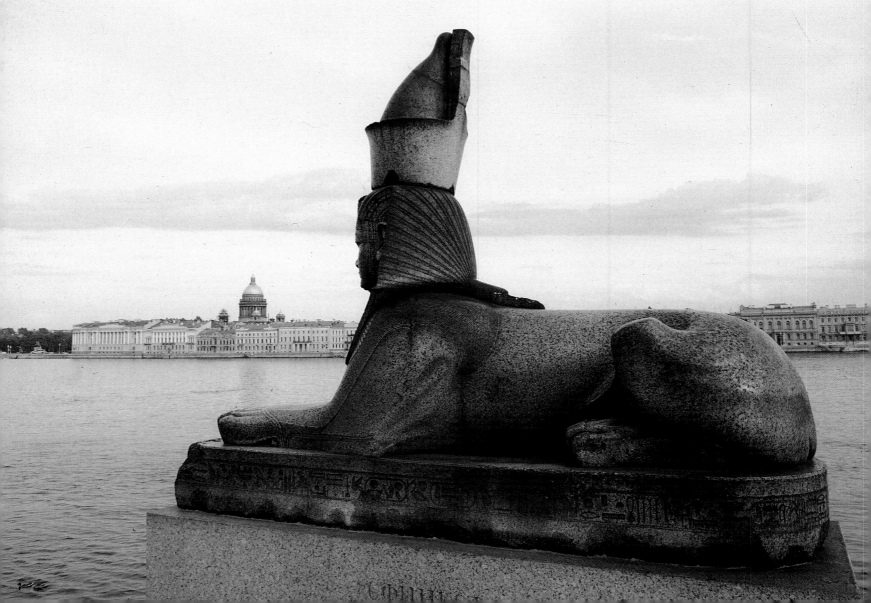

...You will scarcely find another city in the world which demanded greater sacrifices at its birth than the Palmyra of the North. Petersburg truly is a city built on human bones. The fogs and marshes from which the city appeared testify to the Trojan labour which had to be carried out in order to construct — on unstable soil, seemingly woven out of the mists — this "Paradise".
Everything here speaks of a great struggle with nature. Everything here is "in defiance of the elements". In nature nothing was permanent, sharply drawn or proudly pointing skyward; everything clung to the earth as if waiting resignedly for the waters to close over this forlorn land.
And the city was created like an antithesis of the surrounding nature, or a challenge to it. Let "chaos be stirring" beneath its squares, streets and canals — the city itself is all calm straight lines, hard, firm stone, precise, strict and regal with its golden spires serenely rising to the heavens.

Nikolai Antsiferov,
The Soul of Petersburg, 1922

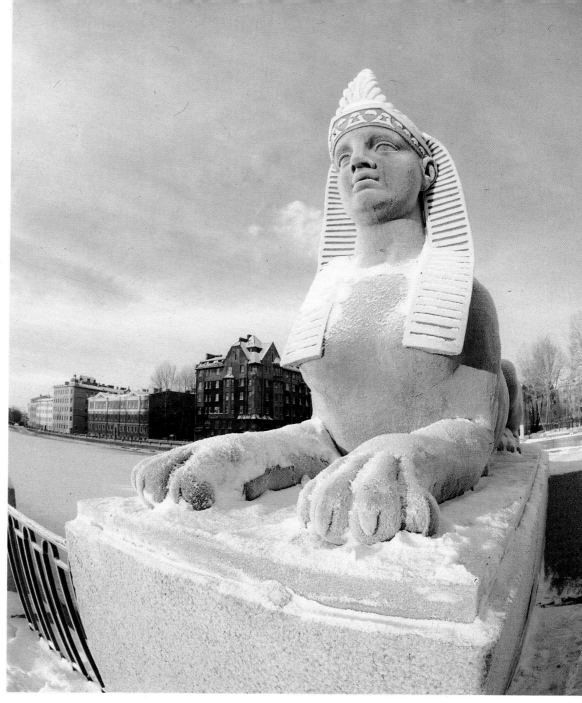

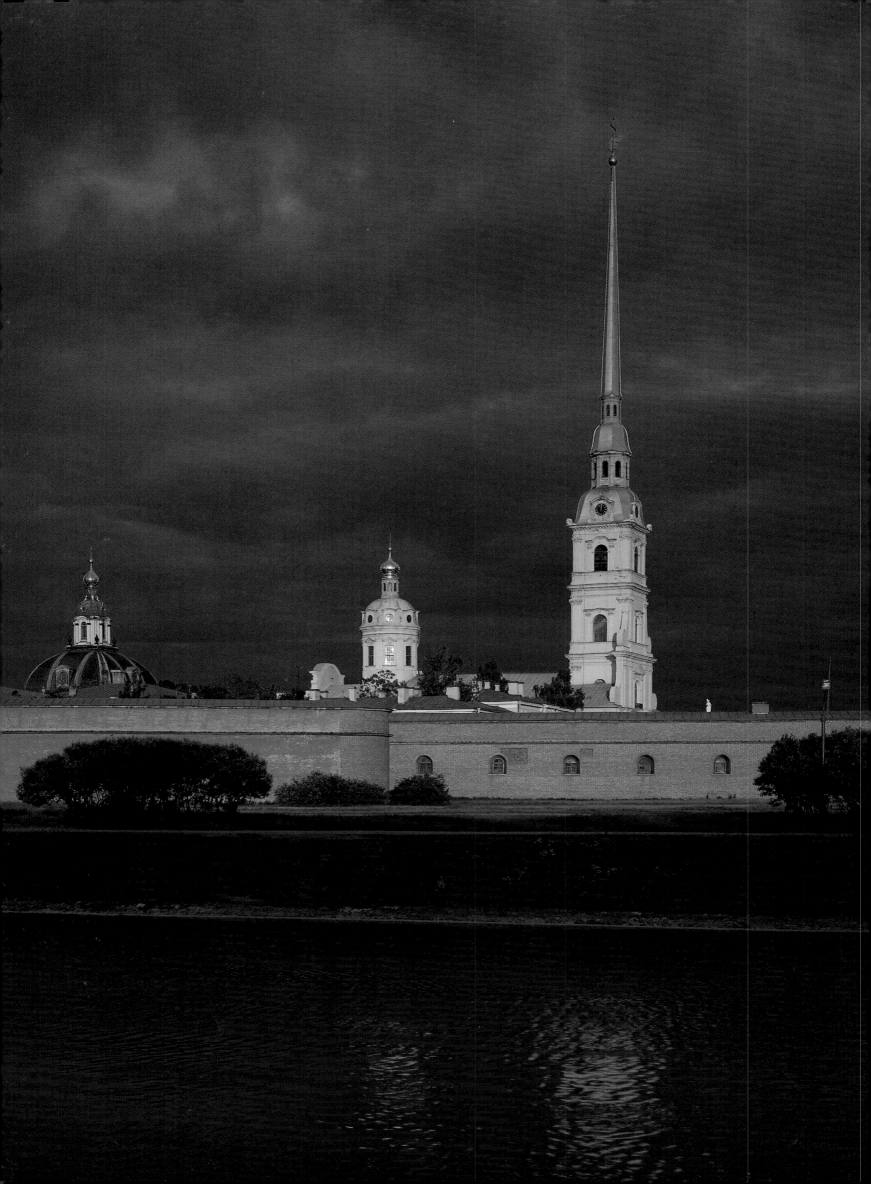

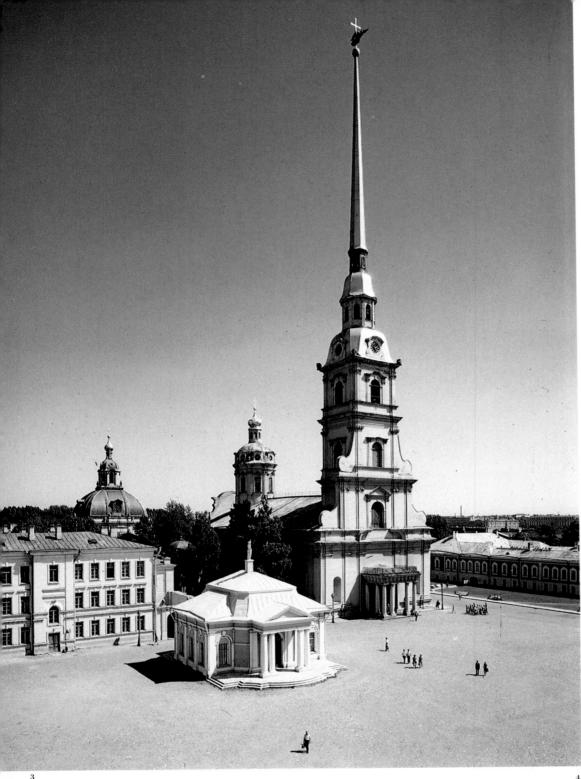

Previous pages:

1 View of the SS Peter and Paul Cathedral from the *Kronwerk*

2 The Royal Doors of the iconostasis in the SS Peter and Paul Cathedral

On 27 May 1703 — the date considered to be the birthday of the city — the Peter and Paul Fortress was begun at the command and to the plan of Peter the Great on Zayachy (Hare) Island. Between 1705 and 1734 the architect Domenico Trezzini was in charge of work here. Standing on Cathedral Square is the SS Peter and Paul Cathedral — a piece of architecture in the Petrine Baroque style which Trezzini built in 1712–33. Its dominant feature is the multi-tiered bell-tower topped by a gilded spire and a weather-vane in the form of a flying angel (its total height is 122.5 metres). The cathedral became the burial place of the Russian emperors from Peter

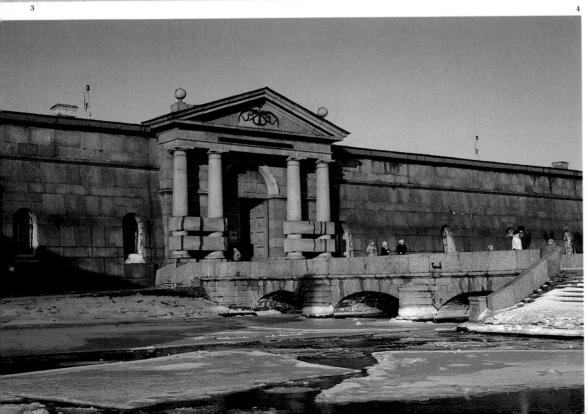

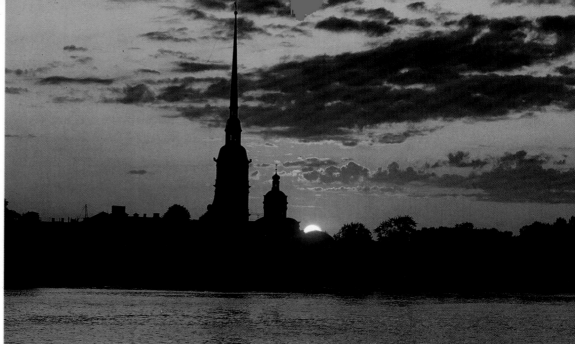

the Great onwards. It contains a magnificent carved wooden iconostasis created in 1722–26 by I. Zarudny in the traditions of the European Baroque. Close by the cathedral is the boathouse, built in 1761–62 by A. Vist to keep the «grandfather of the Russian fleet» — the boat in which Peter the Great had learnt to sail.

3 SS Peter and Paul Cathedral and the Boathouse on Cathedral Square

4 The Neva Gate and the Commandant's Pier

5 Detail of the iconostasis in the SS Peter and Paul Cathedral

6 The St John Gate

7 View of the Peter and Paul Fortress from Palace Embankment

8 The Peter Gate

9 The central nave of the SS Peter and Paul Cathedral

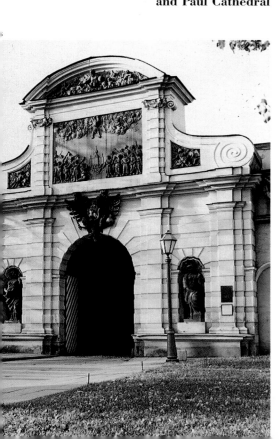

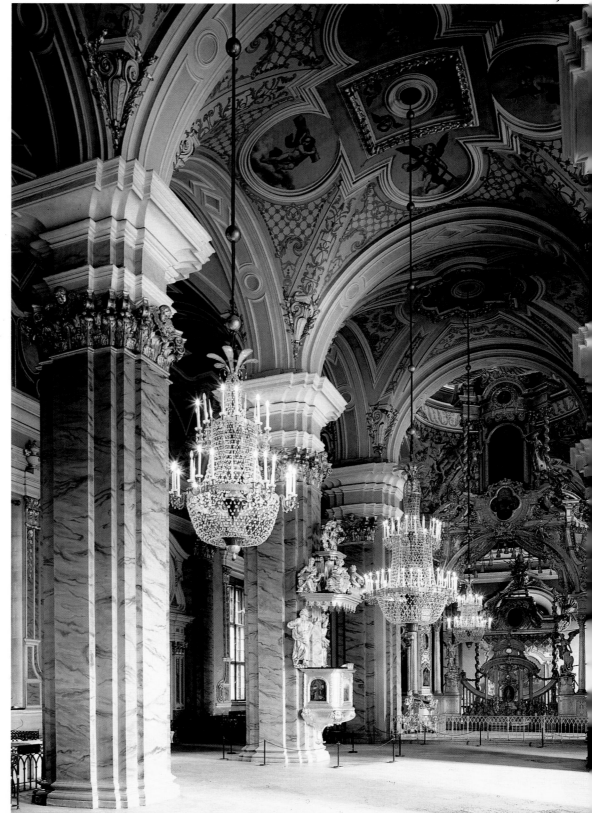

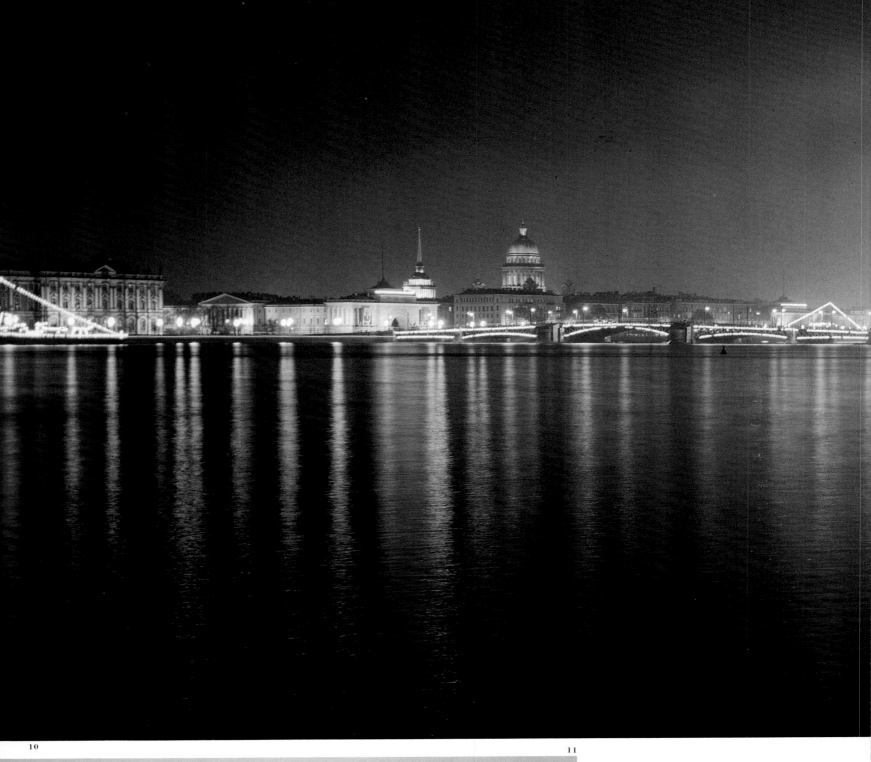

10

11

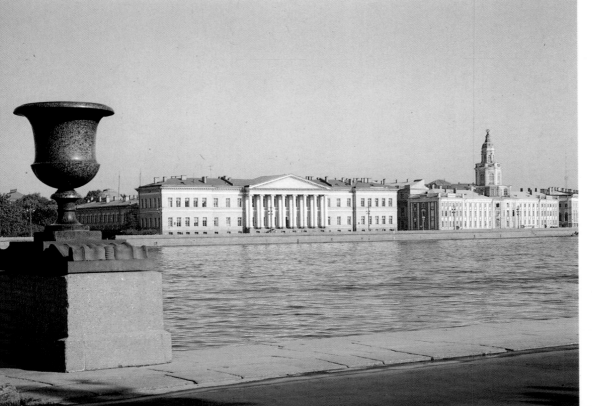

10 View of the Winter Palace, Admiralty, St Isaac's Cathedral and the Spit of Vasilyevsky Island

11 View of the Academy of Sciences (1783–85, architect Giacomo Quarenghi) and the *Kunstkammer* (1718–34, architect Mikhail Zemtsov, Georg Johann Mattarnovi, Nikolaus Herbel and Gaetano Chiaveri; 1754–58, architect Savva Chevakinsky) from Admiralty Embankment

12 Sphinx (13th century B.C.) on the landing-stage in front of the Academy of Arts

13 The Exchange (Central Naval Museum). 1805–10. Architect Jean-François Thomas de Thomon

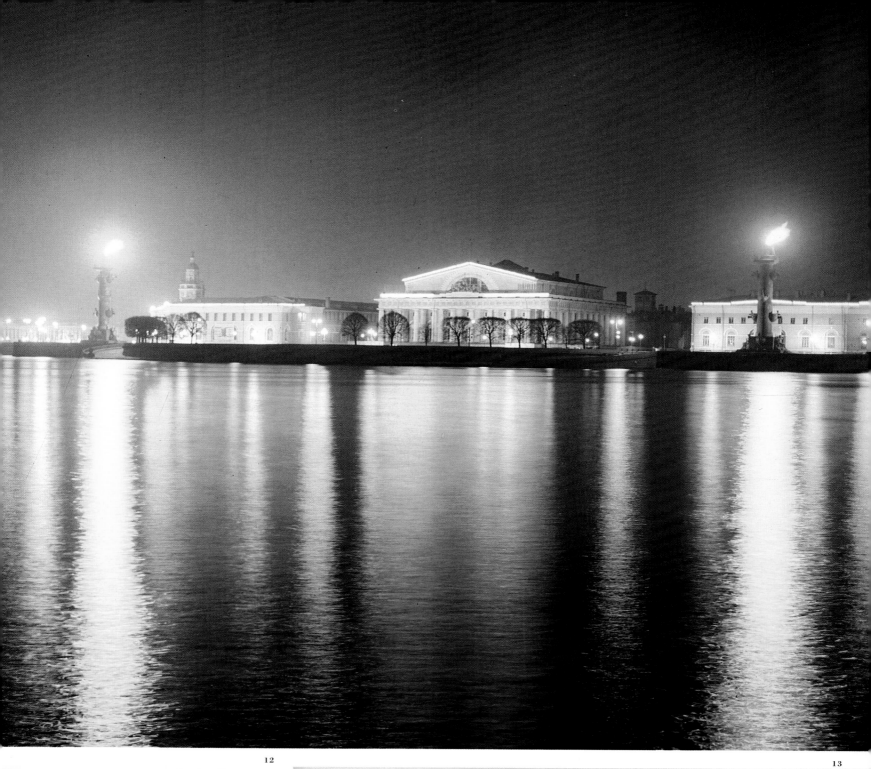

12

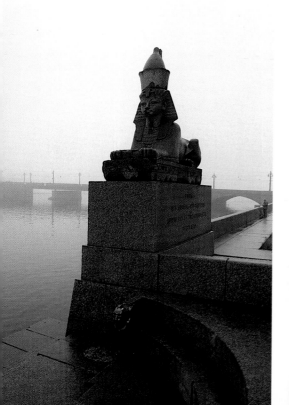

13

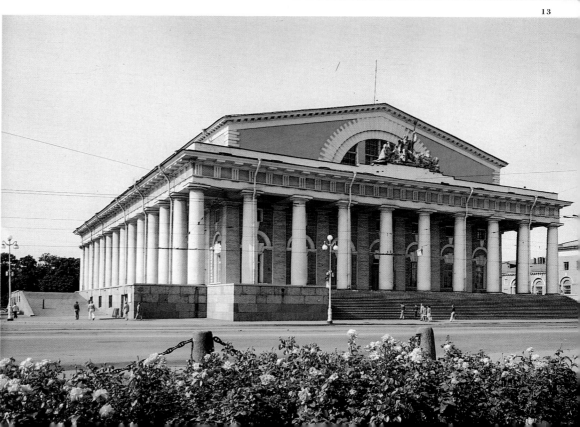

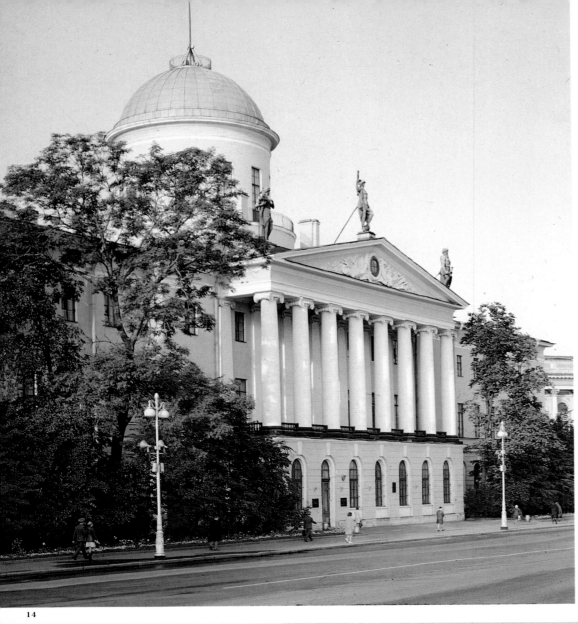

14

14 The Pushkin House (Russian Academy of Sciences Institute of Russian Literature; the building of the former St Petersburg Customs House). 1829–31. Architect Giovanni Luchini

15 The "New Holland" Arch. 1765–1780s. Architects Savva Chevakinsky and Jean-Baptiste Vallin de la Mothe

16 Rostral column on the Spit of Vasilyevsky Island (sculptures after models by I. Chamberlain and J. Thibault)

17 The Academy of Arts. 1764–88. Architects Alexander Kokorinov and Jean-Baptiste Vallin de la Mothe

Overleaf:

18 View of the Menshikov Palace from University Embankment

19–21 The palace interiors

22 Monument to Peter the Great ("The Bronze Horseman"). 1774–78. Sculptor Etienne Maurice Falconet

23 View of Decembrists' Square from Admiralty Embankment

15

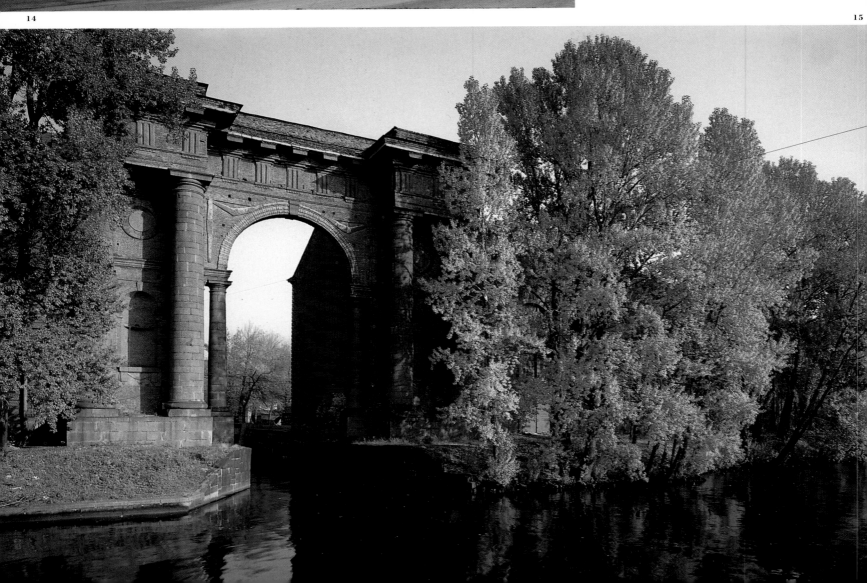

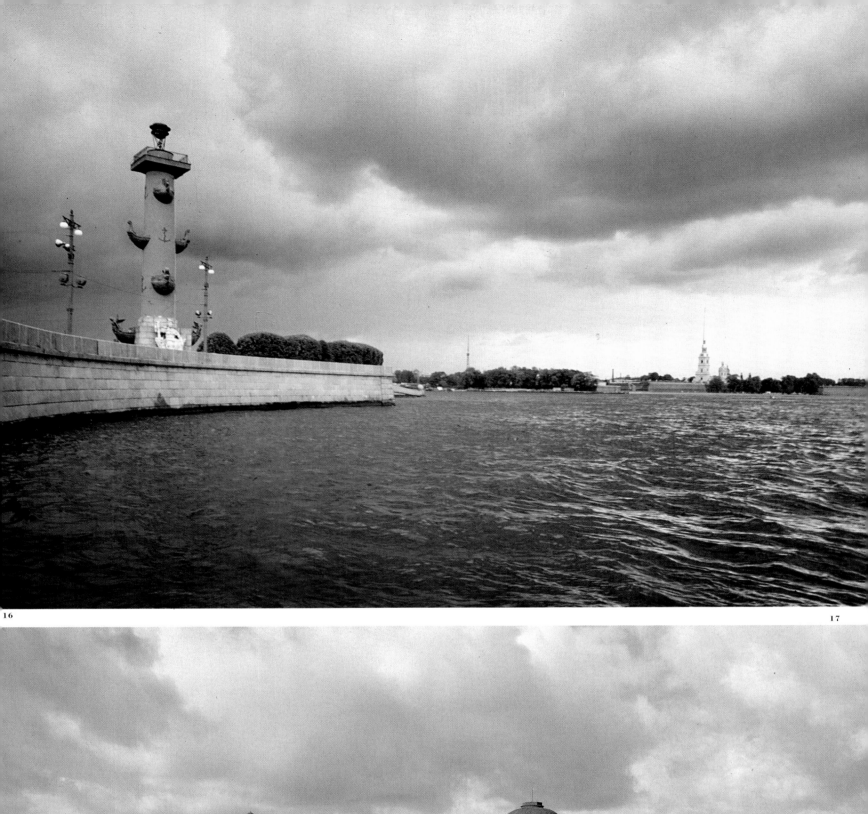

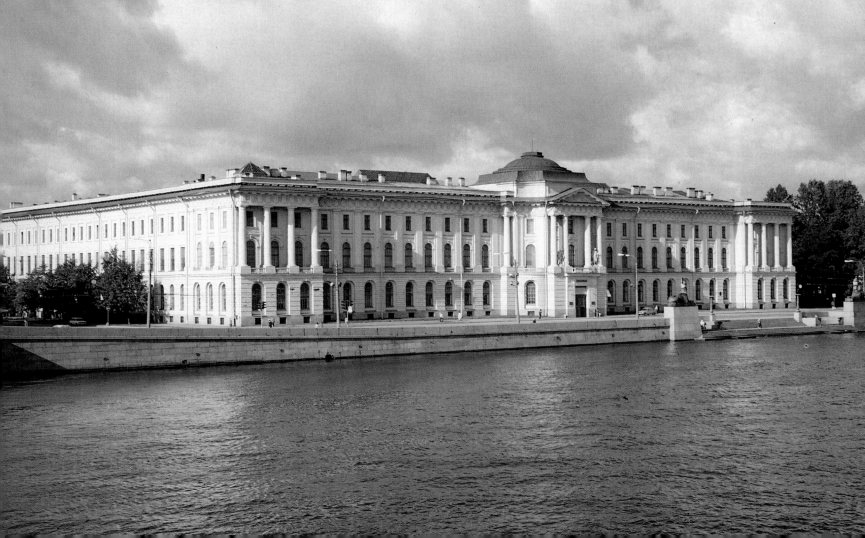

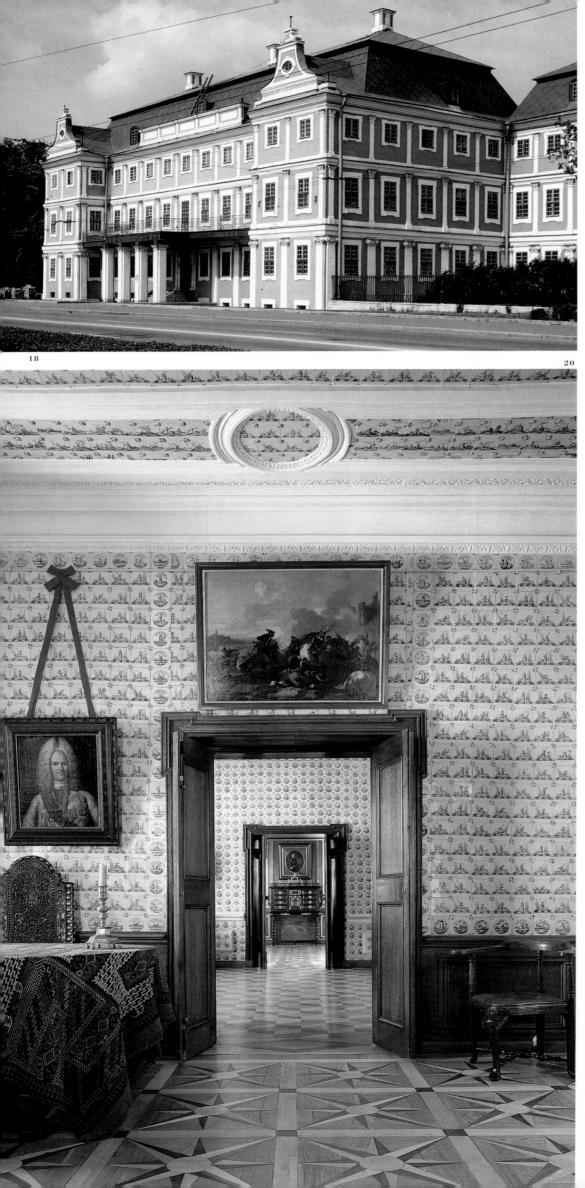

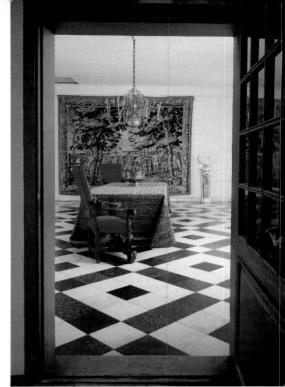

18
20

The Menshikov Palace is a fine example
of the architecture of the Petrine Baroque.
It was built in two stages, 1710–12 and
1713–27 (architects: Giovanni Fontana and
Gottfried Schädel), for Prince Alexander
Menshikov — the close friend and associate
of Peter the Great. The façades with their
simple finishing are typical for Petersburg
architecture in the early eighteenth century.
The relatively small and low rooms in the
palace have large glazed windows and doors
and are decorated with ceramic tiles,
carved wooden panels, silks and paintings.
Before the October Revolution of 1917
the building housed the First Cadet Corps;
after it, the Military-Political College and
other institutions. In 1967 the palace was
given to the Hermitage department of early
eighteenth-century Russian culture.

21

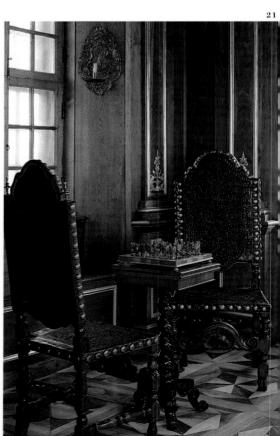

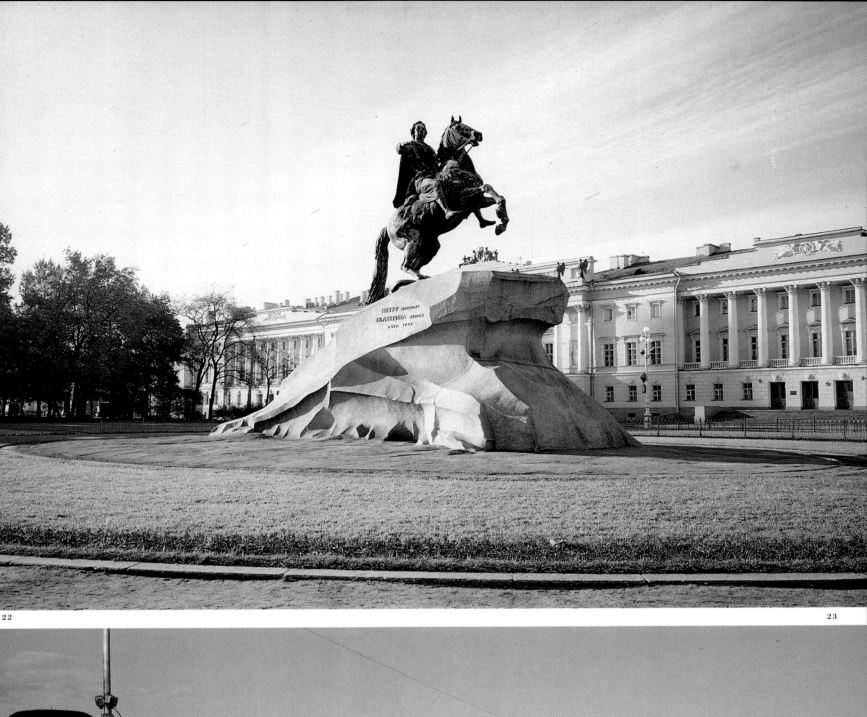

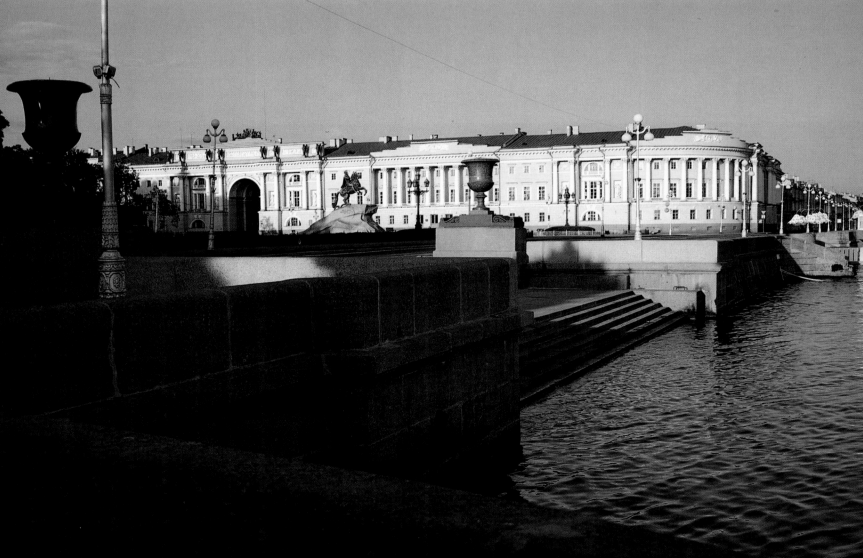

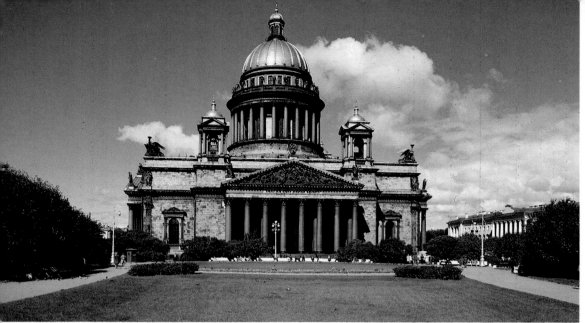

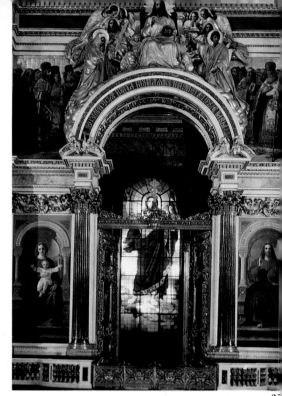

St Isaac's Cathedral, a great work of late Classical architecture, was the chief place of worship in St Petersburg before the October Revolution of 1917. The first wooden church on this site was founded in 1710 in honour of Peter the Great and named after Isaac of Dalmatia because Peter was born on that saint's feast-day (30 May O.S.). The cathedral we see today was built between 1818 and 1858 to the design of Auguste Montferrand and is one of the major achievements of Russian construction technique. The building is decorated with statues and high reliefs; the interior is finished with malachite, lapis lazuli, porphyry and various kinds of marble and adorned with mosaics, paintings, bronze and gilding.

St Isaac's Cathedral is an extremely important landmark in St Petersburg, determining together with the SS Peter and Paul Cathedral and the Admiralty the city's silhouette.

24, 27, 28 St Isaac's Cathedral

25 Central part of the iconostasis

26 Colonnade of the iconostasis

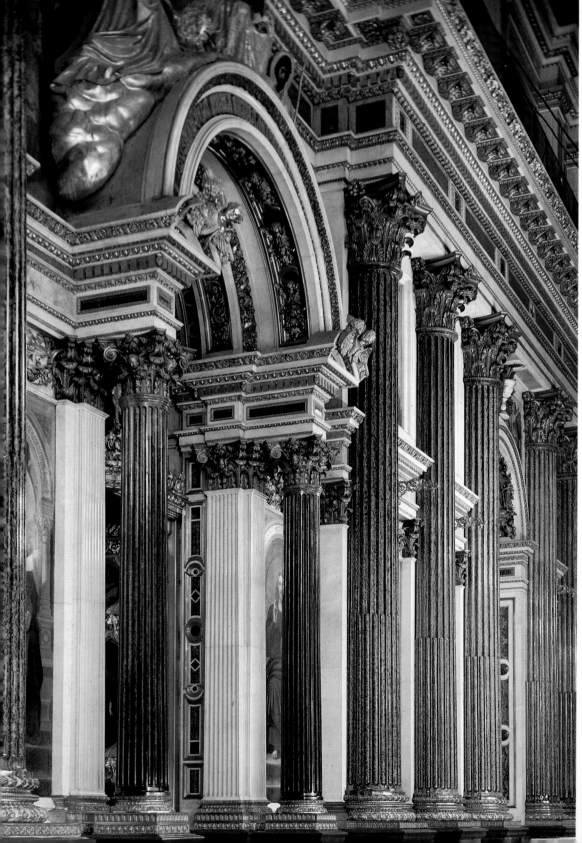

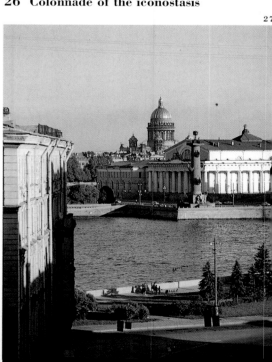

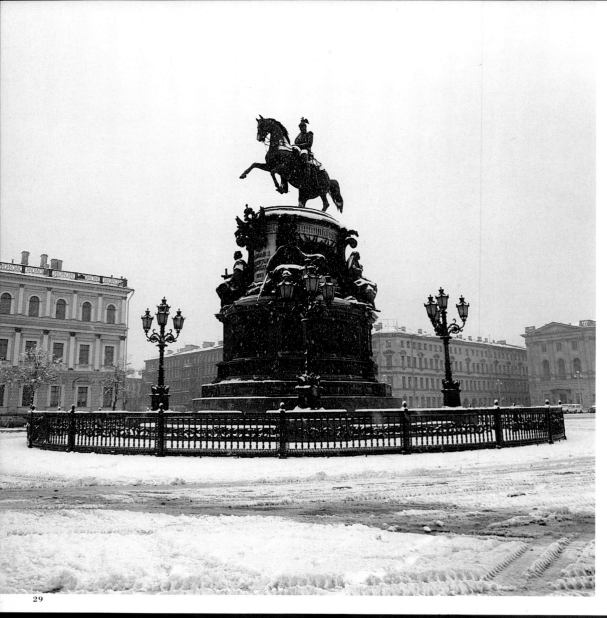

29 Monument to Nicholas I (1856–59, sculptor Piotr Klodt) on St Isaac's Square

30 St Isaac's Square

31, 33 The building and auditorium of the Mariinsky Theatre

32 Ballet-dancers from the Mariinsky Theatre on the Spit of Vasilyevsky Island. A scene from Minkus's ballet *La Bayadère*

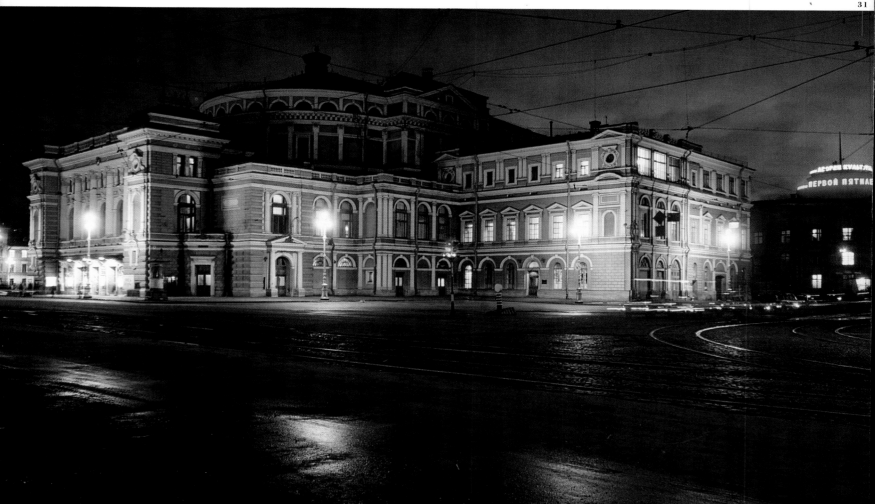

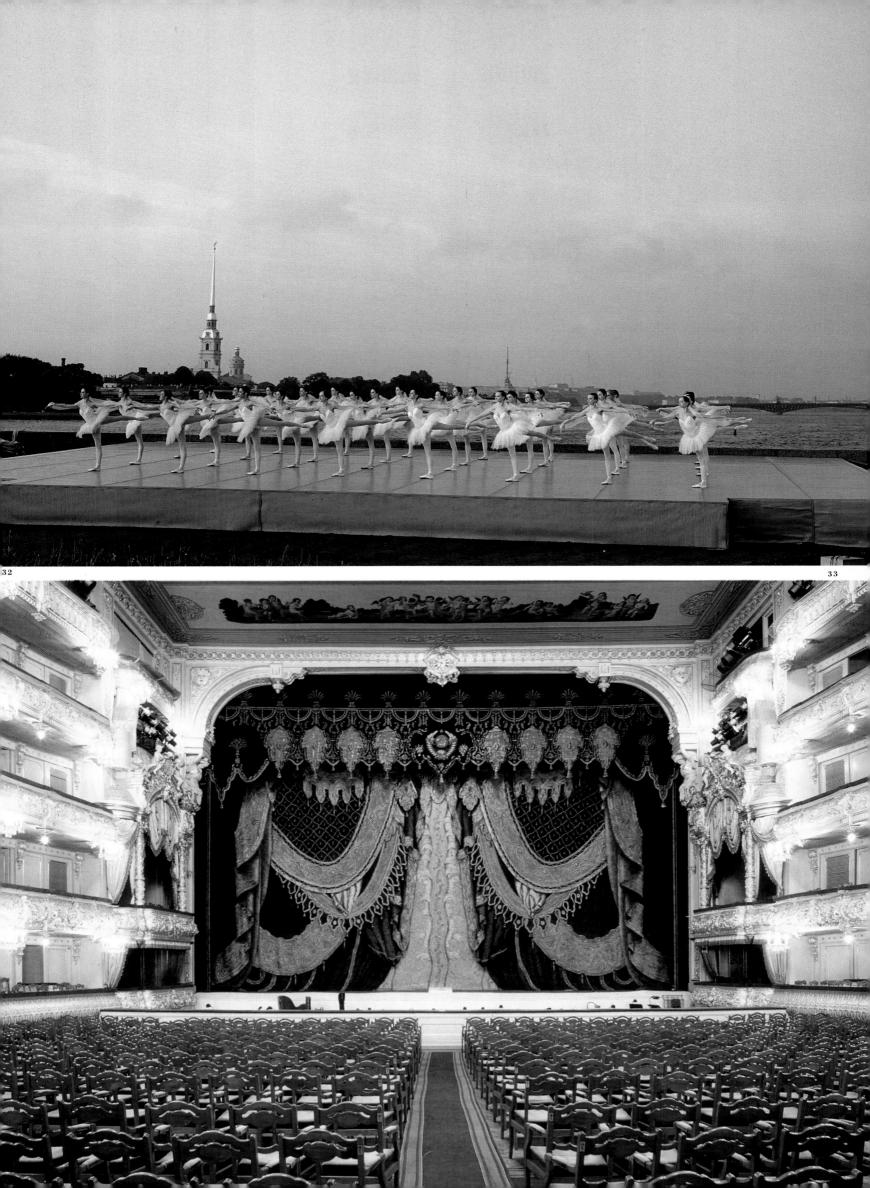

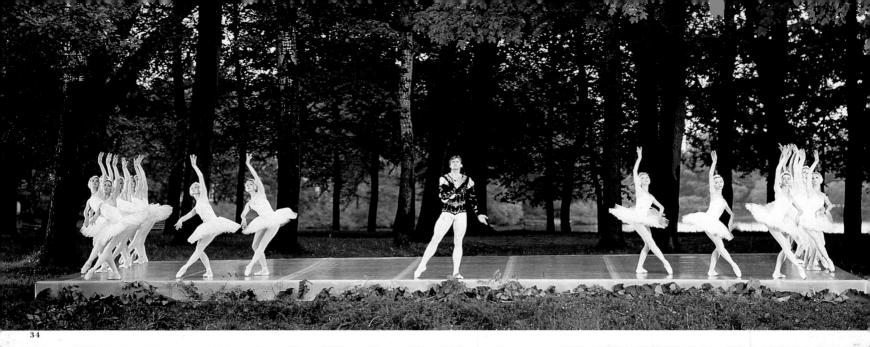

34

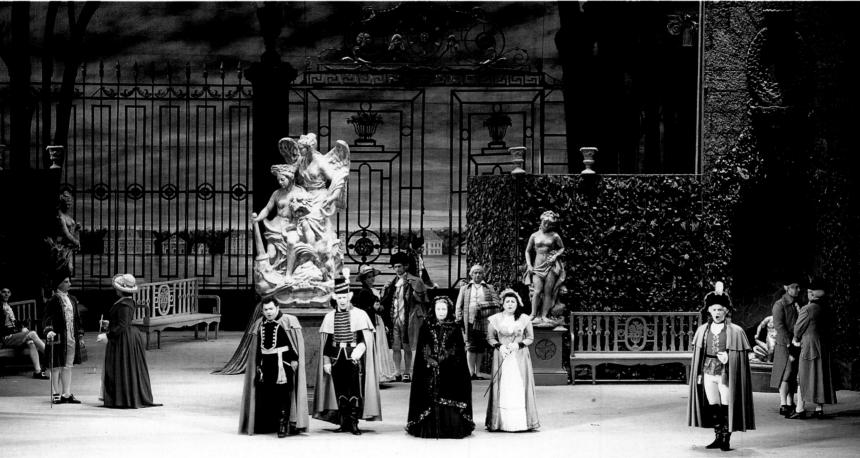

35

36

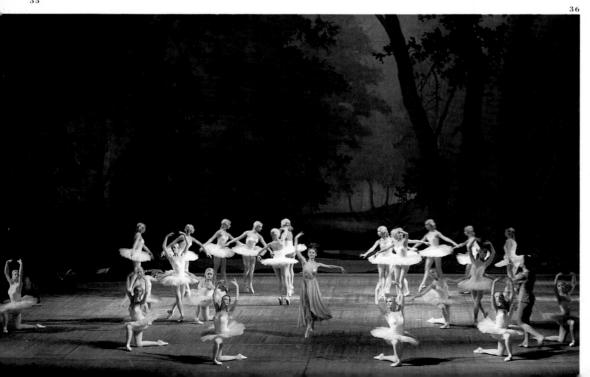

The Mariinsky Opera and Ballet Theatre is one of the largest and most important theatres in Russia. Its history can be traced back to 1783. Outstanding Russian singers, including the great Chaliapin, sang in the opera company here. The ballet company of the Mariinsky Theatre — the Kirov Ballet — is known throughout the world and has undoubtedly had an influence on many of the ballet schools of Europe and America.

34 The Summer Gardens. Scene from Tchaikovsky's ballet *Swan Lake*

35 Scene from Tchaikovsky's opera *The Queen of Spades*

36 Scene from Tchaikovsky's ballet *The Sleeping Beauty*

37 Scene from Musorgsky's opera *The Khovansky Affair*

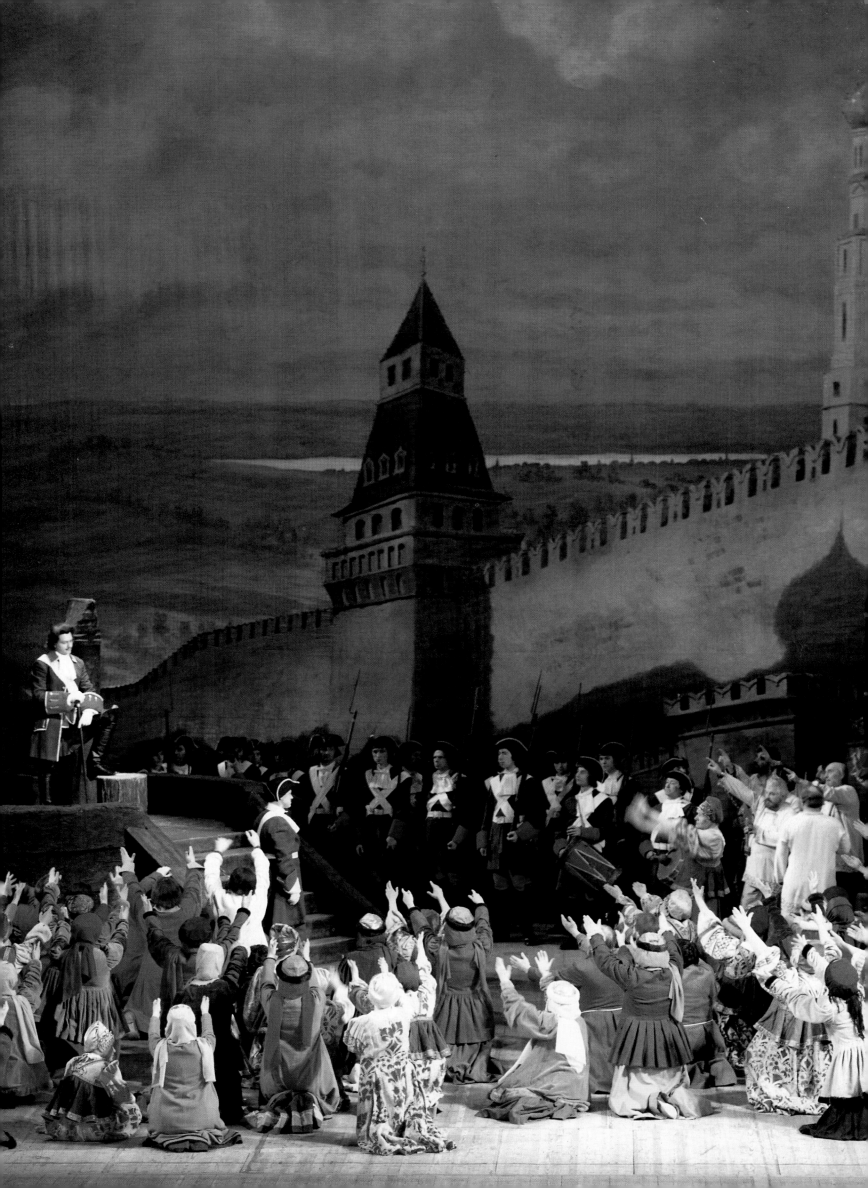

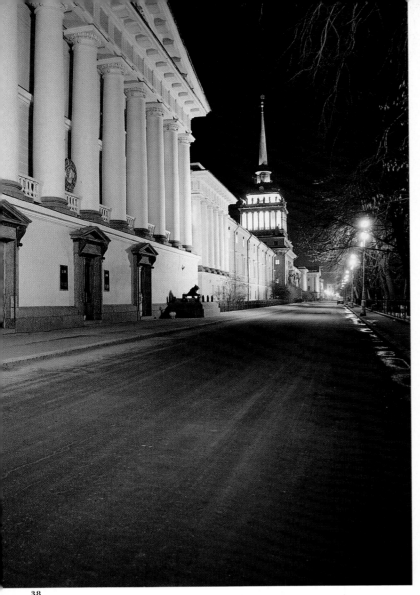

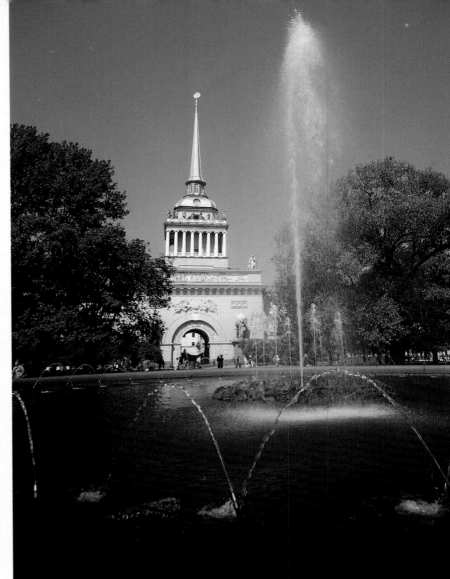

38

39

40

The Admiralty was constructed in 1806–23 by the architect Adrian Zakharov on the site of the Admiralty Shipyard founded in 1704 on the left bank of the Bolshaya (Greater) Neva and originally designed by Peter the Great. The Admiralty is a key architectural focus and the meeting-point of the three main streets in the city centre: Nevsky Prospekt, Voznesensky Prospekt and Gorokhovaya Street. The building is an outstanding example of Classicism, a brilliant synthesis of architecture and sculpture. The plastic decoration conveys the idea of Russia's might as a naval power. The spire on the central tower is crowned by a gilded weather-vane shaped like a sailing-ship, which has become a symbol of the city. In the nineteenth and twentieth centuries the building housed the Naval Ministry, the Naval Staff and other bodies, now it is the Higher Naval Engineering College.

38, 39 The Admiralty

40 One of the two pavilions of the Admiralty building facing the Neva

41 The Alexander Column (1830–34, architect Auguste Montferrand) on Palace Square

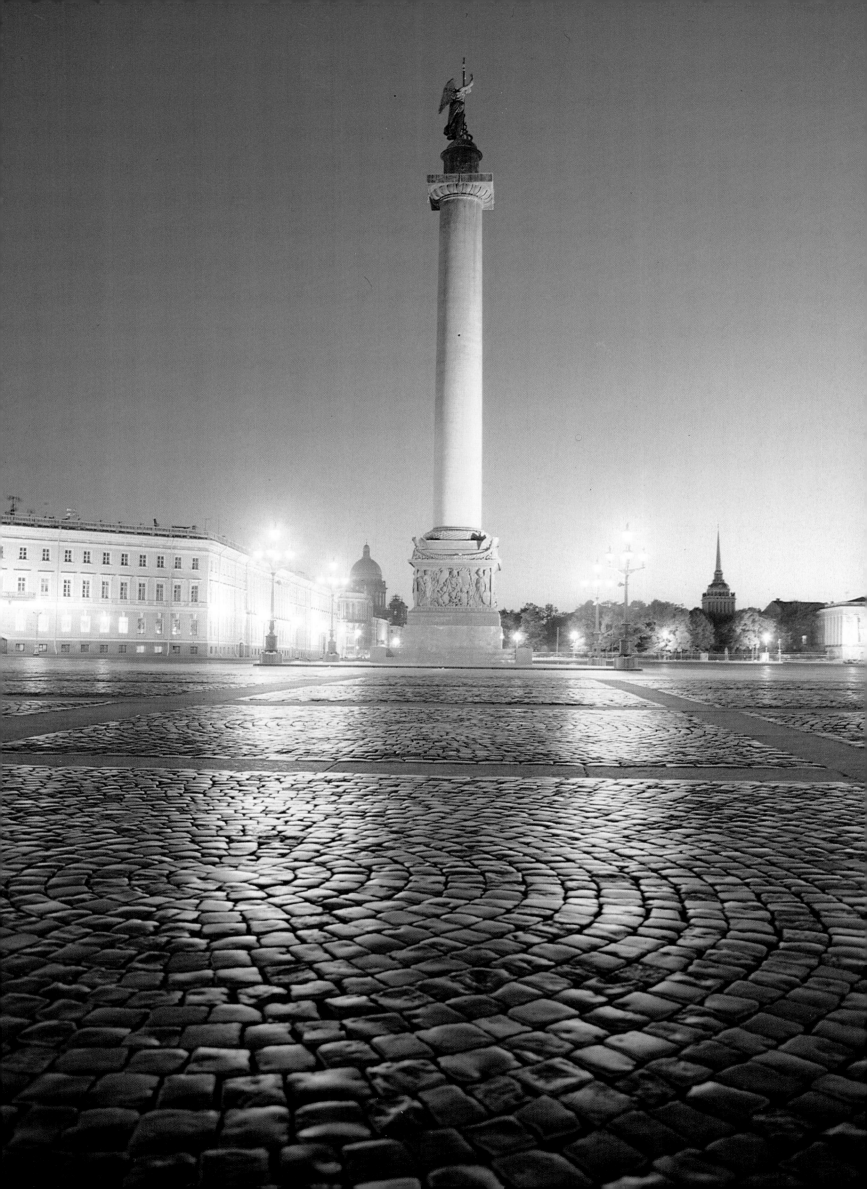

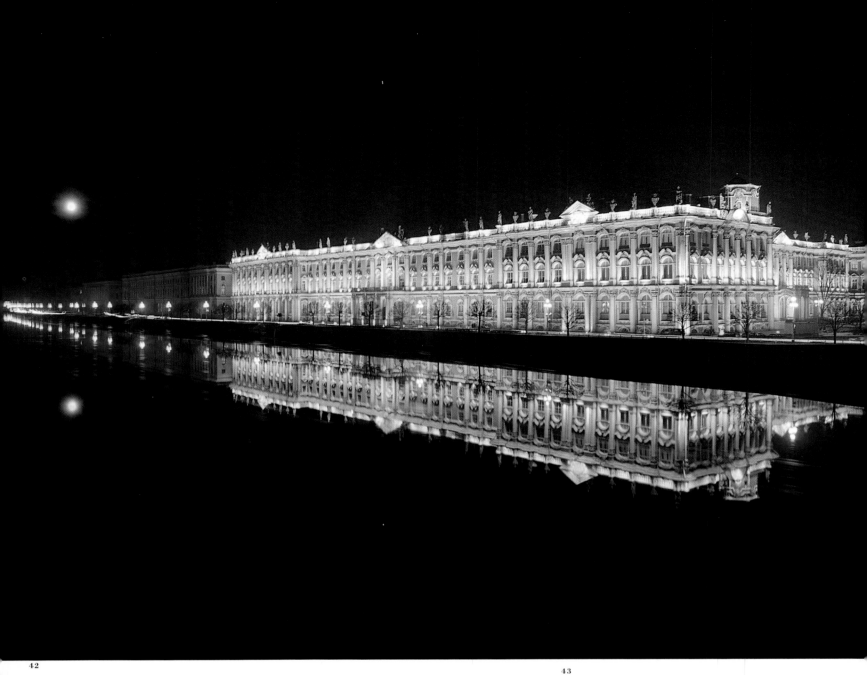

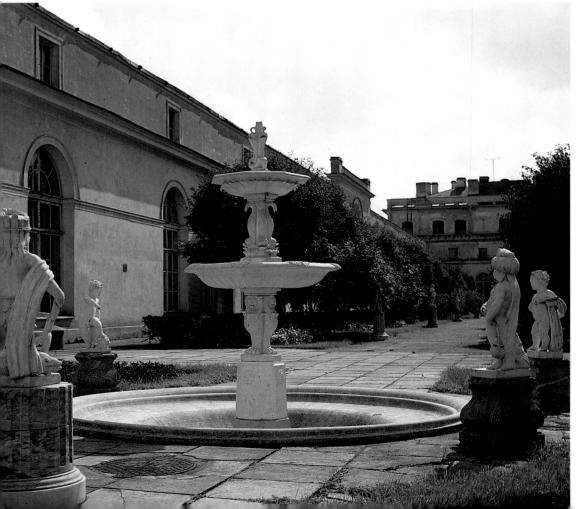

The Hermitage is one of the largest art museums in the world. It occupies five interconnected buildings on Palace Embankment and Millionnaya Street behind: the Winter Palace, the Small Hermitage, Old Hermitage, New Hermitage and Hermitage Theatre. The museum contains items of art produced by primitive cultures, others from the Classical world and the East, ancient and modern, as well as Western European paintings and graphic works and examples of decorative and applied art. The museum's exhibits are displayed in over 350 rooms.

The Winter Palace — a masterpiece of Baroque architecture — was built by Francesco Bartolommeo Rastrelli in 1754–62. From the 1760s the palace was the residence of the Russian rulers.

The Jordan Staircase — the main one in the Winter Palace — gets its name from the fact that at Epiphany members of the imperial family and the senior clergy left the palace here to cross the embankment to a special pavilion known as a "Jordan" erected by the Neva for the traditional Orthodox ceremony of the Blessing of the Waters.

The New Hermitage faces Millionnaya Street. Its portico is supported by ten atlantes carved in granite by Alexander Terebenev.

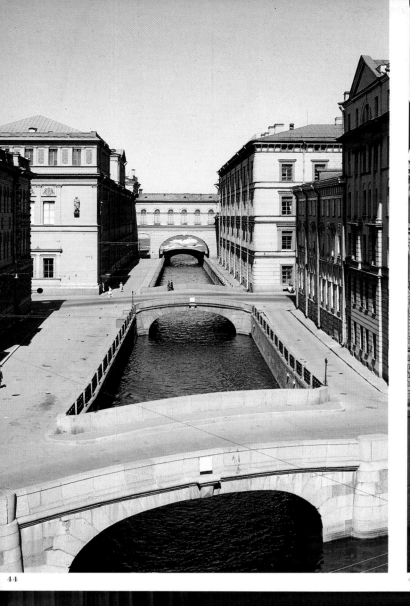

44

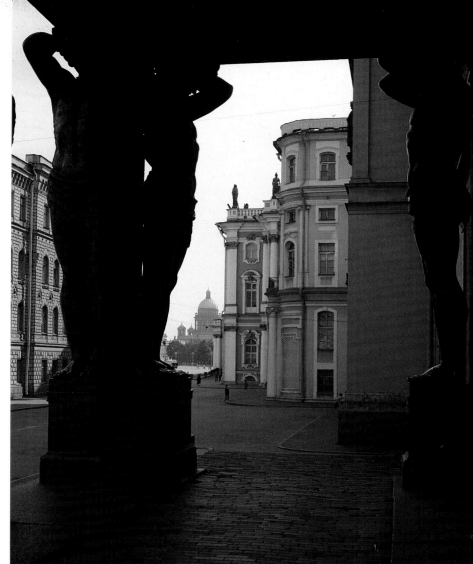

45

46

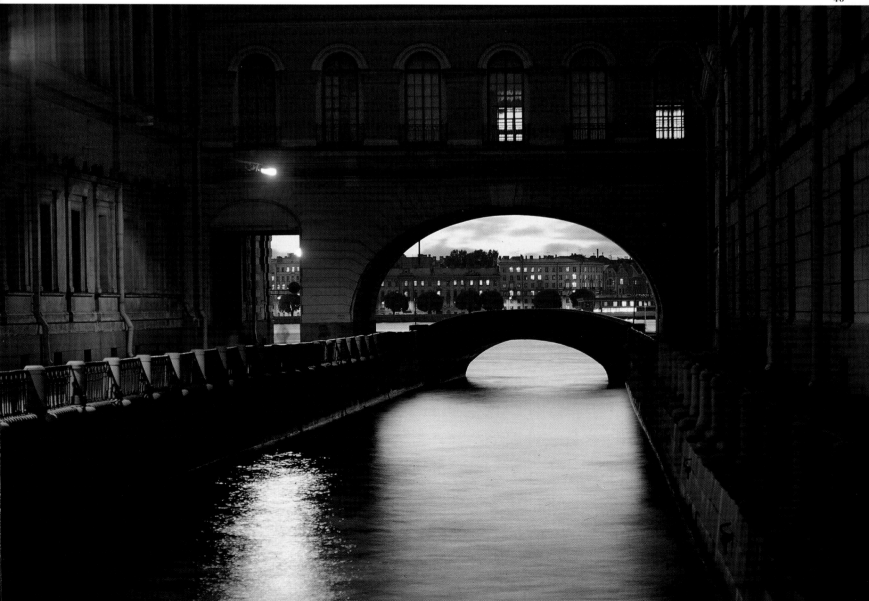

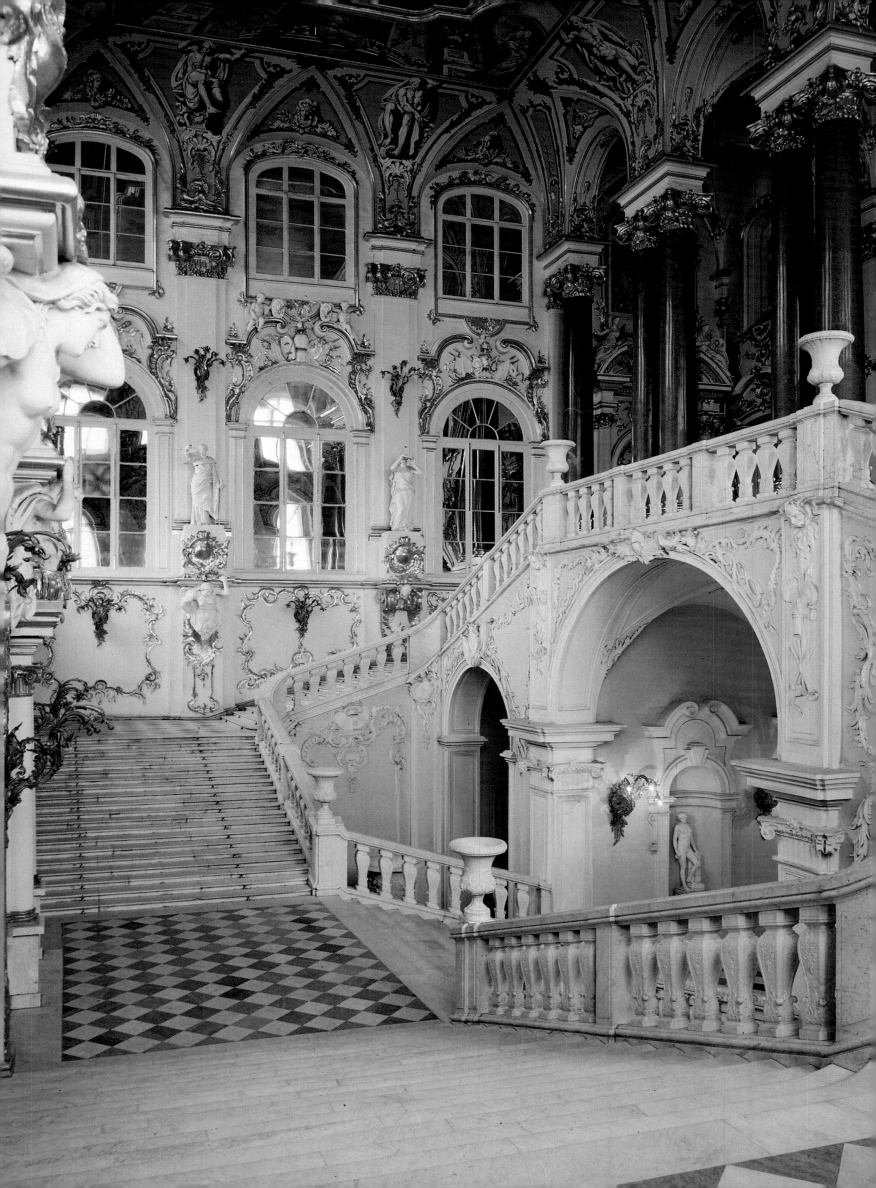

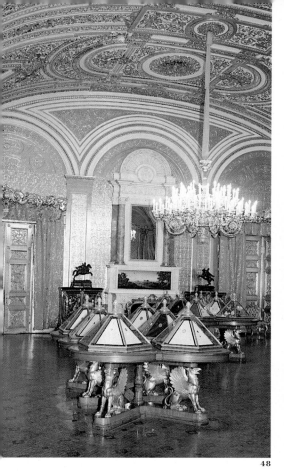

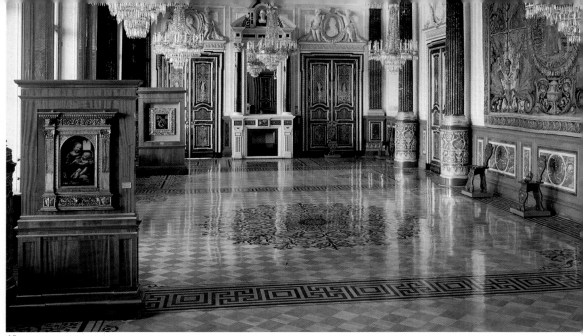

Previous pages:

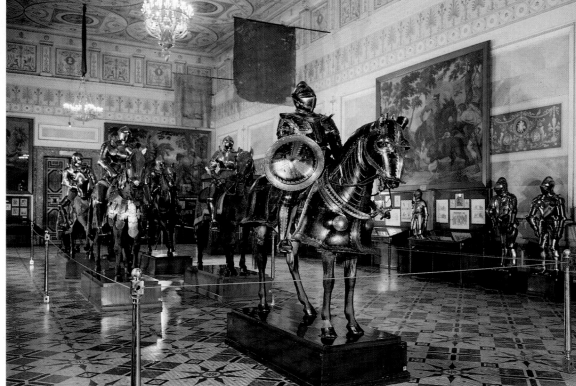

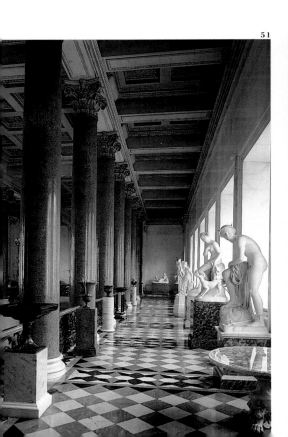

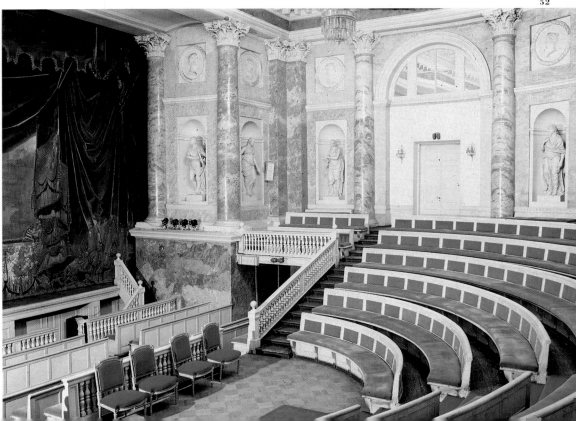

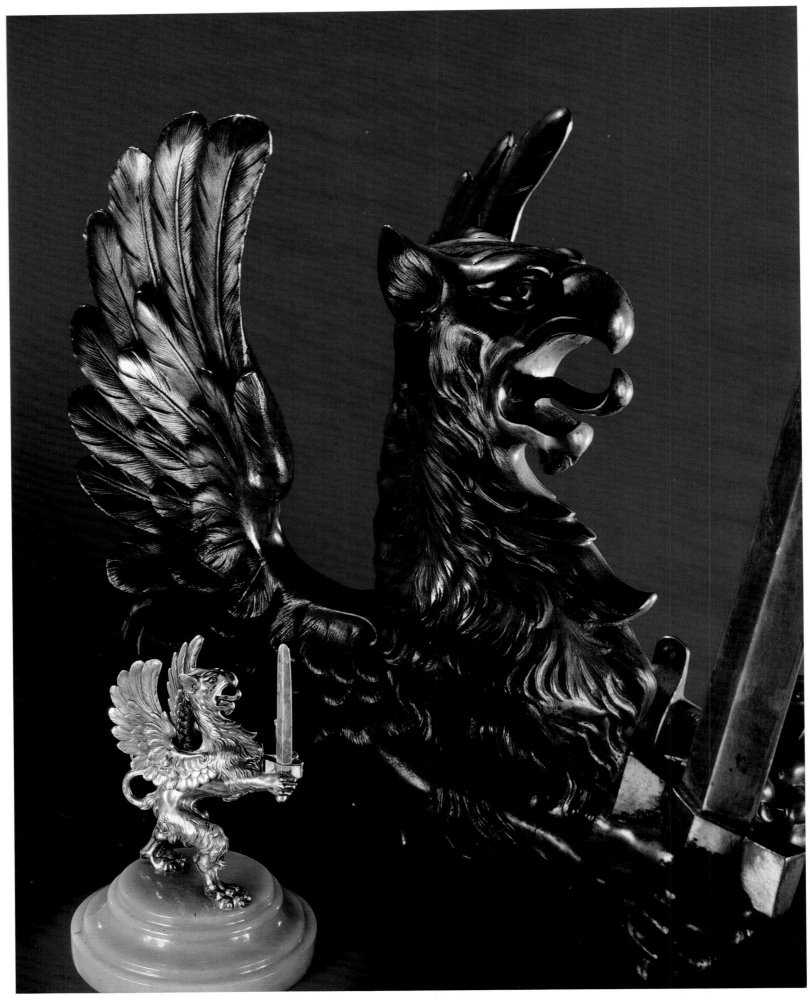

53 GRYPHON, THE COAT-OF-ARMS OF THE ROMANOV HOUSE. 1898
The Fabergé Company
The Hermitage Museum

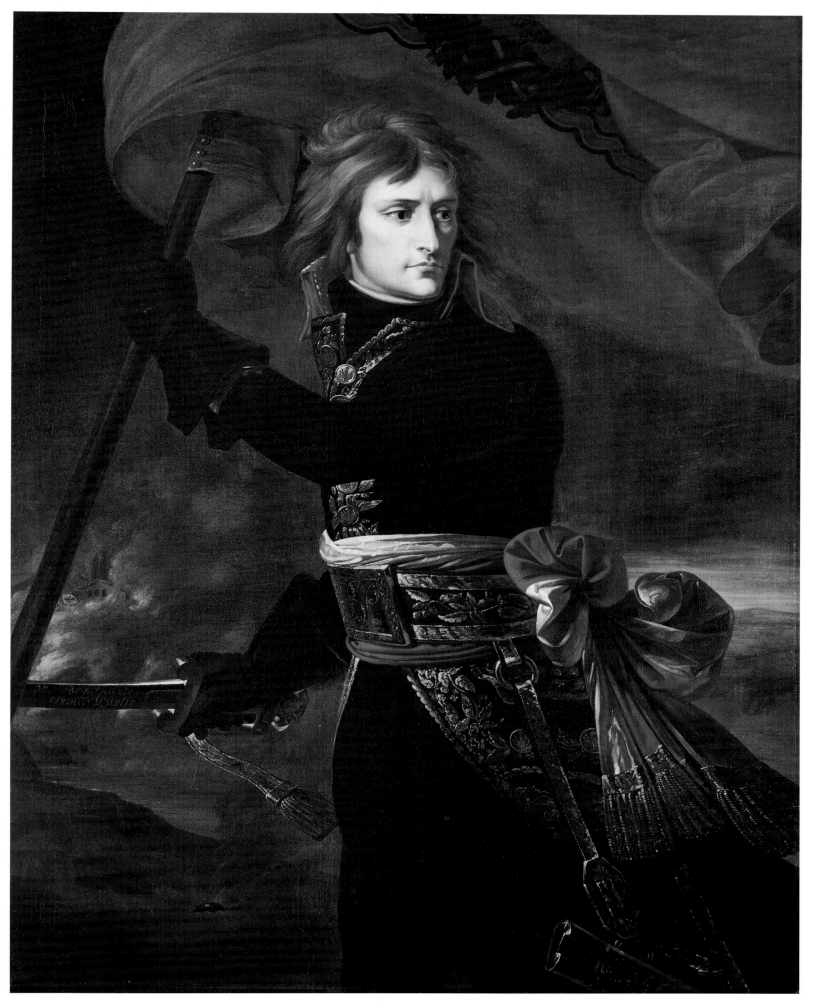

54 NAPOLEON ON THE ARCOLE BRIDGE. 1796/97
By Jean Antoine Gros
The Hermitage Museum

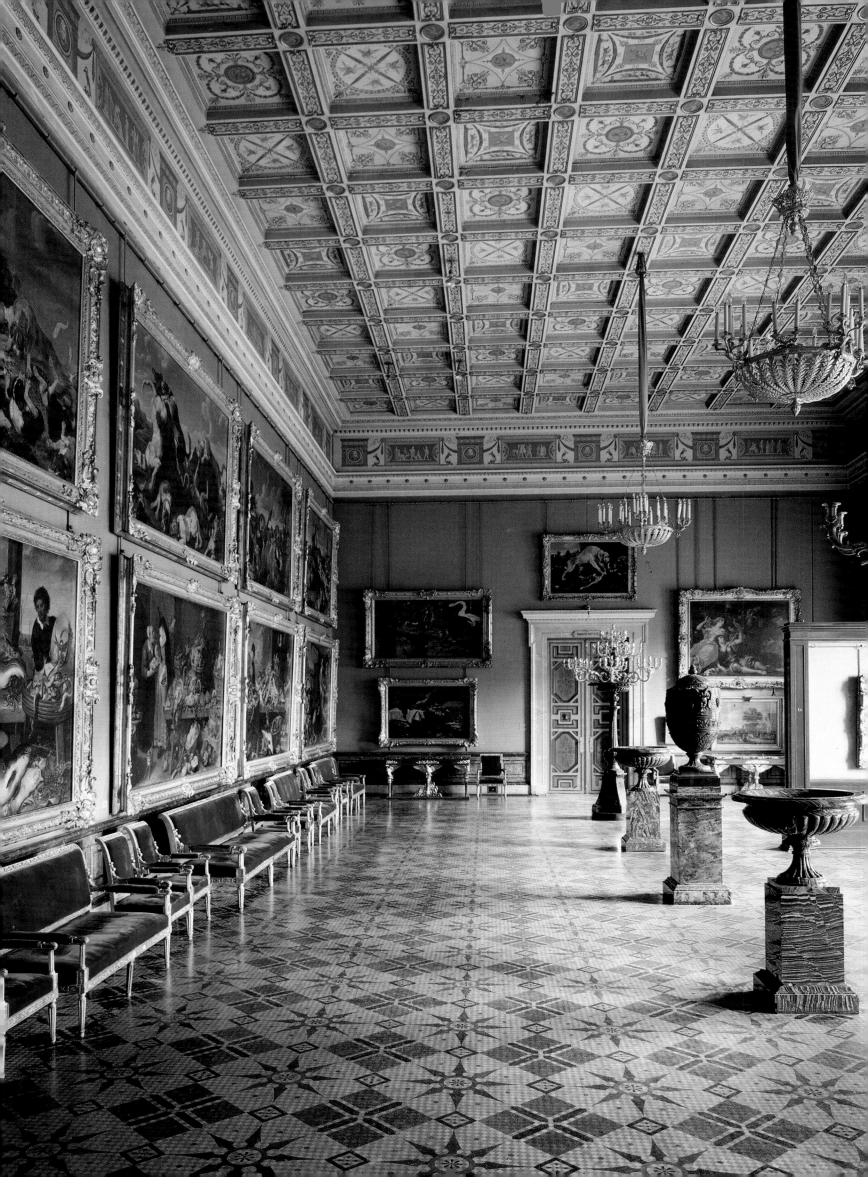

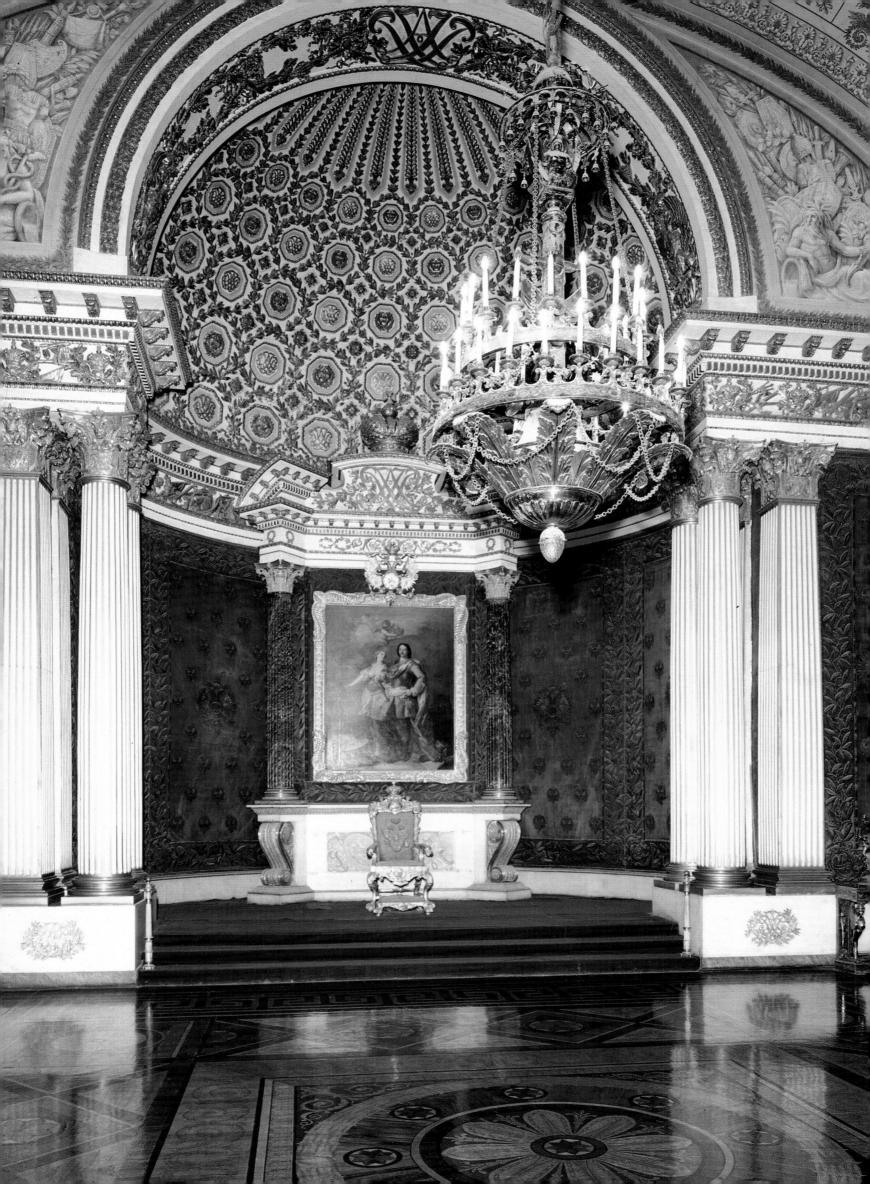

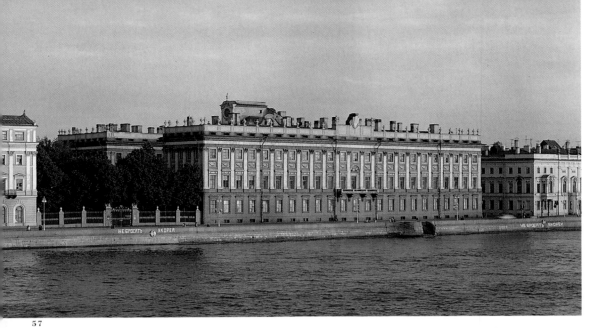

57

The Pushkin Memorial Flat is situated
at number 12 on Moika Embankment.
The great Russian poet lived here from
the autumn of 1836. On 29 January 1837
Pushkin died in his study of a wound
received in a duel with Georges d'Anthès.

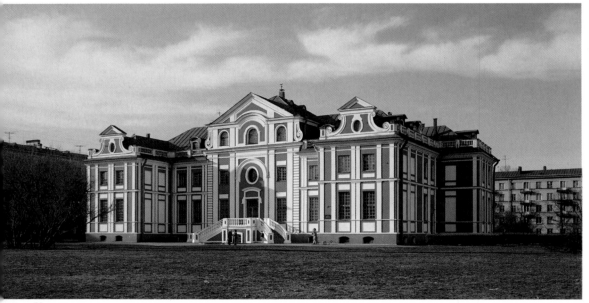

58

59

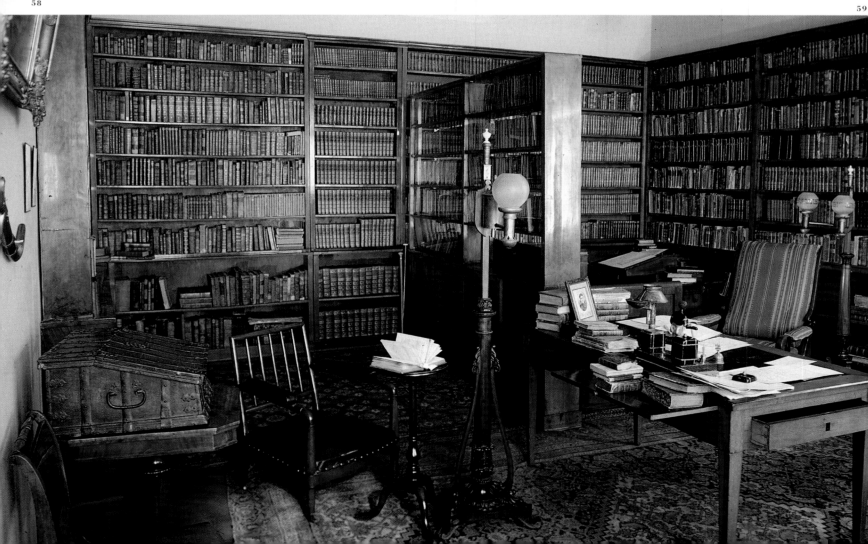

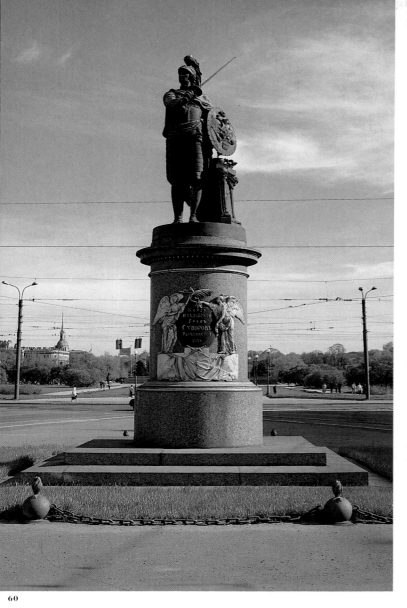

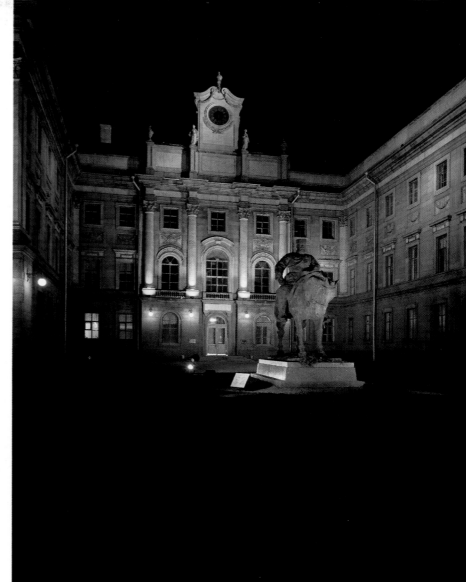

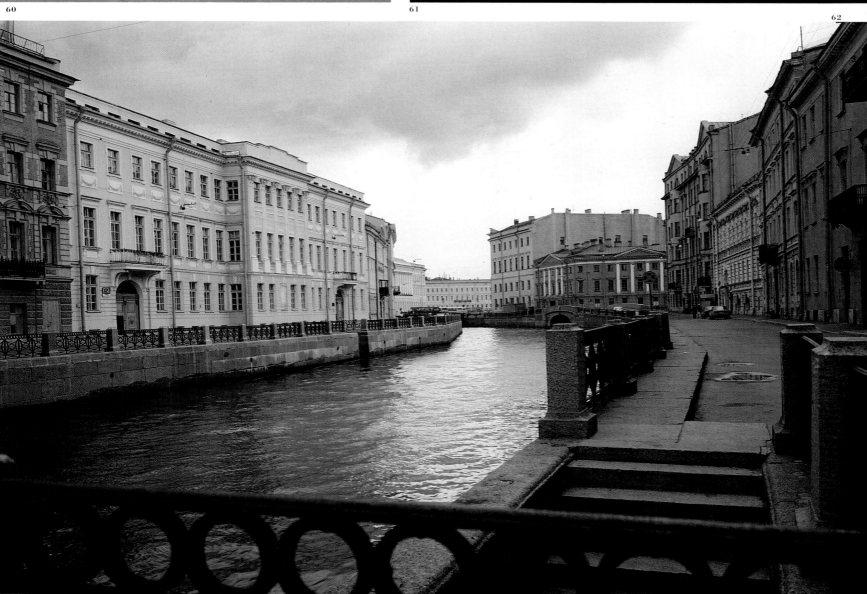

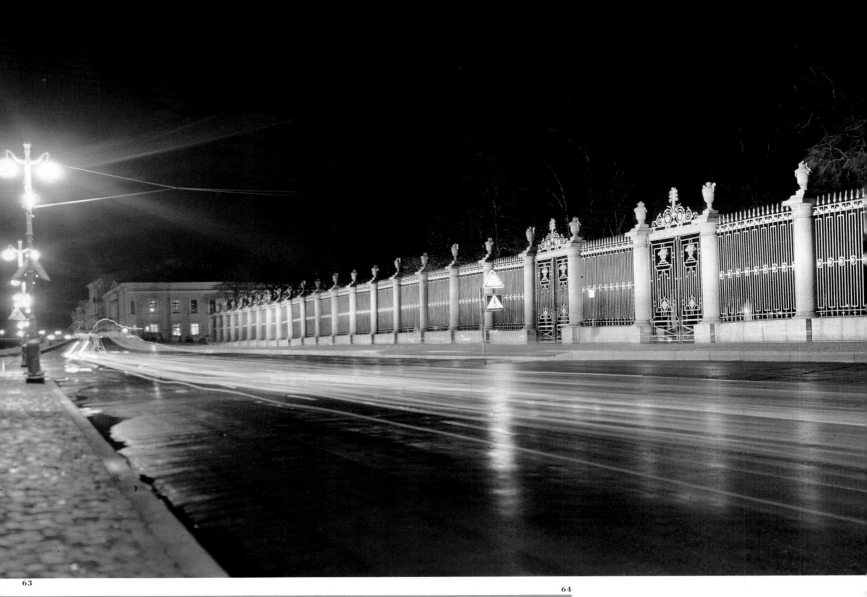

The Summer Gardens were laid out in 1704 at the command of Peter the Great alongside his summer residence. They are located on the left bank of the Neva on an island formed by the Moika and Fontanka Rivers and the Swan Canal. The gardens were adorned with numerous statues, sculptural groups and busts (predominantly Italian work of the late seventeenth and early eighteenth centuries) and with fountains. Out of 250 sculptures, 89 still survive. From the middle of the eighteenth century the Summer Gardens were the place where the aristocracy went to stroll (ordinary people were not allowed in); in the early nineteenth century some of the alleys were converted to permit horseback riding. The railings which separate the Summer Gardens from Neva embankment were set up in 1773–86 (architects: Georg Friedrich Velten, Piotr Yegorov and Timofei Nasonov).

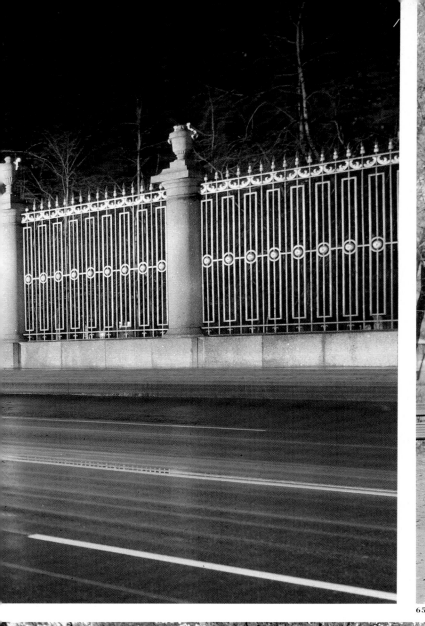

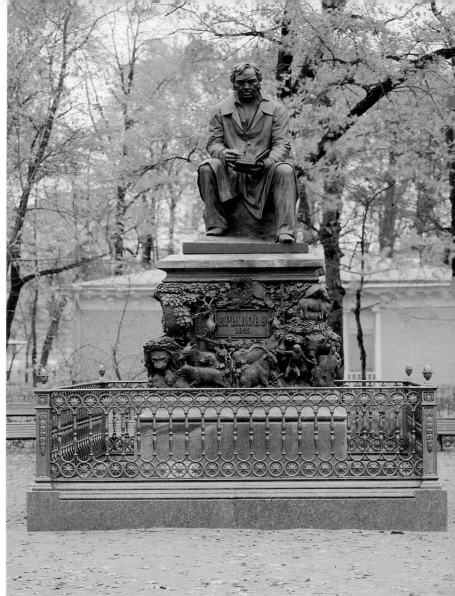

65

66

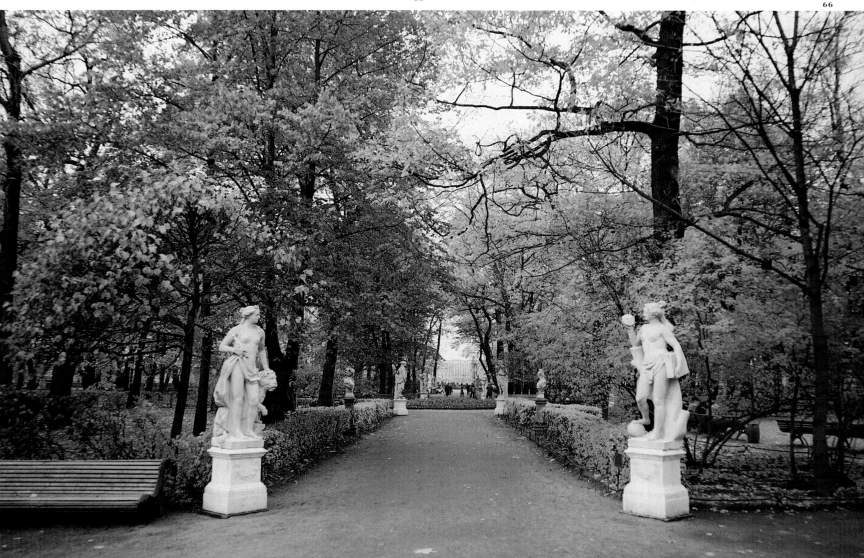

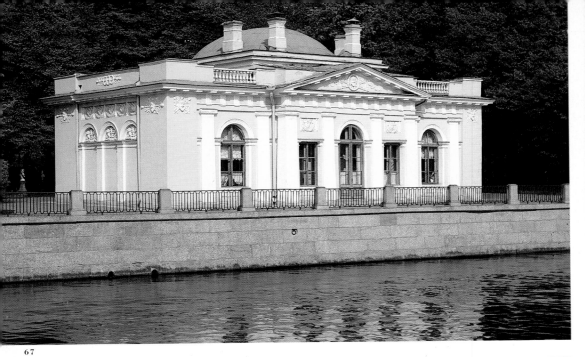

67

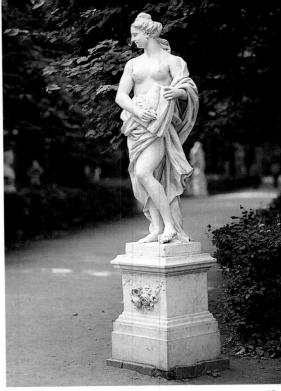

68

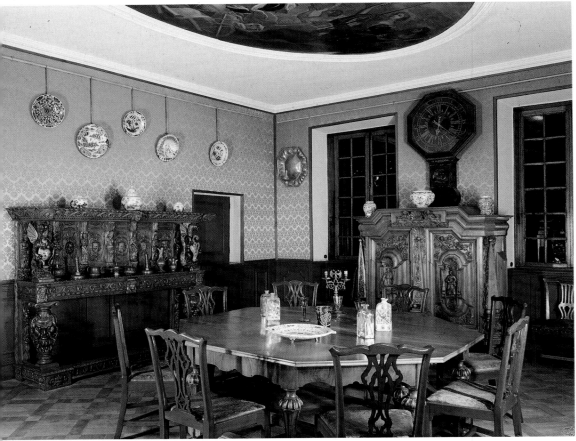

69

70

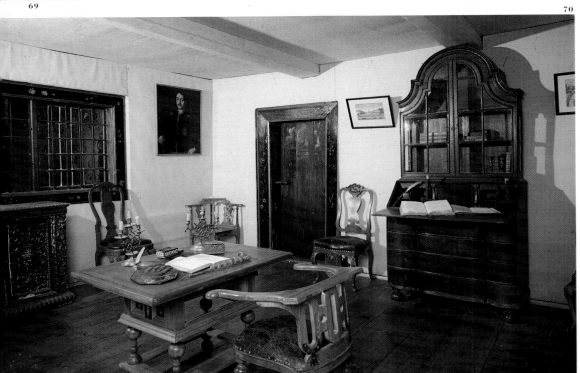

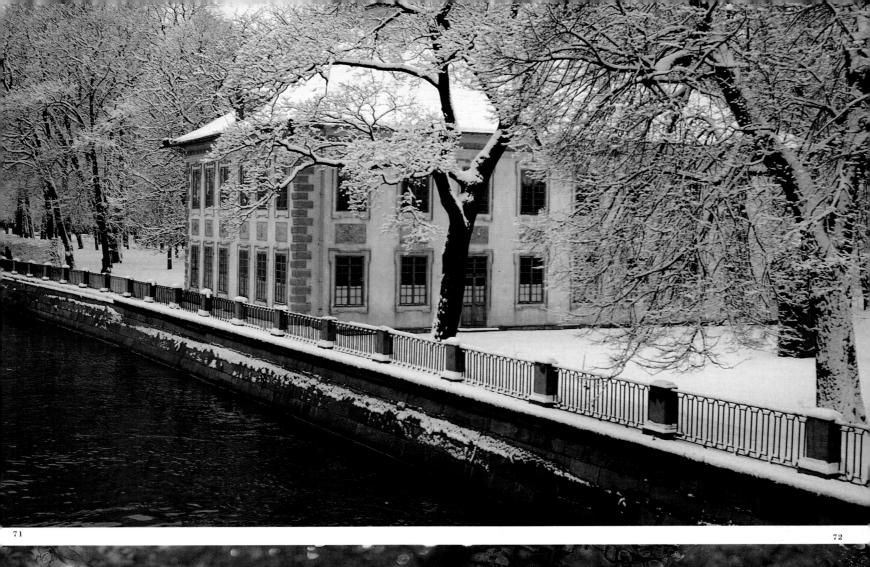

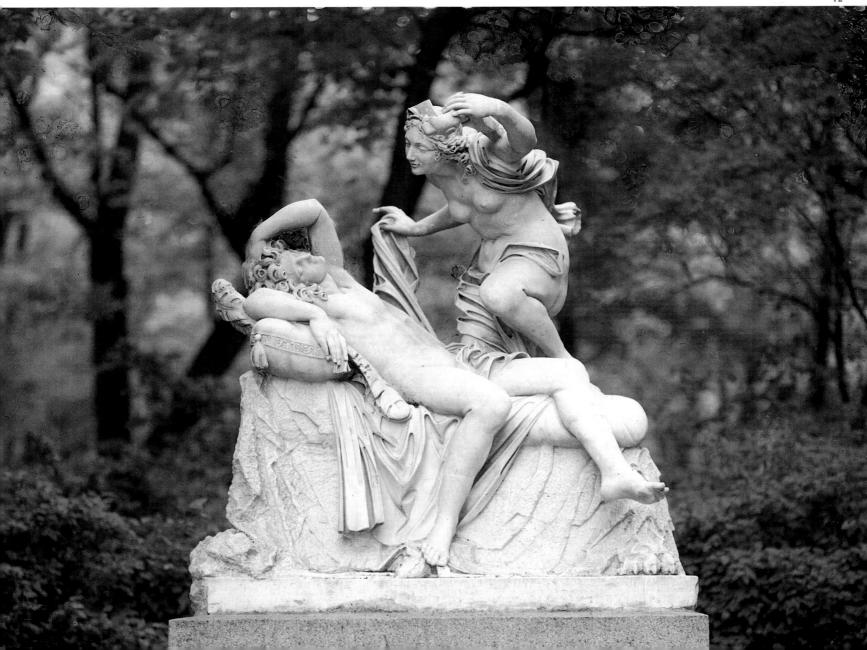

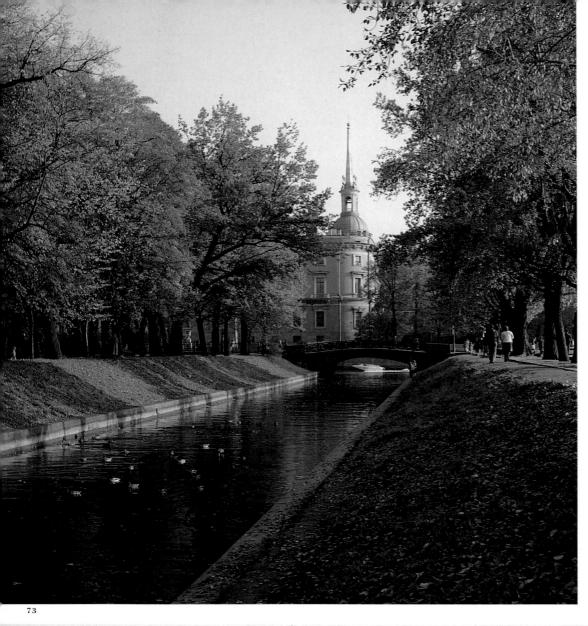

The Mikhailovsky (St Michael) Castle was built in 1797–1800 by a great practitioner of the Classical style, Vincenzo Brenna. In 1800 Carlo Bartolommeo Rastrelli's equestrian statue of Peter the Great was set up in front of the building. The castle was constructed as a residence for Paul I (whose patron saint was the Archangel Michael), but the emperor was destined to live in it less than two months. On the night of 11 March 1801 he was murdered by conspirators in the state bedchamber of the palace. In 1819 the castle was given over to the Chief Engineering College, hence its second name — the Engineers' Castle. Its pupils later included the writer Dostoyevsky.

73 The Mikhailovsky (St Michael) Castle from the Swan Canal

74, 76 The Mikhailovsky Castle

75 Monument to Peter the Great in front of the Mikhailovsky Castle

73

74

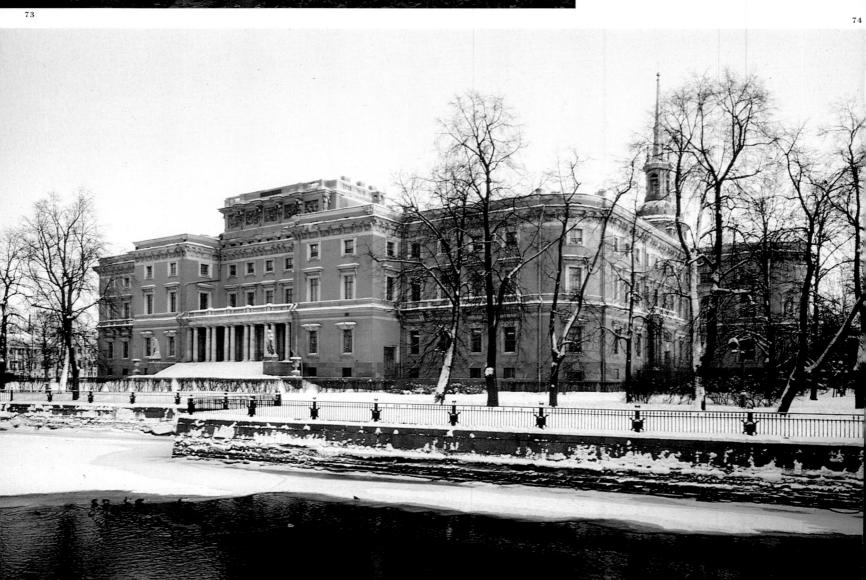

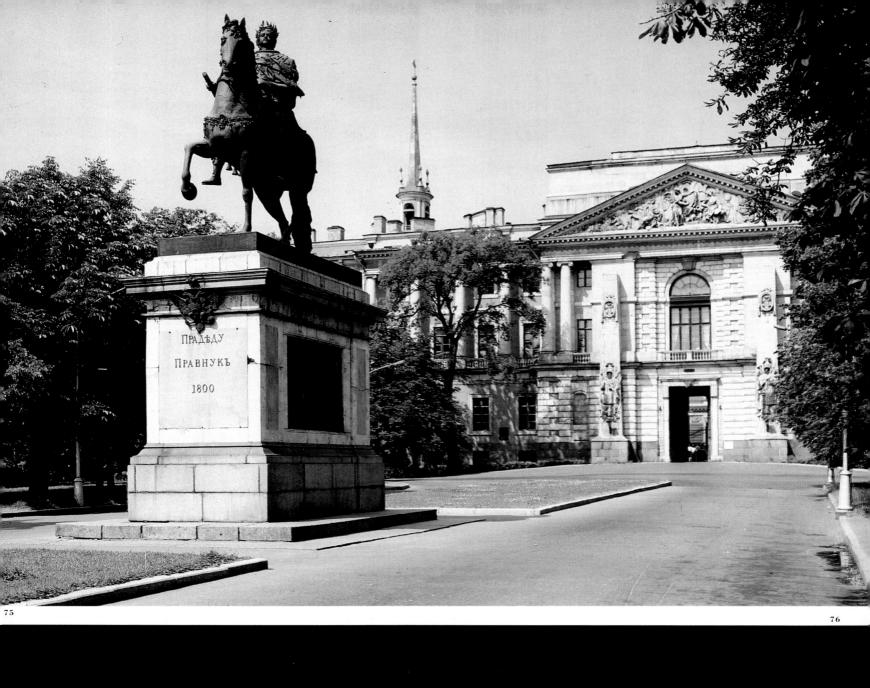

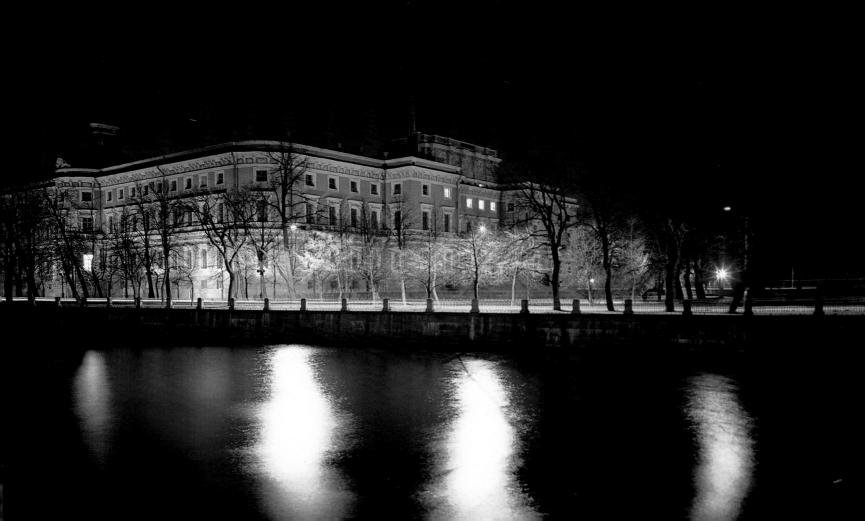

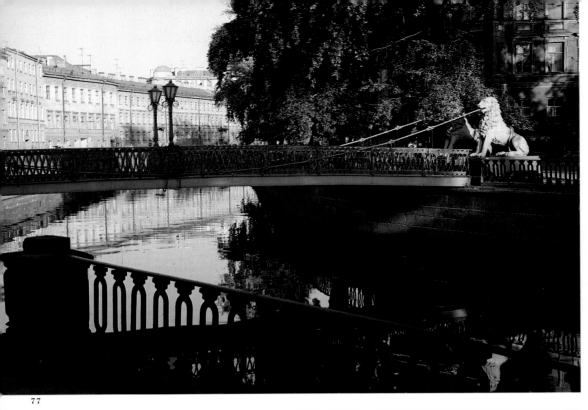

77

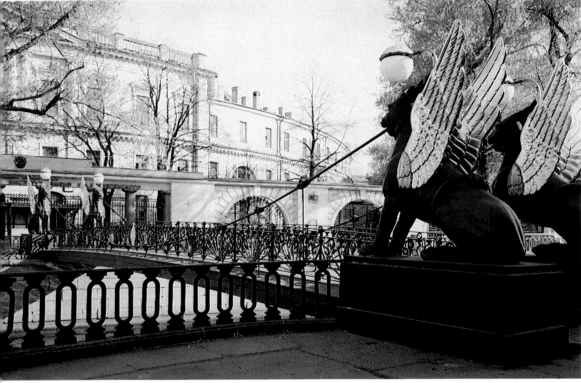

78

Bridges are an inseparable element in the architectural landscape of this "Northern Venice" washed by the waters of the Neva and transected by its many branches, smaller rivers and canals. In St Petersburg and the suburbs there are some 800 bridges. Something special is added to the feel of the city by the raising of the bridges across the Neva at night to allow large ships to pass up and down. This regular practice becomes a moving spectacle in the White Nights of June.

77 Lion Bridge over the Griboyedov Canal. 1825–26. Engineers G. Traitteur and V. Khristianovich

78 Bank Bridge over the Griboyedov Canal. 1825–26. Engineer G. Traitteur

79

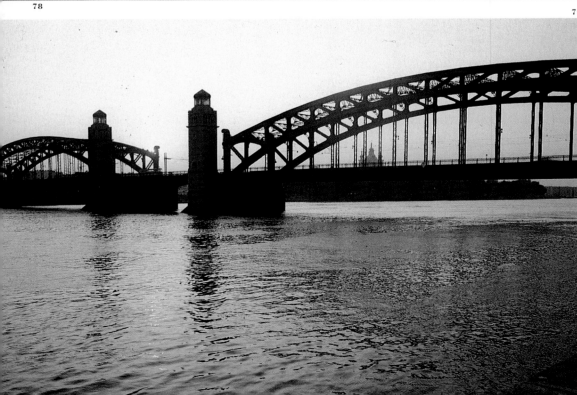

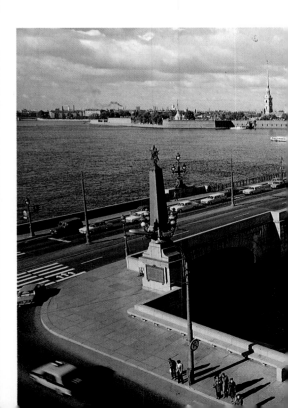

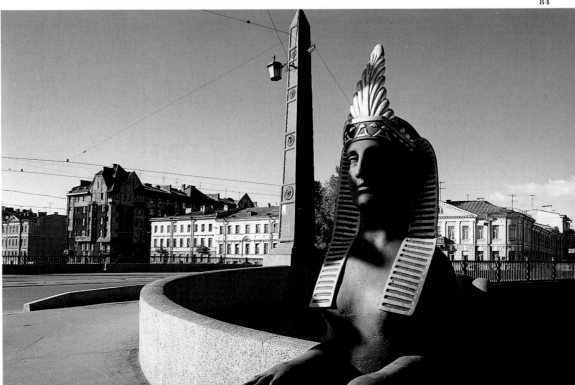

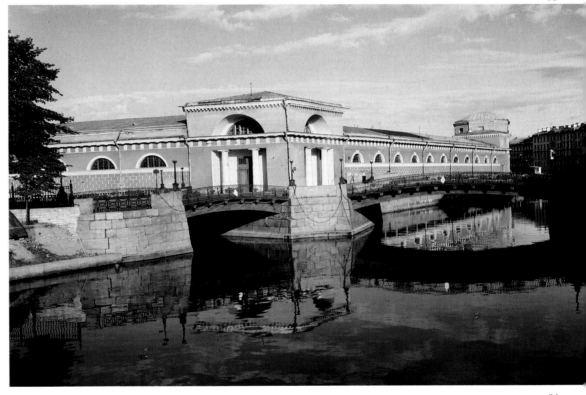

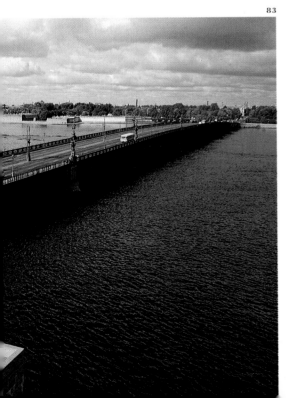

79 Peter the Great Bridge across the Neva. 1908–11. Engineers G. Krivoshein, S. Bobrovsky and G. Perederiy

80 Anichkov Bridge over the Fontanka River. 1906–08. Engineers S. Bobrovsky, G. Krivoshein; architect Piotr Shchusev

81 Chernyshov Bridge over the Fontanka River. 1785–87. Engineer A. Viazemsky

82 Malo-Koniushenny and Theatre Bridges spanning the junction of the Moika River and the Griboyedov Canal. 1829–30. Engineers G. Traitteur and Ye. Adam

83 Trinity Bridge. 1897–1903. Designed by the French Batignolle Company; built with a participation of Russian engineers

84 Egyptian Bridge. 1954–56. Engineer V. Demchenko, sculptor Pavel Sokolov

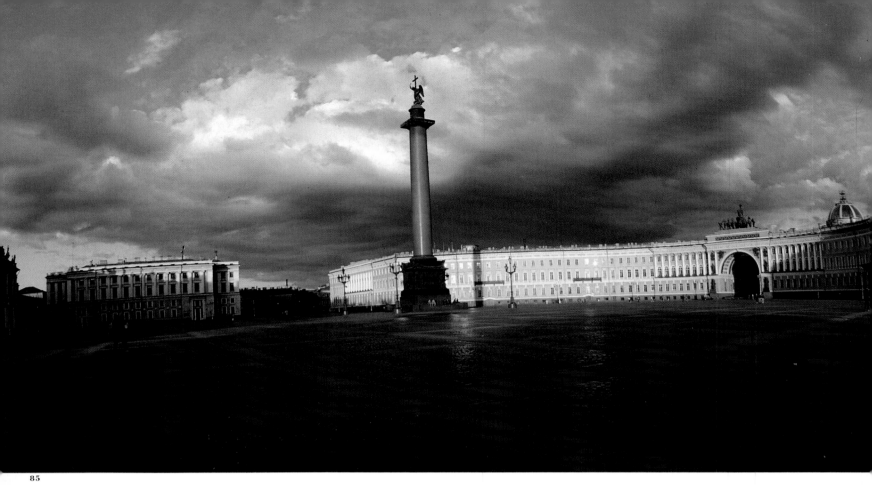

85

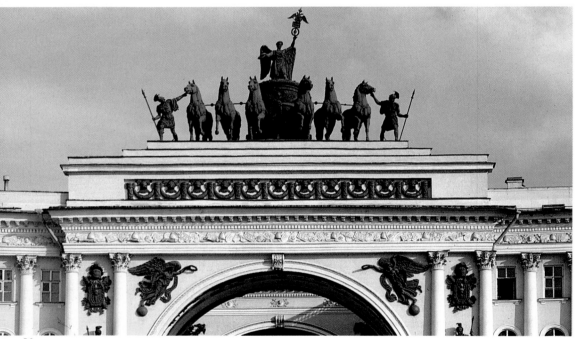

86

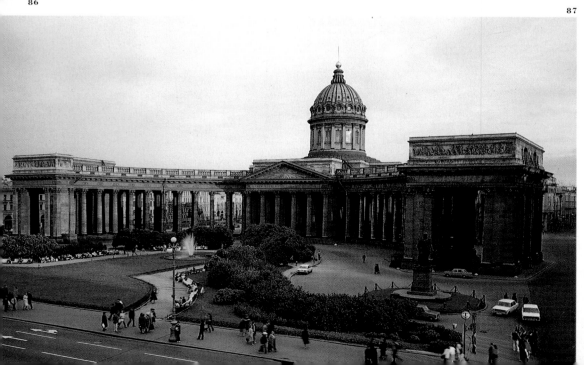

87

85 The Alexander Column and the
General Staff building (*right*; 1819–29,
architect Carlo Rossi) on Palace Square

86 The arch of the General Staff building.
Sculptors Stepan Pimenov and Vasily
Demuth-Malinovsky

87 The Cathedral of Our Lady of Kazan.
1801–11. Architect Andrei Voronikhin

88 Monument to Mikhail Kutuzov. 1837.
Sculptor Boris Orlovsky, architect Vasily
Stasov

89 Nevsky Prospekt

88

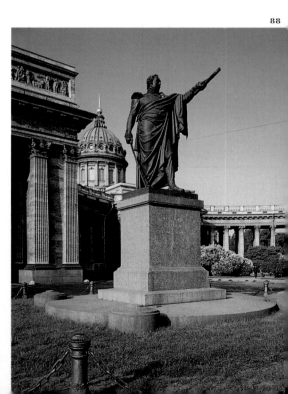

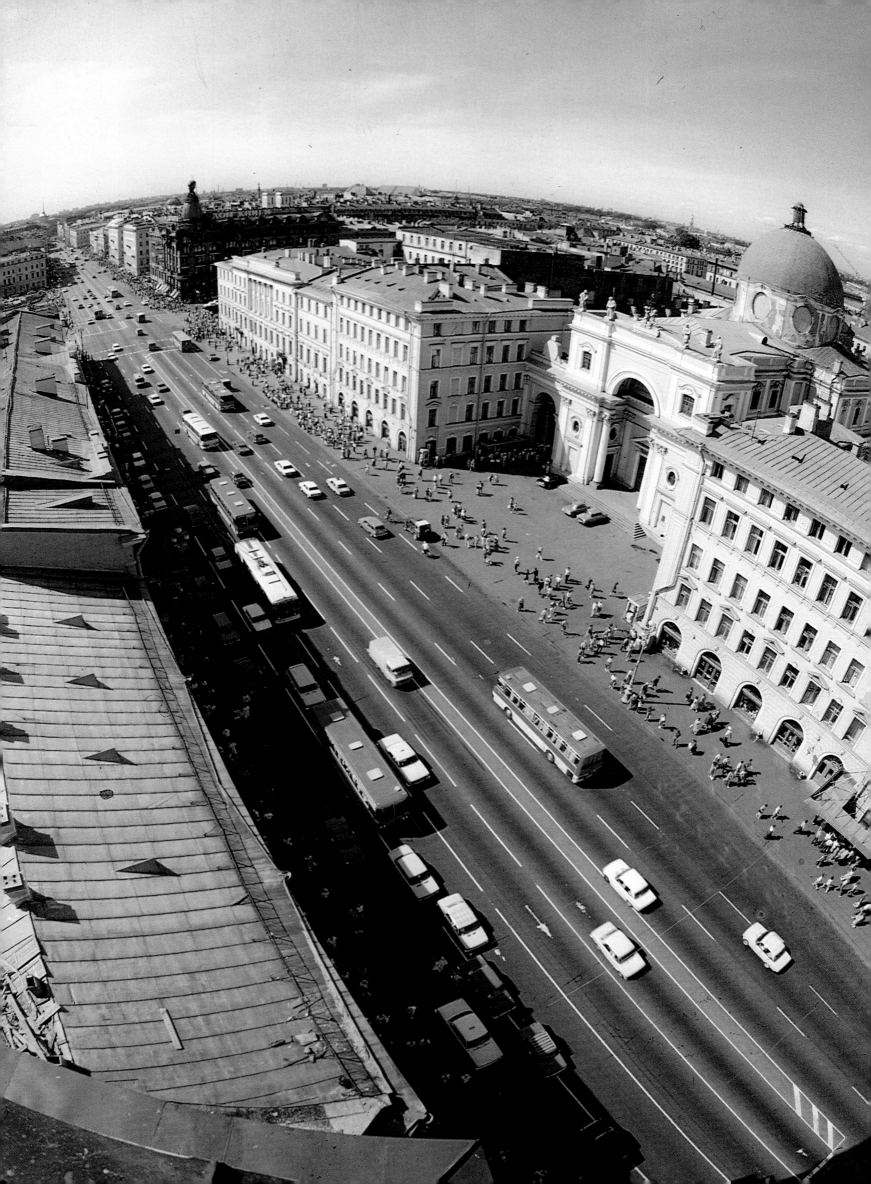

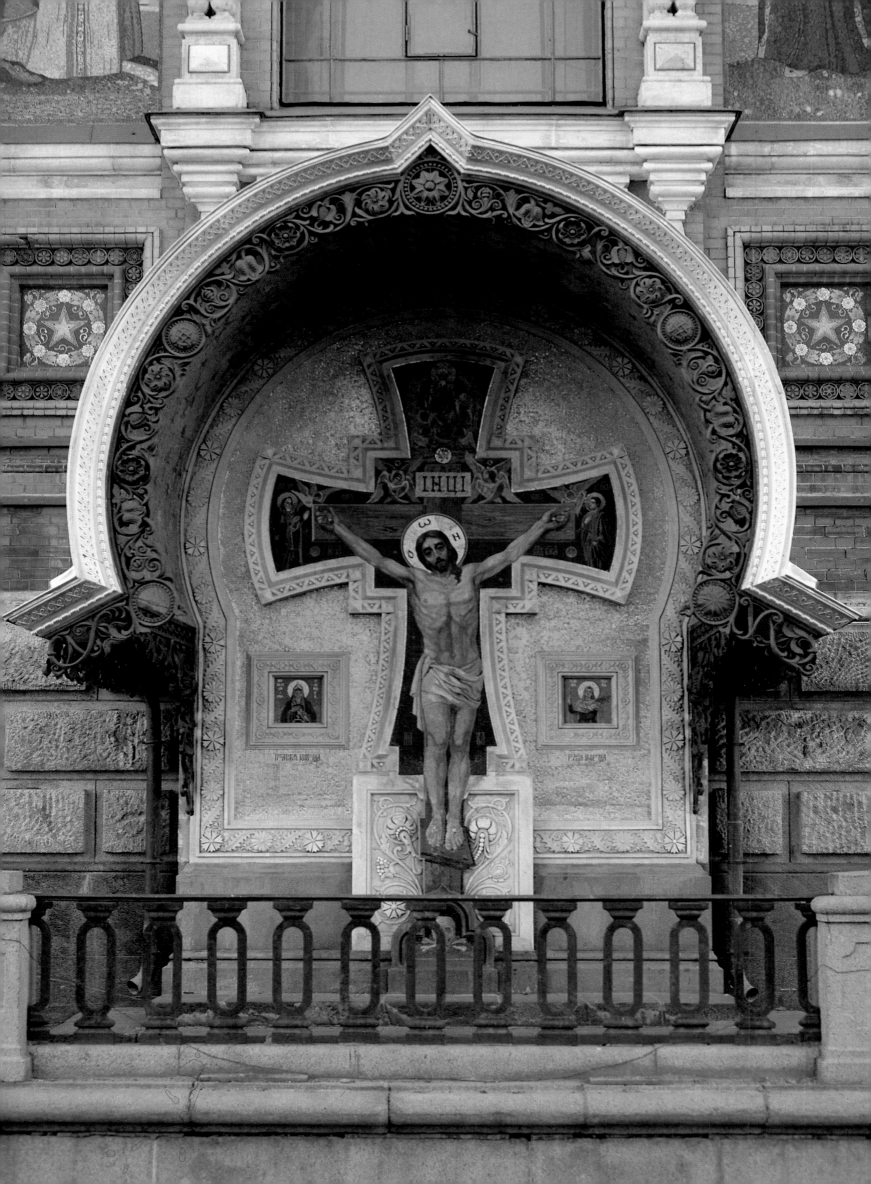

The Church of the Resurrection of Christ (or the "Saviour-on-the-Spilt-Blood") was built in 1883–1907 (architects: I. Makarov and A. Parland) as a memorial church on the spot where Emperor Alexander II was fatally wounded by revolutionary terrorists on 1 March 1881. The style of the building was inspired by Russian architecture of the sixteenth and seventeenth centuries. It employs, in particular, compositional devices first used in the creation of St Basil's Cathedral on Red Square in Moscow.

90, 93 The Church of the Resurrection of Christ (the "Saviour-on-the-Spilt-Blood")

The Mikhailovsky Palace was constructed in 1819–25 in Classical style by Carlo Rossi to be the residence of Grand Duke Mikhail, the brother of Alexander I and Nicholas I. Between 1895 and 1898 it was converted to become the Emperor Alexander III Russian Museum, now simply the Russian Museum. In the early 1900s a wing was built to house the museum's ethnographic department, which later became independent (and is now the Russian Ethnographic Museum). Alongside the Tretyakov Gallery in Moscow, the Russian Museum is one of the two greatest repositories of Russian art.

91 The Rossi Pavilion in the Mikhailovsky Garden. 1819–23. Architect Carlo Rossi

92 The Mikhailovsky Palace (The Russian Museum)

94 The Mikhailovsky Palace from the Mikhailovsky Garden

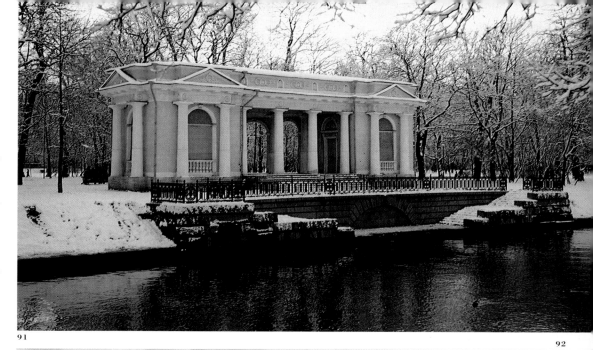

91

92

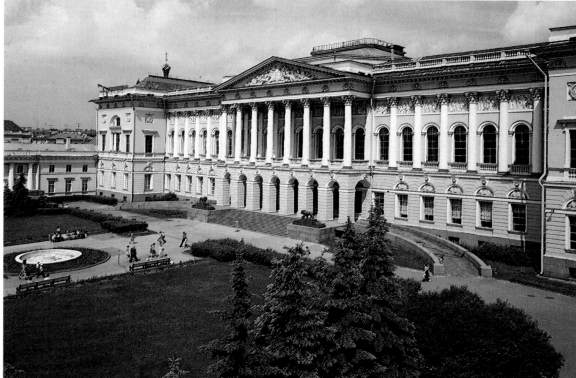

93

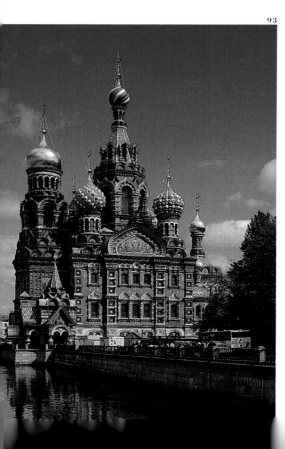

94

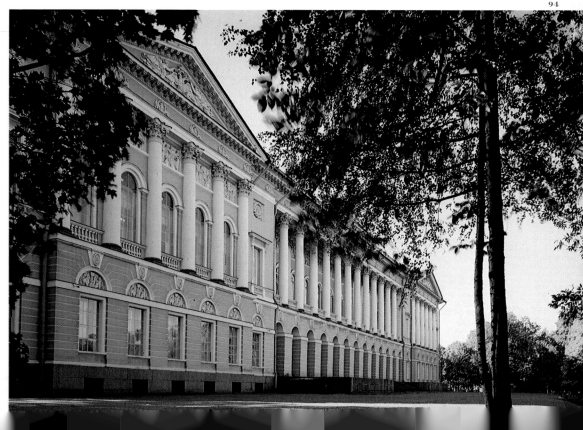

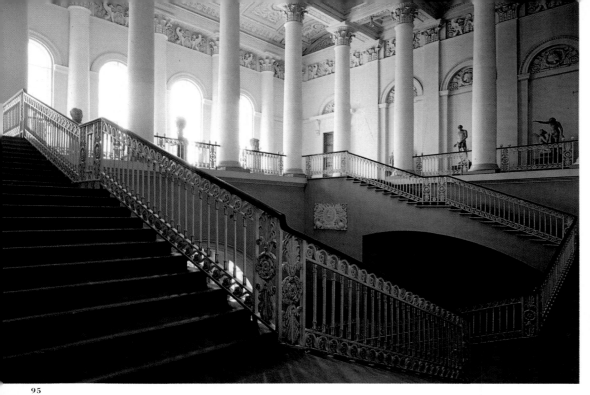

95

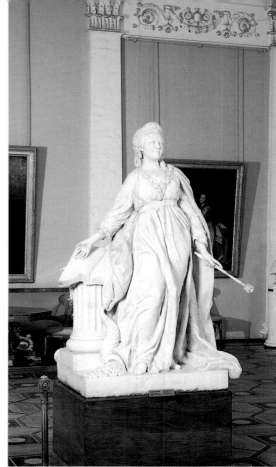

96

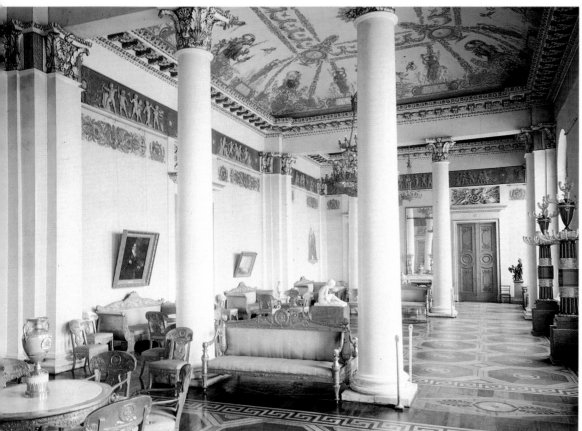

97

95 The State Staircase in the Mikhailovsky Palace

96–99 Rooms in the Russian Museum

99

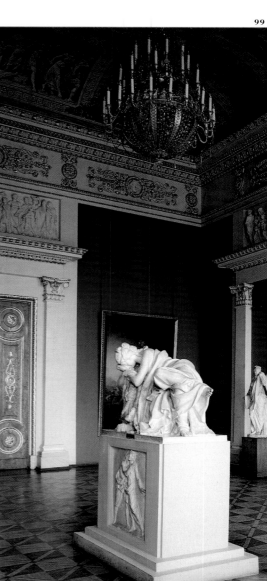

98

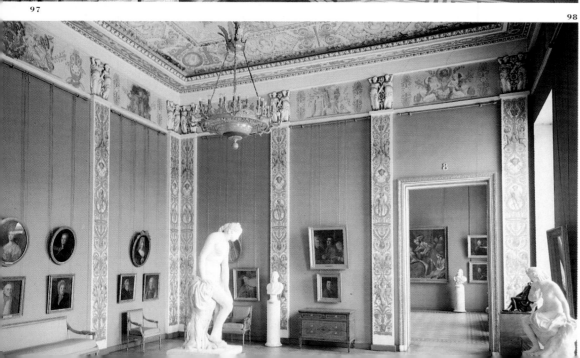

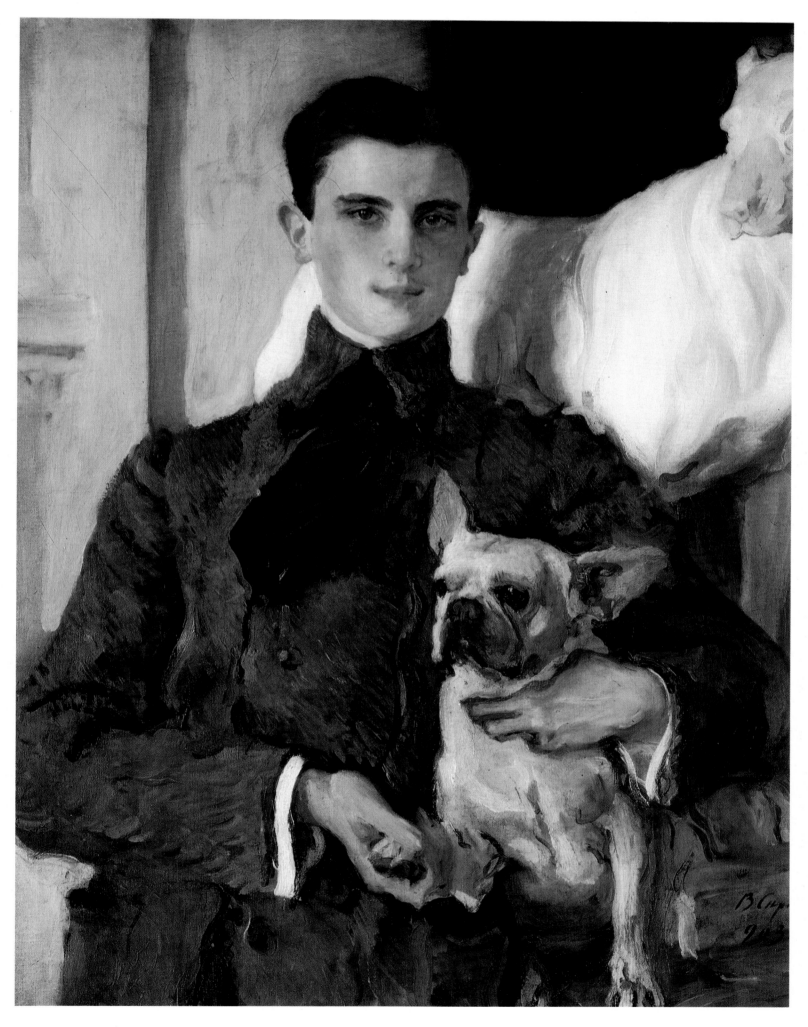

**100 PORTRAIT OF COUNT FELIX SUMAROKOV-ELSTONE,
LATER PRINCE YUSUPOV. 1903
By Valentin Serov
The Russian Museum**

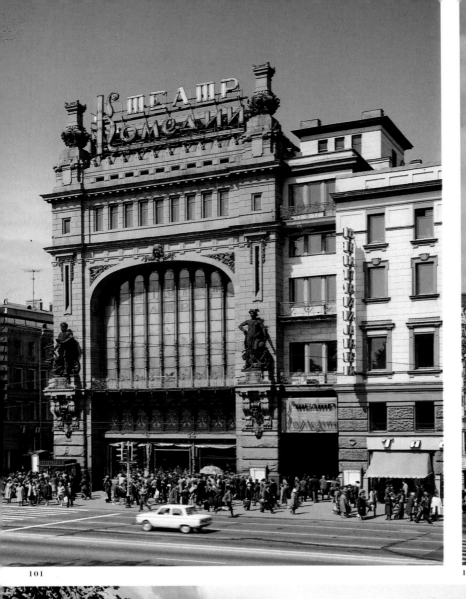

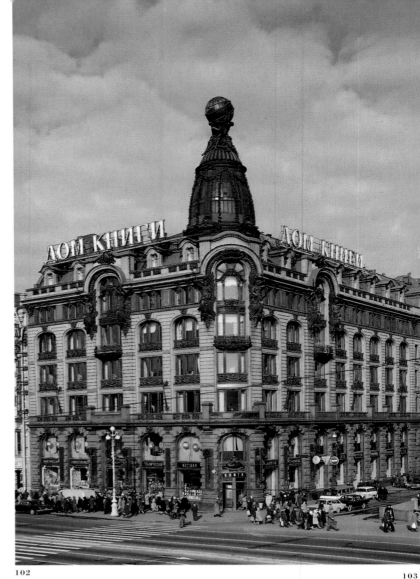

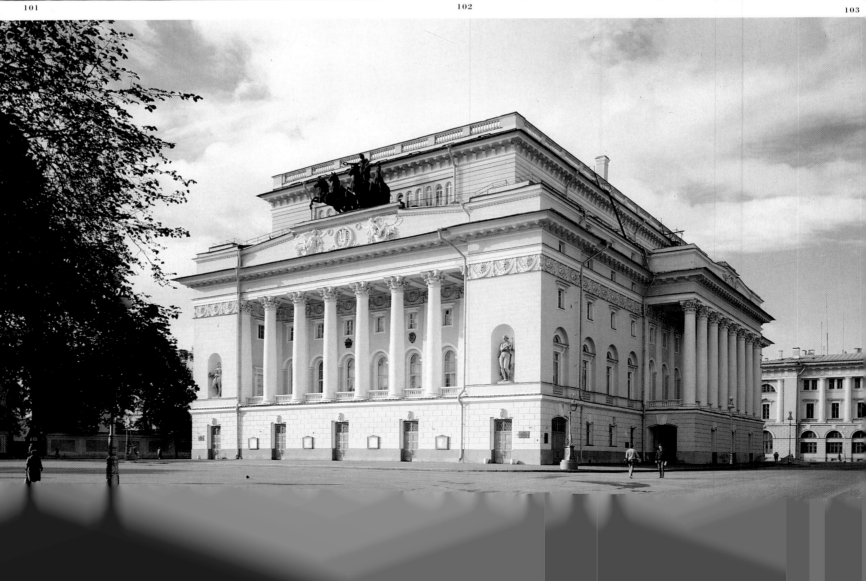

Nevsky Prospekt is the main thoroughfare of the city centre, extending for 4.5 km. It begins close to the Admiralty and Palace Square and ends by the Monastery of St Alexander Nevsky. Nevsky Prospekt is made up today mainly of late nineteenth- and early twentieth-century apartment houses. Situated on this great avenue and nearby are palaces of the Russian aristocracy, cathedrals, museums, theatres and major shops.

101 The Yeliseyev shop. 1901–03. Architect Gavriil Baranovsky

102 The House of Books (formerly, the Singer Company building). 1902–04. Architect Pavel Suzor

103 The Alexandrinsky Theatre. 1828–32. Architect Carlo Rossi

104 Monument to Catherine the Great in the garden near the Alexandrinsky Theatre (1873, sculptors Matvei Chizhov and Alexander Opekushin)

105 Pavilion of the Anichkov Palace. 1817–18. Architect Carlo Rossi

106 The Moscow (Nicholas) Railway Terminal. 1851. Architect Konstantin Thon

107 The Great Gostiny Dvor (trading arcade), the Rusca Pavilion and the building of the former City Council (Duma)

104

105

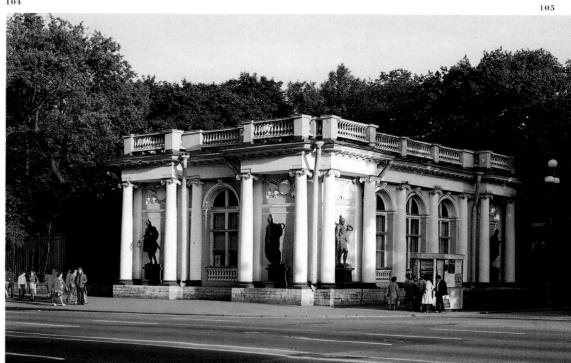

106

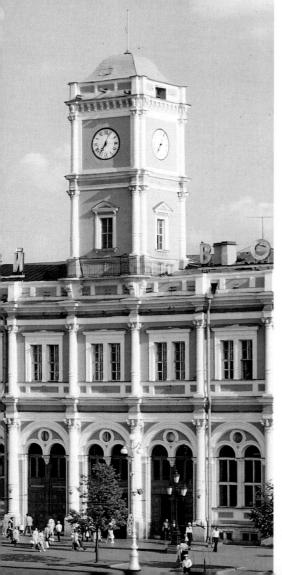

107

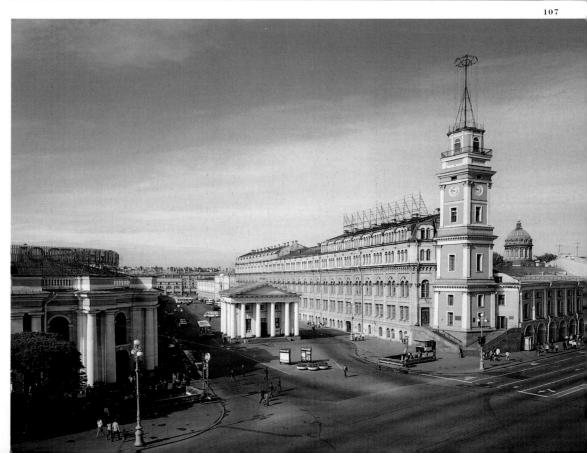

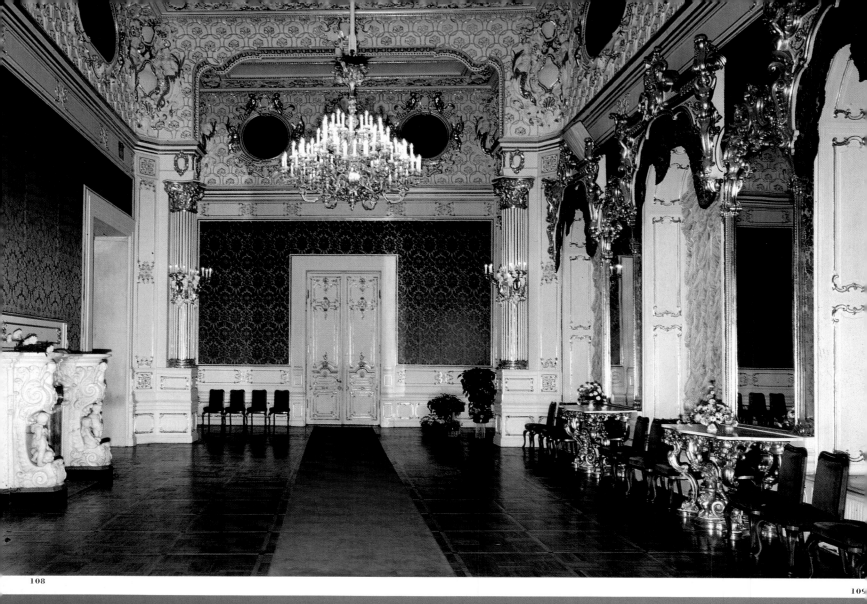

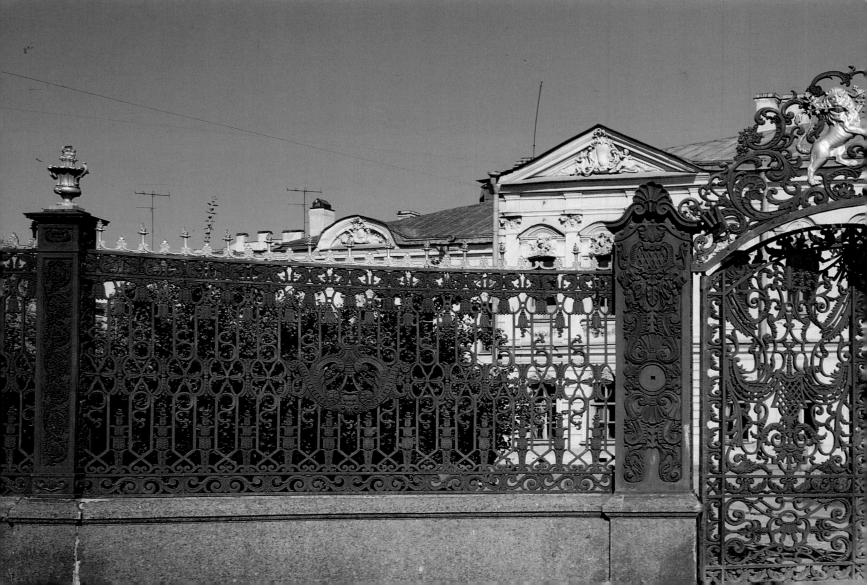

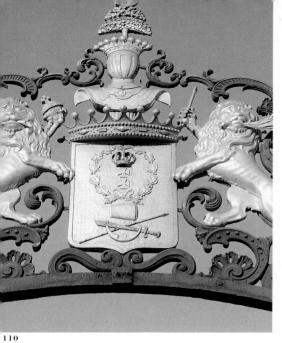

108 A hall in the Shuvalov Palace

109, 110 The Sheremetev Palace. 1750–55. Architects Savva Chevakinsky and Fiodor Argunov

111 The Bezborodko Dacha. 1773–77; 1783–84. Architect Carlo Rossi

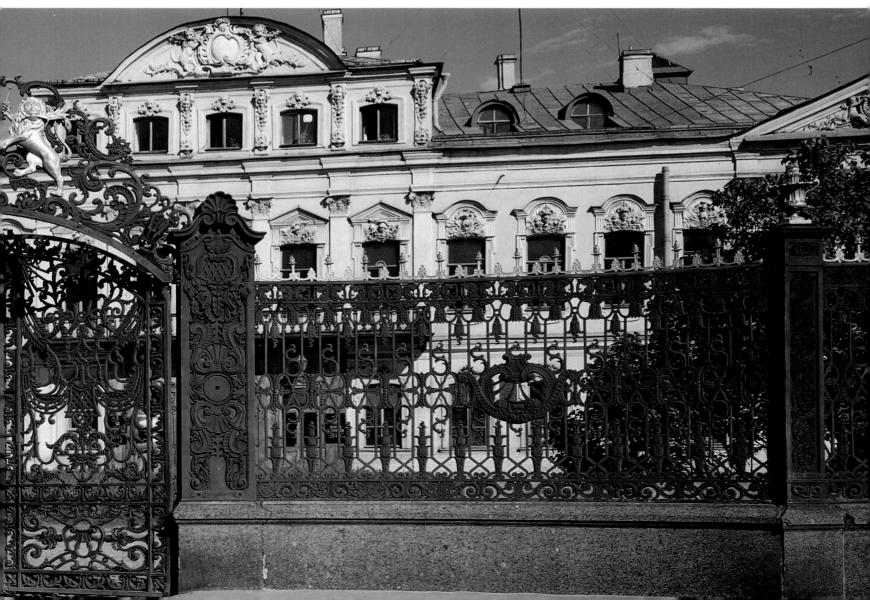

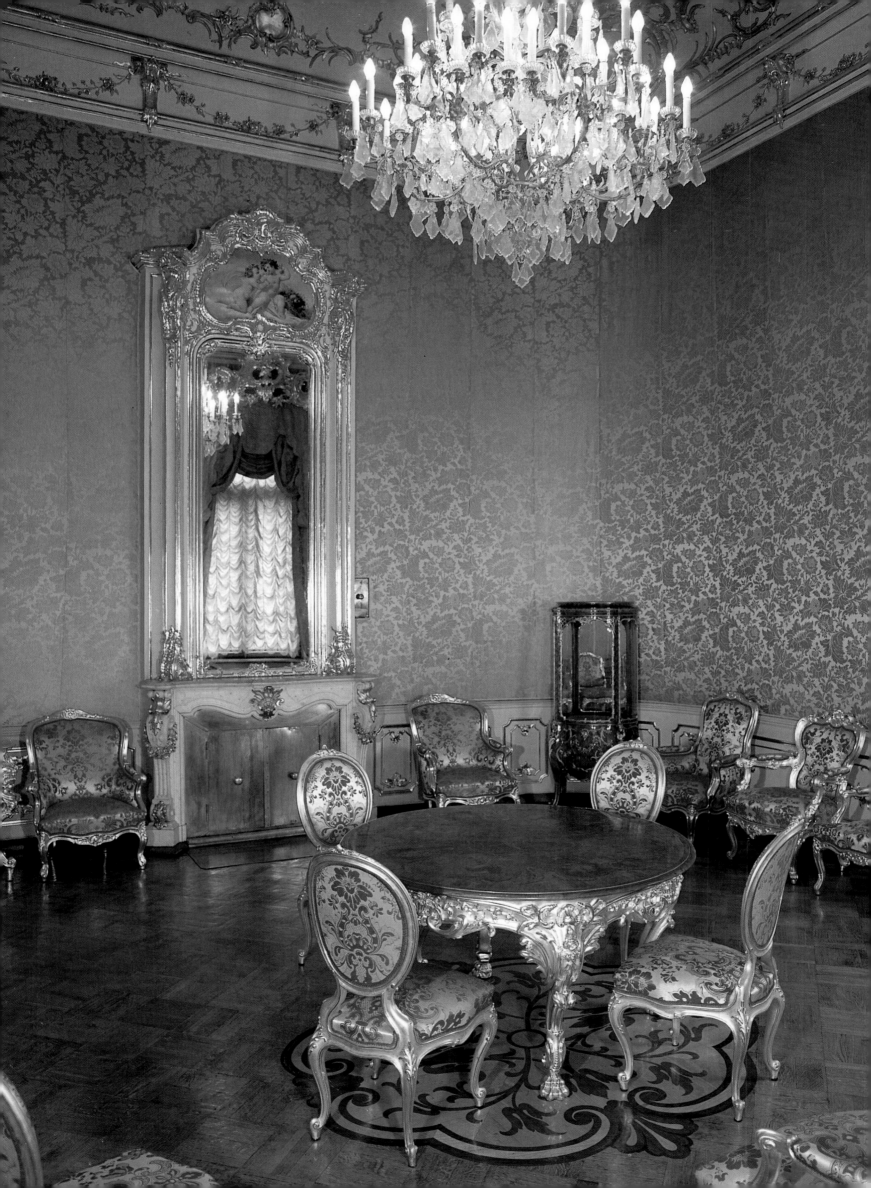

112, 114 Interiors of the Beloselsky-
Belozersky Palace

113 The Beloselsky-Belozersky
Palace. 1846. Architect Andrei
Stakenschneider

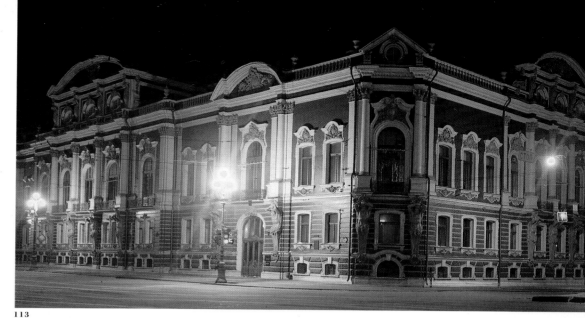

113

114

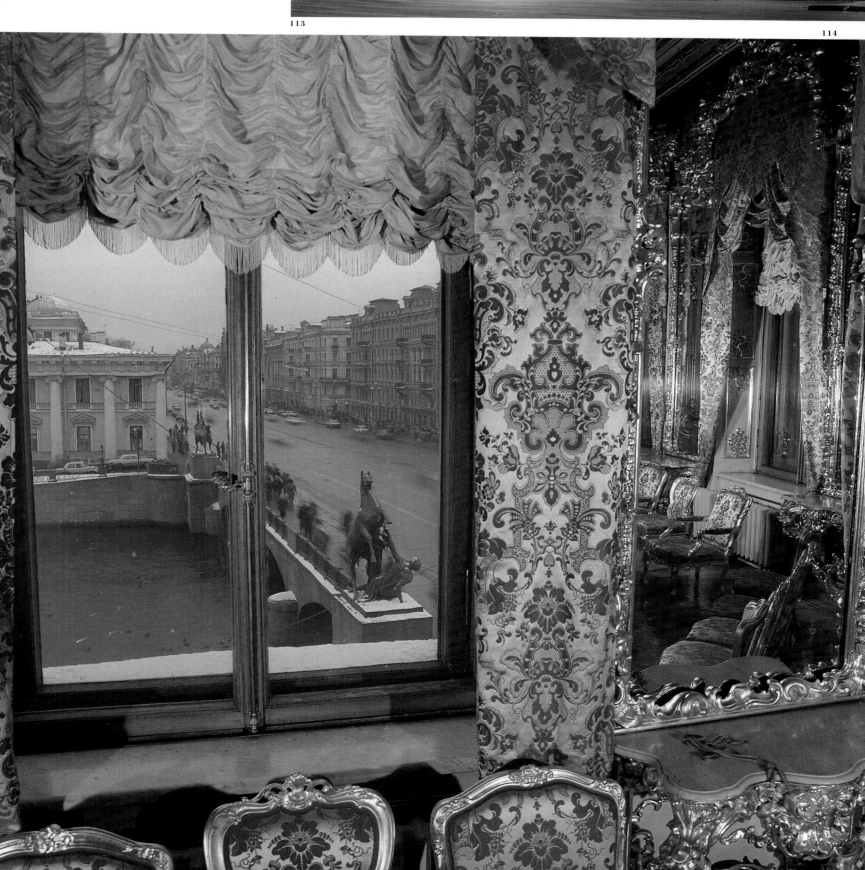

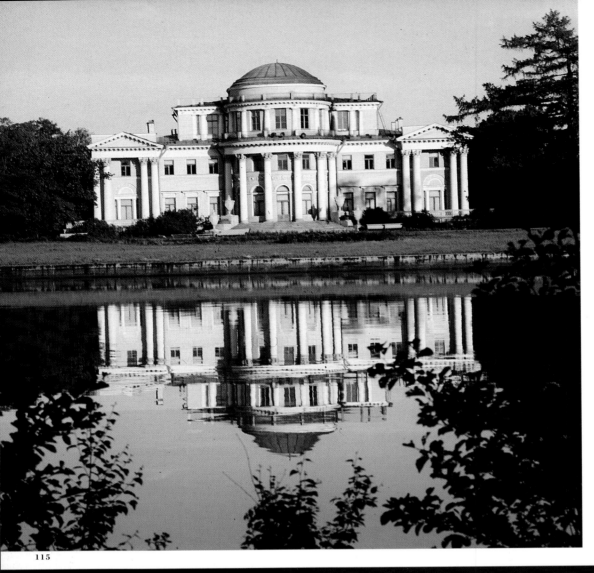

The early-nineteenth-century Yelagin Palace stands on a low rocky terrace, its main façade towards the park and its rear — with a hexastyle semi-rotunda in the centre — overlooking the Srednyaya Nevka River. Today the palace is used for exhibitions of applied art.

115 The Yelagin Palace. 1780; 1818–22. Architect Carlo Rossi

The Tauride Palace designed by Ivan Starov is an embodiment of the fundamental ideas of Russian Classicism. The austere simplicity of the palace façades contrasts with the opulent decoration of the halls. Today the building accommodates the Interparliamentary Assembly of CIS states.

116 The Tauride Palace. 1783–89. Architect Ivan Starov

The Narva Triumphal Arch is a monument to Russia's victory over Napoleon. The name comes from the fact that at one time the city gate on the road to Narva stood on this site.

117 The Narva Triumphal Arch. 1827–34. Architect Vasily Stasov

115

116

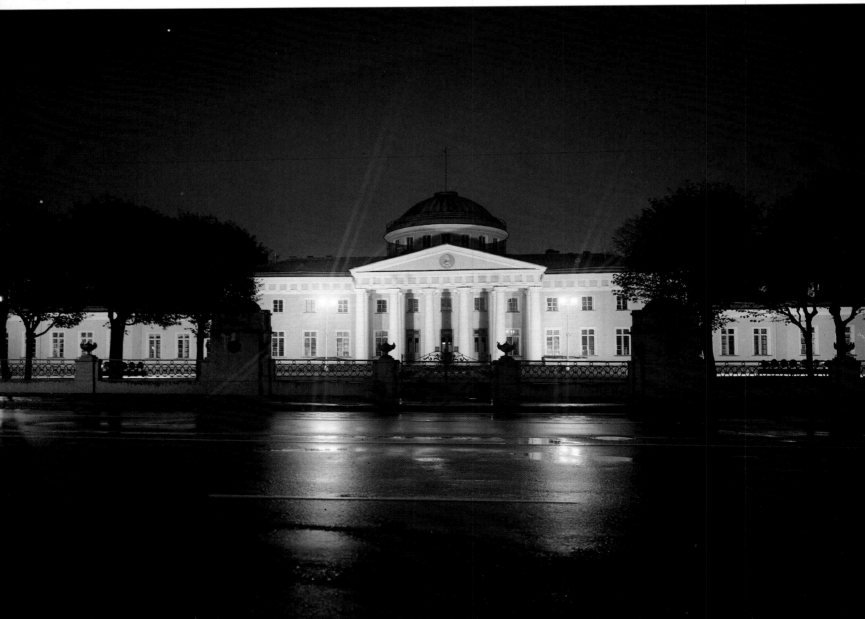

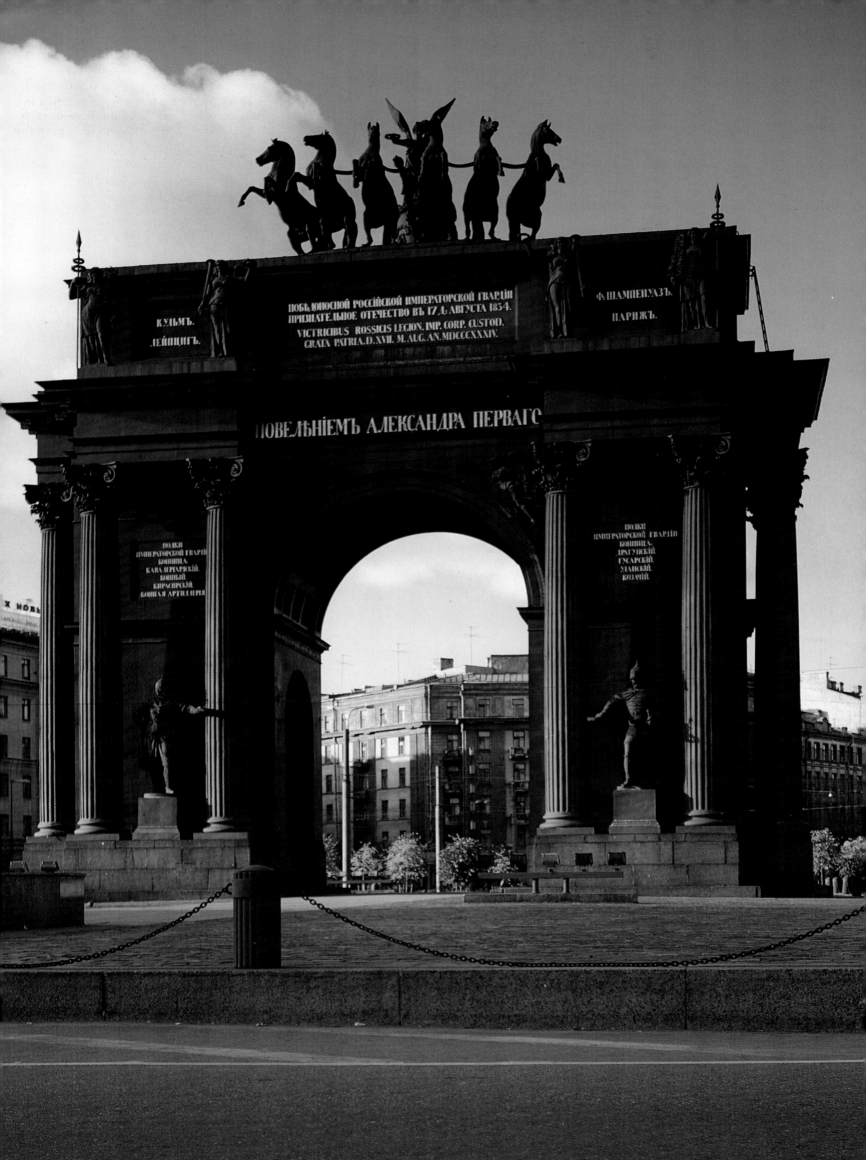

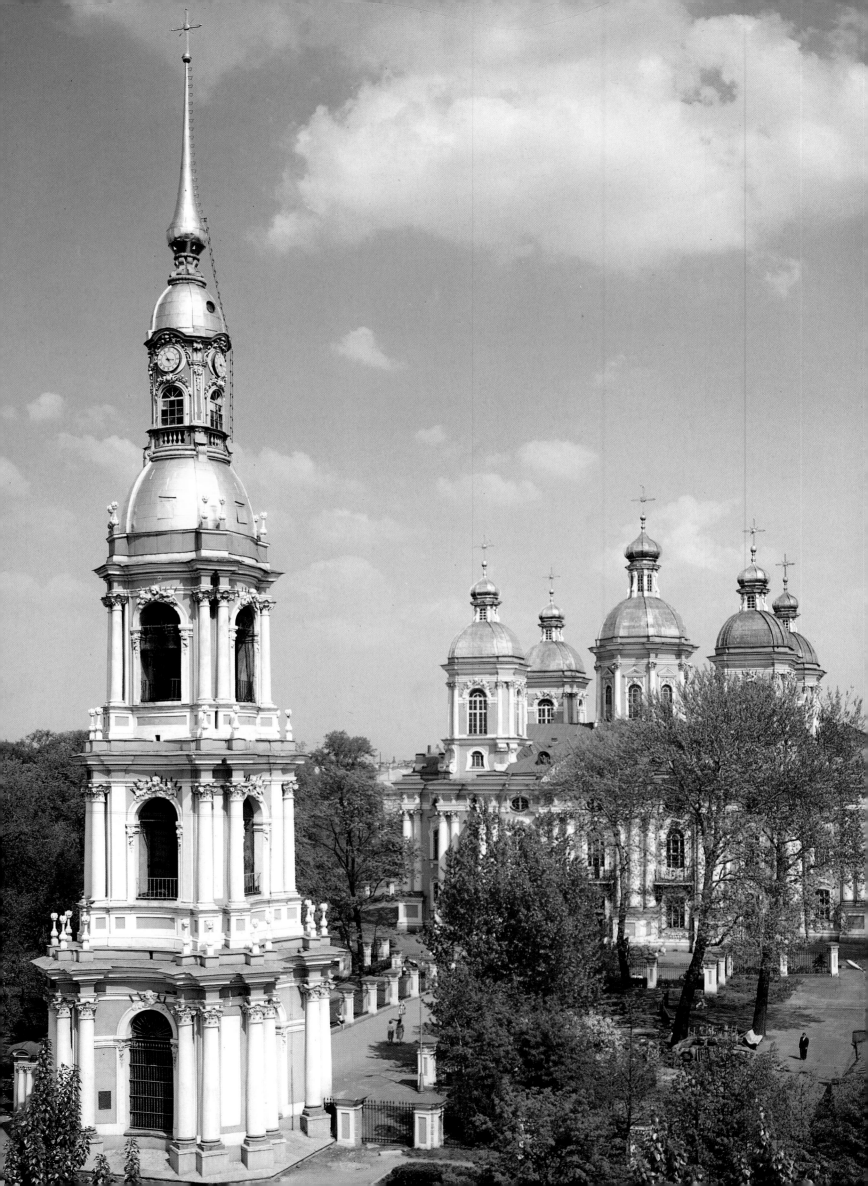

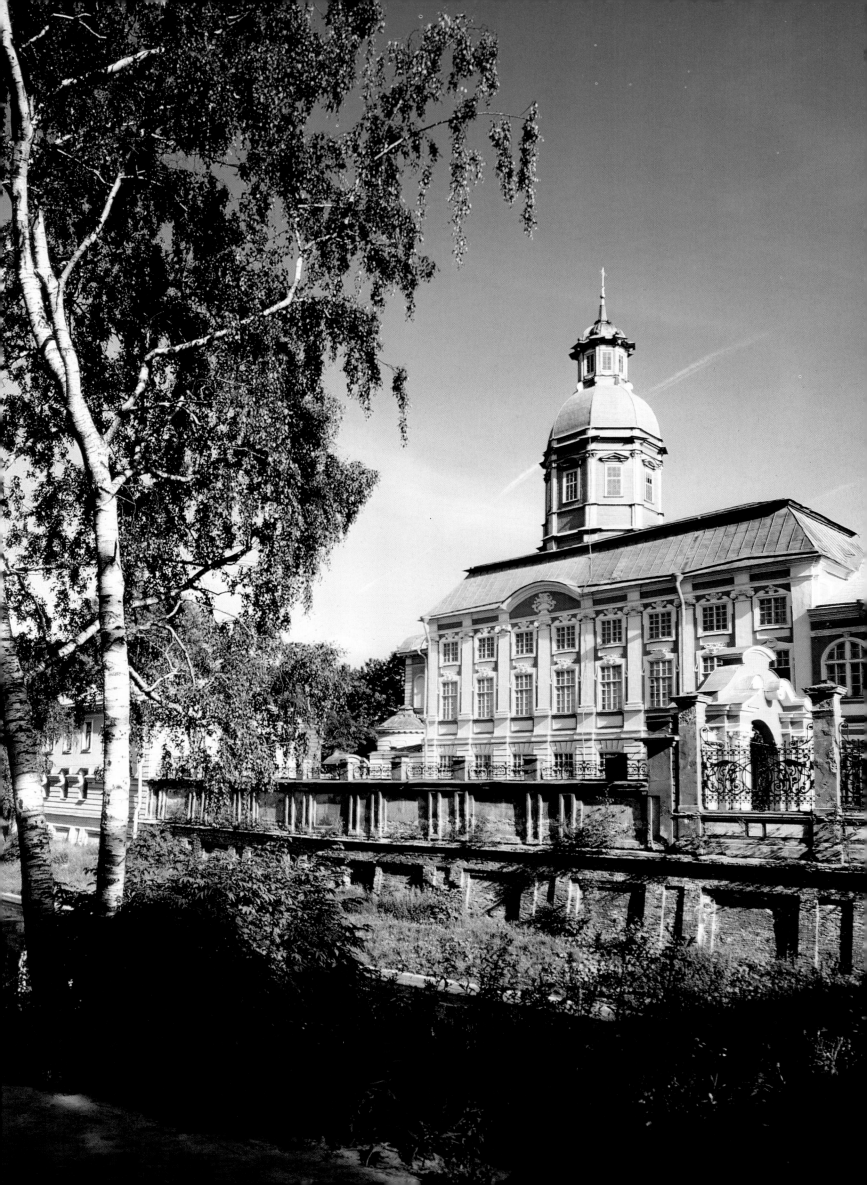

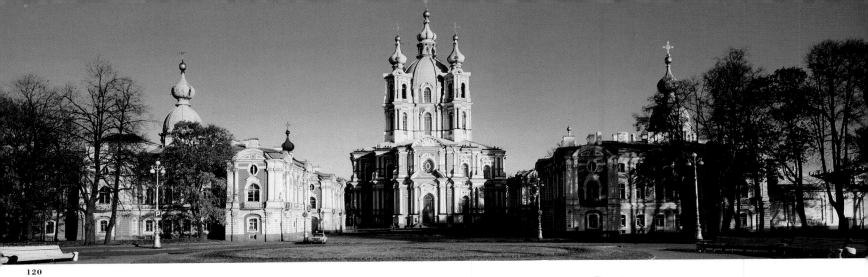

120

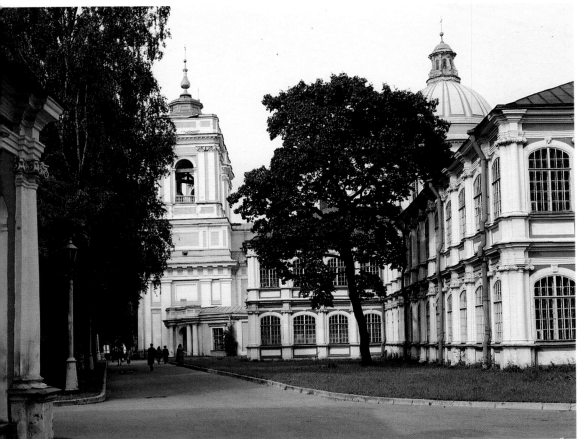

121

122

Previous pages:

118 Ensemble of the Cathedral of St Nicholas and the Epiphany. 1753–62. Architect Savva Chevakinsky

119 The Church of the Annunciation in the Alexandro-Nevskaya *Lavra* (Monastery of St Alexander Nevsky). 1717–25. Architect Domenico Trezzini

Designed by Rastrelli, the Smolny Convent Cathedral is a remarkable example of mid-eighteenth-century Russian architecture. The complexity of the façades, abundant in sculpture and moulding, the placing of clustered columns on the projecting corners, and the highly ornate window surrounds are all typical features of the Russian Baroque. When Vladimir Stasov completed the building, he gave it a Classical interior.

120 The Smolny Cathedral. 1748–64. Architect Francesco Bartolommeo Rastrelli

The Alexandro-Nevskaya *Lavra*, a former monastery, was founded by Peter the Great in 1710 in honour of Prince Alexander Yaroslavich of Novgorod's victory over the Swedes in 1240. The remains of the canonized prince now lie in a silver shrine in the Trinity Cathedral here. Peter made the monastery the highest ranking in Russia. (The title *lavra* is reserved for the most important Orthodox monasteries.) The monastery is the location of the city's functioning Theological Academy.

121 The Alexandro-Nevskaya *Lavra*

Chevakinsky's Baroque-style Cathedral of St Nicholas and the Epiphany draws on the traditional forms of Russian church architecture. It was built on the former parade-ground of the Marines Regiment. Today St Nicholas's is the chief functioning cathedral in the city.

122 The Bell Tower of the Cathedral of St Nicholas and the Epiphany

123 The Cathedral of St Nicholas and the Epiphany

Overleaf:

124 View of the Smolny Convent

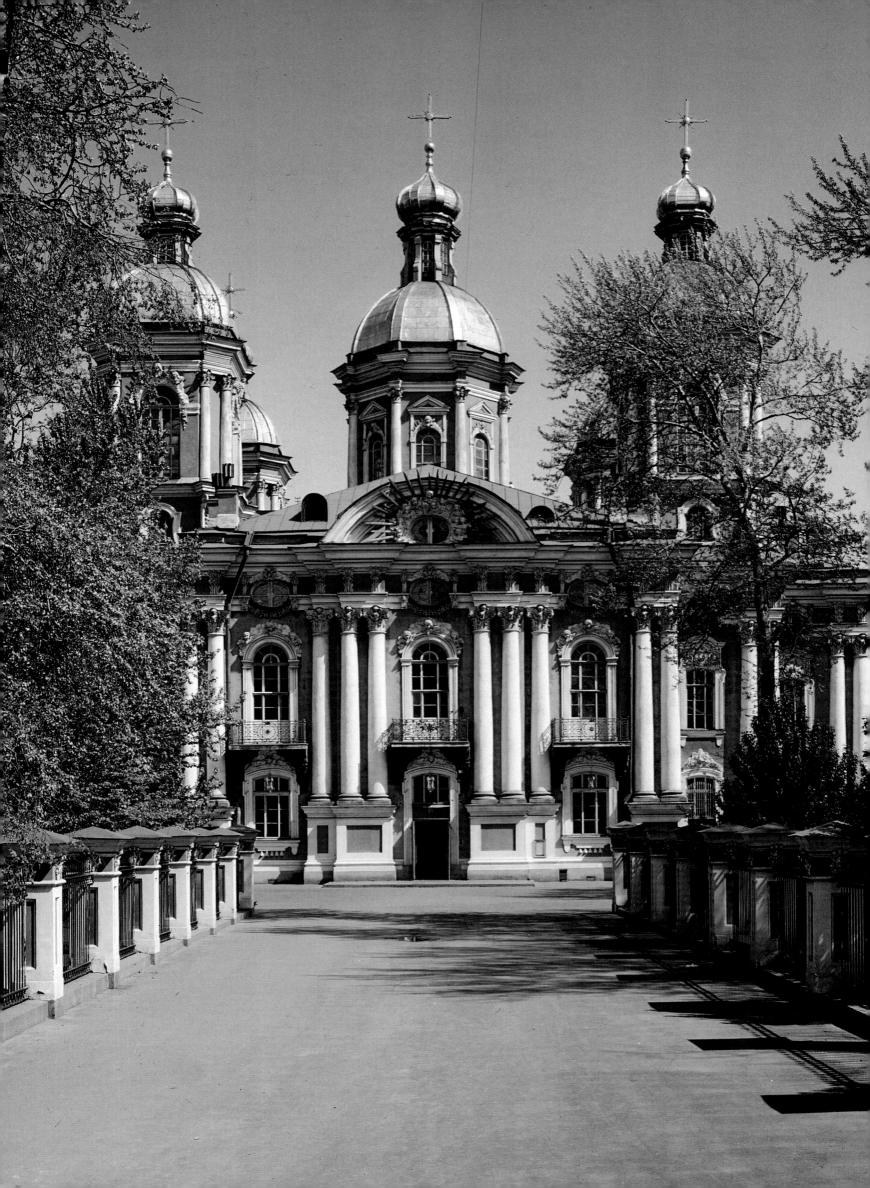

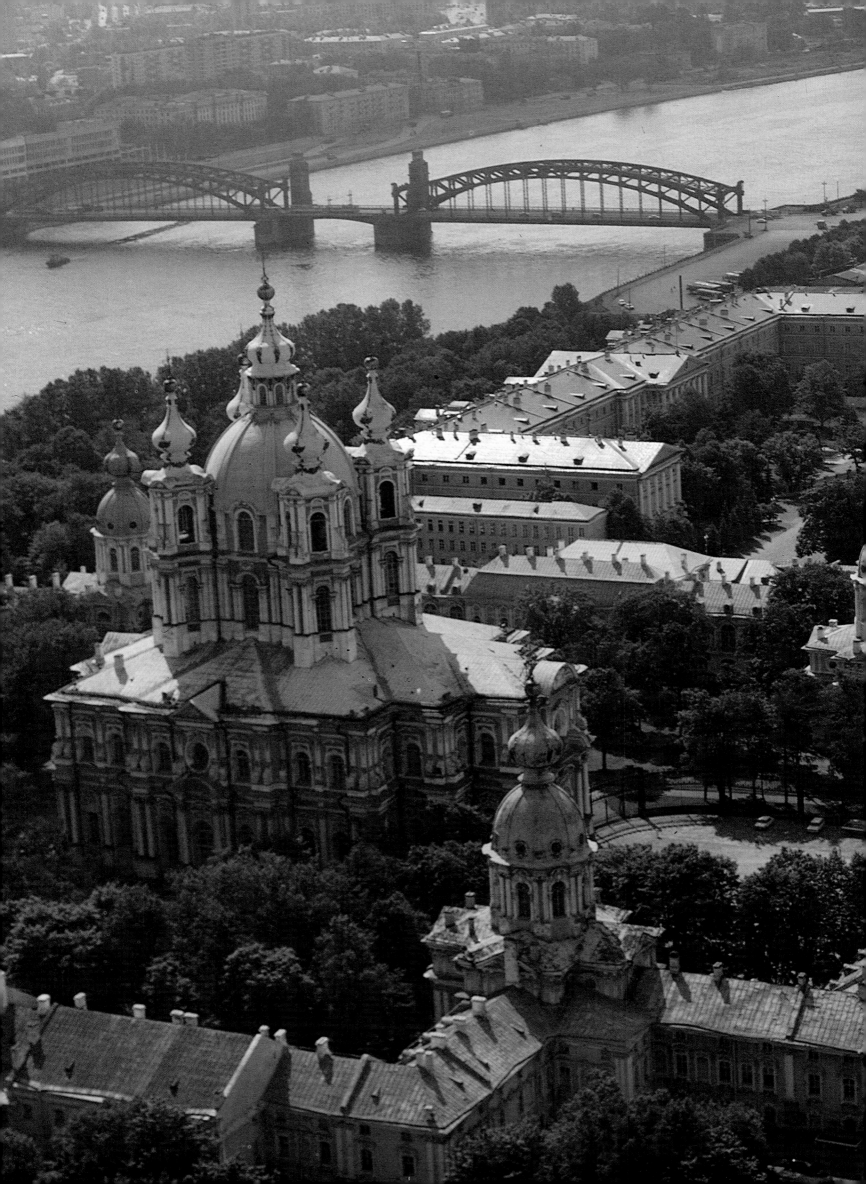

The Environs of Saint Petersburg

At the same time as the new capital was springing up, suburban residences for the Russian monarchs also began to appear. Within a period quite insignificant in historical terms, before the eighteenth century was out, St Petersburg became surrounded by a necklace of beautiful ensembles not only worthy of the capital but even echoing the various hues of its multicoloured brilliance. Triumphal and resplendent Peterhof; Tsarskoye Selo with its magnificent palace set in a park just made for meditative strolls; and Pavlovsk, where a smaller, yet still majestic palace is encircled by a rare variety of gardens, groves, alleys, bridges and paths. And in addition to these sparkling gems the necklace includes the estates at Oranienbaum, Strelna, Gatchina and more.

Peterhof is undoubtedly the most brilliant of the residences built outside the former capital, conceived with more than an eye to Versailles. Fountain jets, flanked by statues and mascarons glistening with gold, spurt upwards as if saluting the waves lapping the sea shore to which the alleys of the park descend. The exquisite palace towering over the park and the cascade of festive fountains was designed by the architect Rastrelli, the same man who built the Winter Palace in St Petersburg itself. The palace-and-park complex in Peterhof, though not very large, is so rich in artistic ingenuity, so generously endowed with light-hearted artifice, so refinedly simple, that it seems truly majestic in its inexhaustible variety. And the gloomy sea, visible nearly everywhere in Peterhof, provides an austere background to set off the glittering splendour of the palace, fountains and park.

Rastrelli also built the splendid Great (or Catherine) Palace in Tsarskoye Selo, with a façade extending more than three hundred metres. The regular French and landscaped English parks together with the finely proportioned pavilions which later appeared on the shores of the estate's lakes and ponds endowed this residence to the south of the capital with a special air of lyrical melancholy. It was here, at the Tsarskoye Selo Lyceum, that Alexander Pushkin studied at the beginning of the nineteenth century, here that he composed his first poetic works. And for Russians the wooded groves of Tsarskoye Selo have become an inseparable part of their cultural heritage, the Castalian spring of Russian literature, the dwelling of the national muses.

In its architecture Tsarskoye Selo represents the transition from the festiveness of the Baroque to the austere intimacy of Classicism which was to shape the character of perhaps the most surprising among St Petersburg's suburban attractions — Pavlovsk.

Situated no more than ten minutes' drive from Tsarskoye Selo, Pavlovsk already belongs to another era. The palace, an elegant and unpretentious creation of Charles Cameron which was extended and rebuilt several times, has retained both its severity of outline and an openness towards its surroundings. The park itself, laid out to the design of Cameron by Pietro Gonzaga and Vincenzo Brenna, is an exceptional piece of landscape gardening implemented in complete harmony with nature. Dark firs against a background of bright stands of birch, trees clustering on hilly slopes, stone pavilions set in amongst leafy boughs, statues made of bronze and marble, and romantic ruins in the spirit of Rousseau are all reflected in the waters of the winding Slavianka. The rare concord in which all these buildings, alleys, slopes and trees co-exist has made Pavlovsk a place with a special and unique charm. At a later time the concerts held in the famous Vauxhall (railway station building) where performers included the great Johann Strauss turned Pavlovsk into a musical centre of quite some importance.

In their appearance these park-and-garden complexes have kept the youth of St Petersburg alive, remaining untouched by the coarseness of the nineteenth-century "age of iron". Not only does one find in them a breath of unencumbered history, the chance to admire beautiful creations from the past, but time itself seems to have stood still amongst the sea, trees and rivers which even now remember Russia when it was young.

Mikhail Guerman

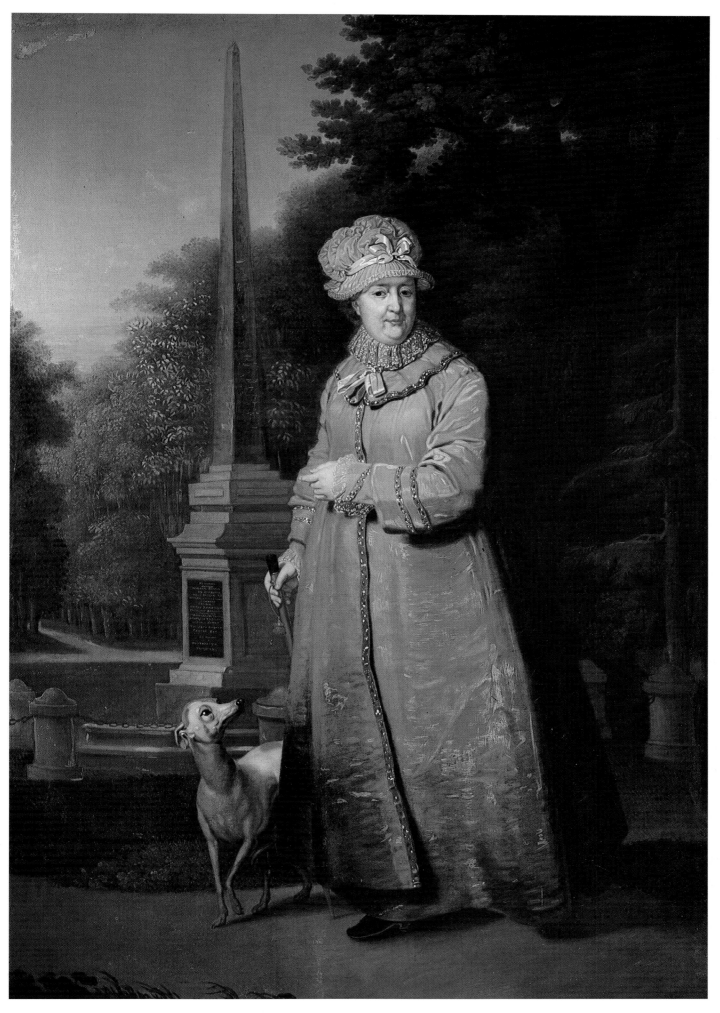

**125 PORTRAIT OF CATHERINE THE GREAT STROLLING
IN THE PARK AT TSARSKOYE SELO**
By Vladimir Borovikovsky
The Russian Museum

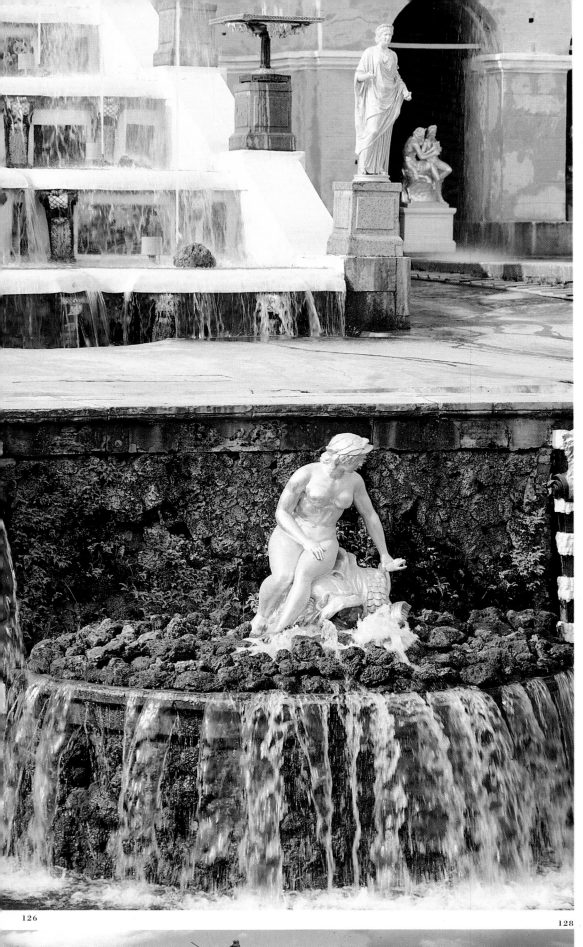

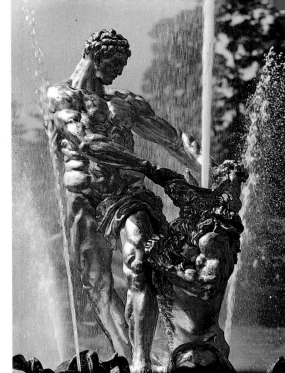

PETERHOF

The Peterhof ensemble is a magnificent
monument of Russian architecture and
landscape gardening of the eighteenth
and first quarter of the nineteenth century.
Its heart, the Great Palace, was begun
under Peter the Great in 1715, but
subsequently rebuilt by Rastrelli.
Construction of the Lower Park on the
shore of the Gulf of Finland started in
1710 with the general lay-out suggested
by Peter himself. The natural rise on which
the palace stands is adorned with terraces.
The centrepiece of the Great Cascade,
Samson Rending Open the Jaws of a Lion,
symbolizes Russia's victory at Poltava
in 1709, the decisive encounter
of the Great Northern War.
The Upper Park, inland from the Great
Palace, is also adorned with pools and
fountains. Peterhof's water-supply system,
constructed in the early eighteenth century,
is unique: unlike the fountains of European
parks which were fed by machinery, here
a natural difference in height from
the source 22 kilometres away powers
the whole magnificent display. The pressure
is so great that the jet of *Samson* soars to
a height of 22 metres.

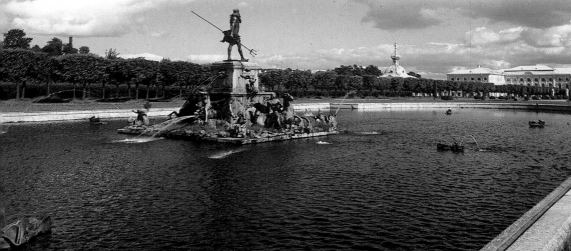

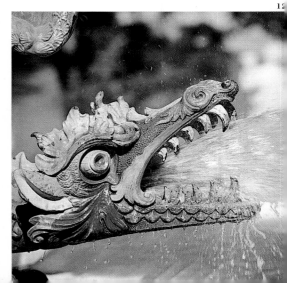

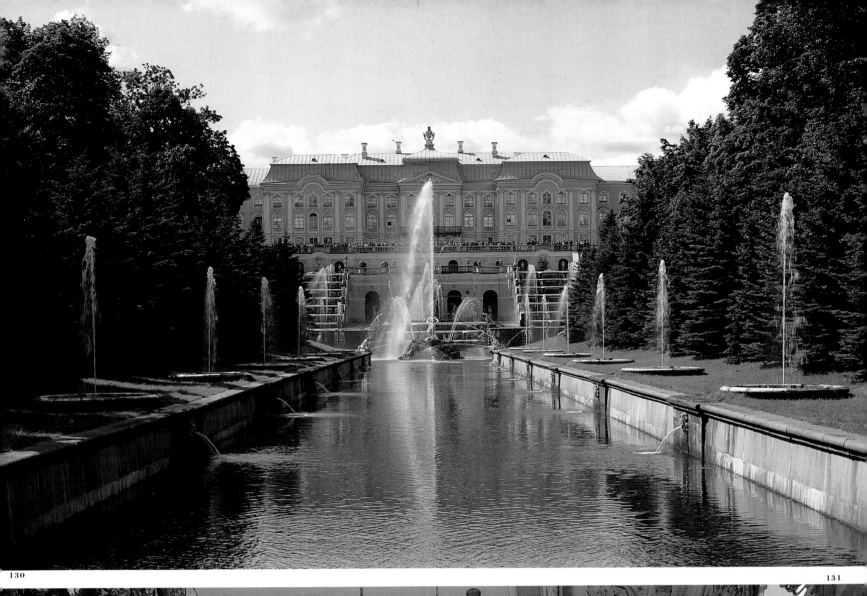

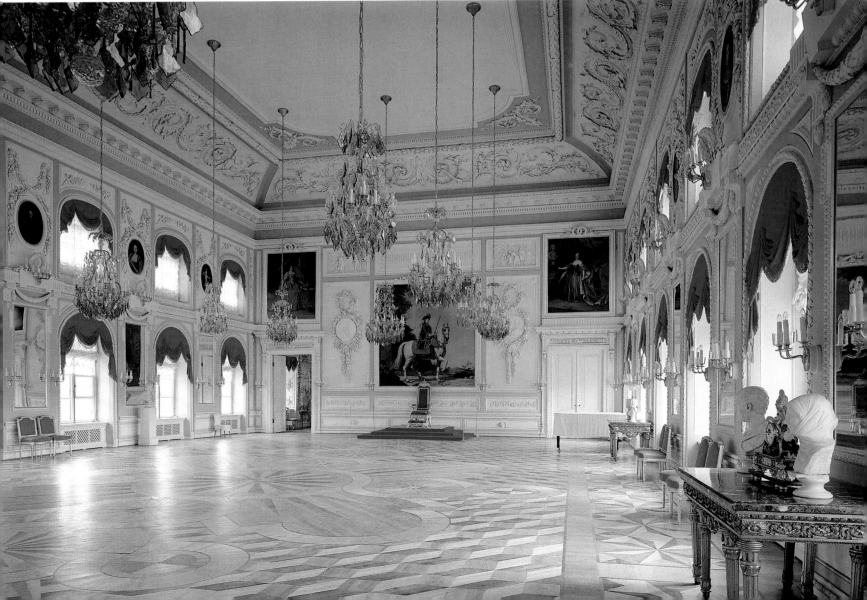

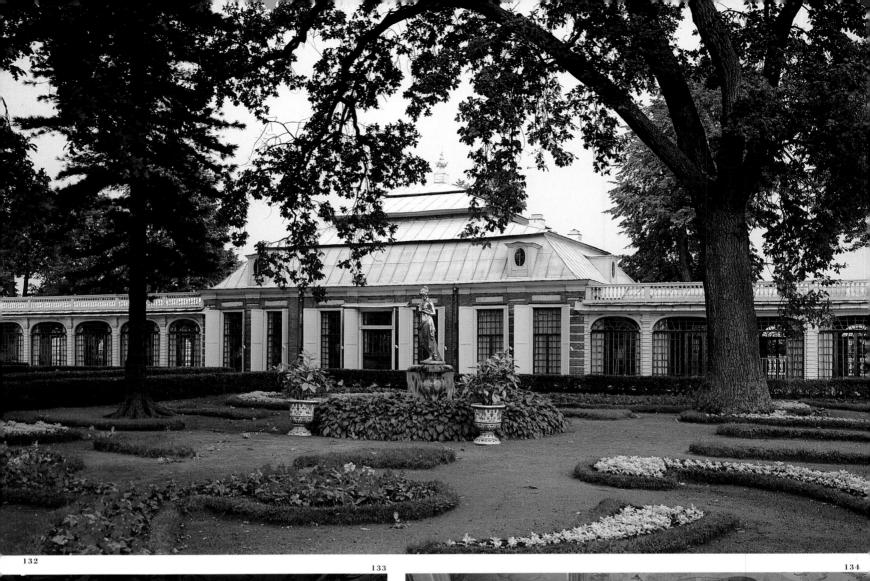

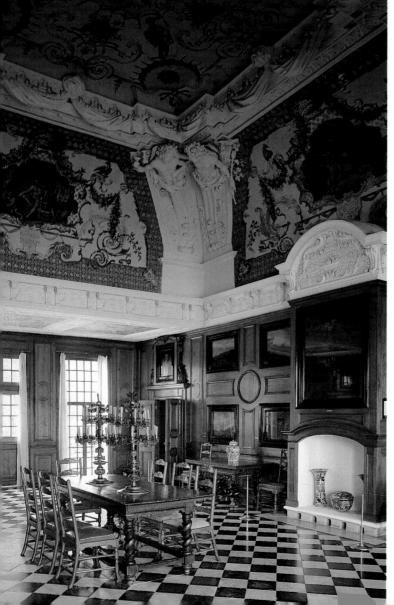

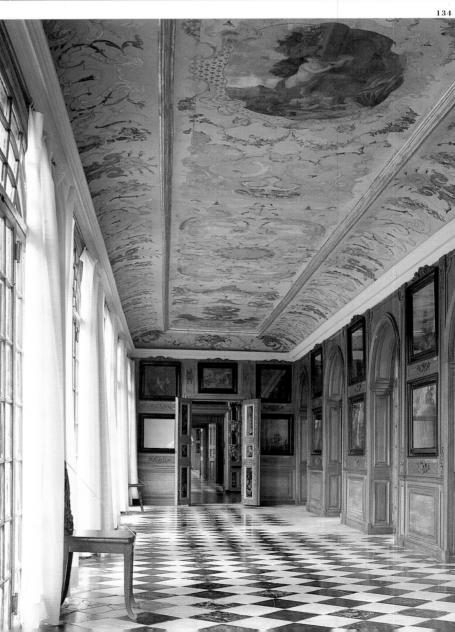

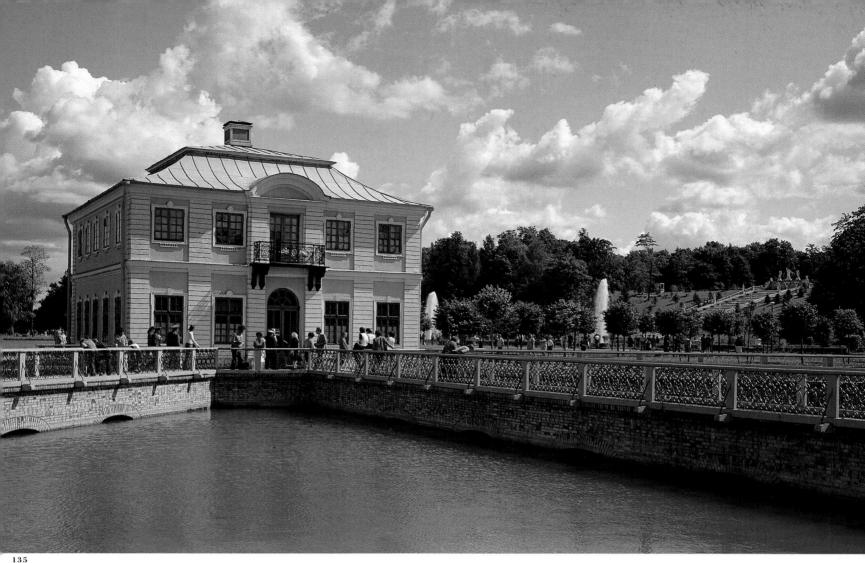

PETERHOF

The small Palace of Monplaisir was erected in 1714–24 in the Lower Park by Johann Braunstein and Jean-Baptiste Le Blond. Among the other architectural gems in the Lower Park is the Hermitage Pavilion designed by Braunstein and constructed in the 1720s.

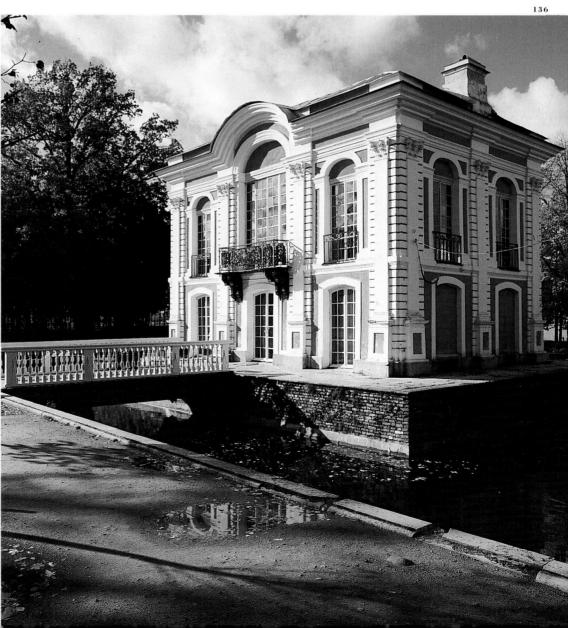

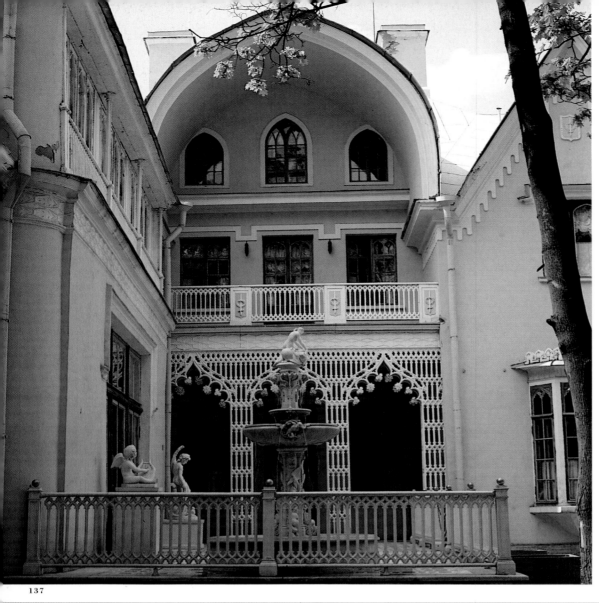

PETERHOF

The last major stage in the evolution of the Peterhof ensemble was the creation of a third park adjoining the Lower Park on the east and called Alexandria after the wife of Nicholas I.

Its most important feature is the Cottage Pavilion built by Adam Menelaws in 1829. Its appearance was strongly influenced by the Gothic style which was in vogue at the time.

137–141 The Cottage

139 *The Large Study*

140 *The Drawing Room*

141 *The Small Study*

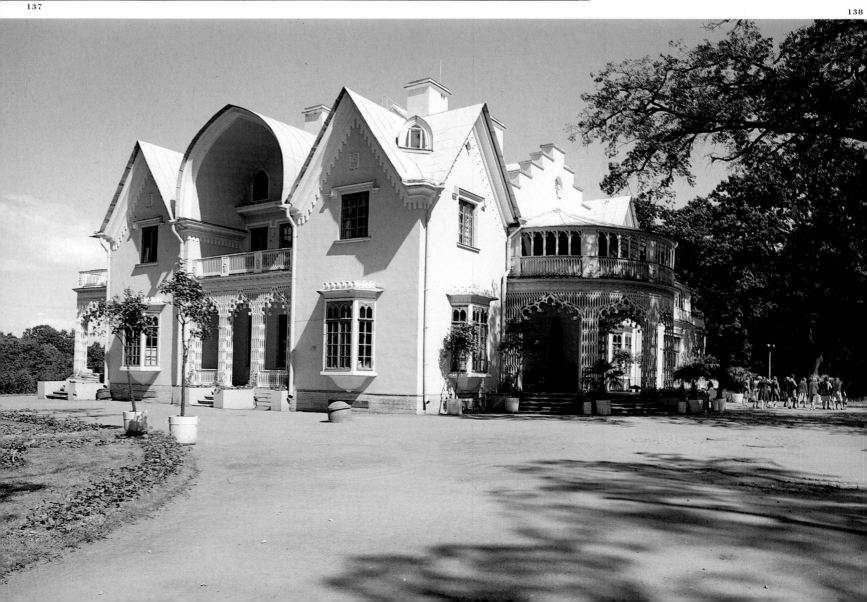

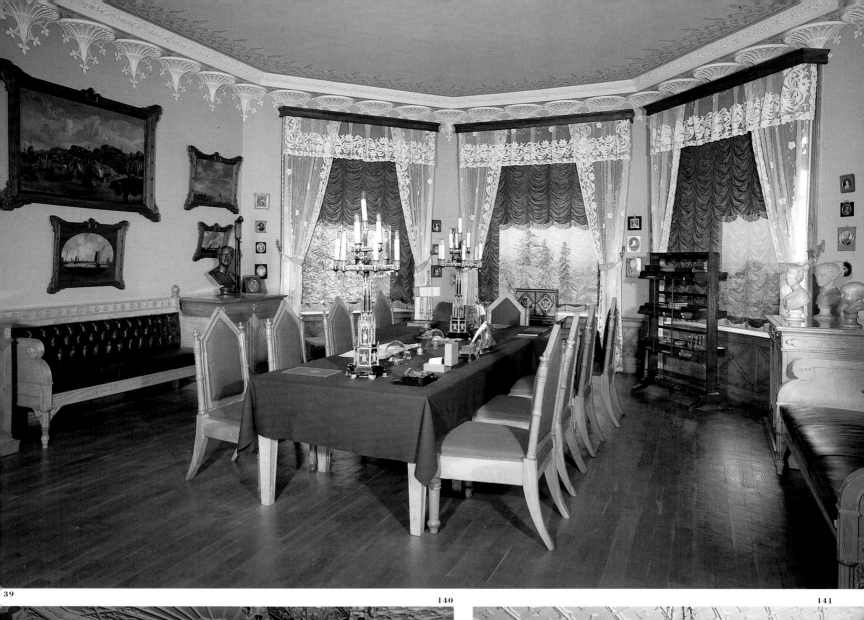

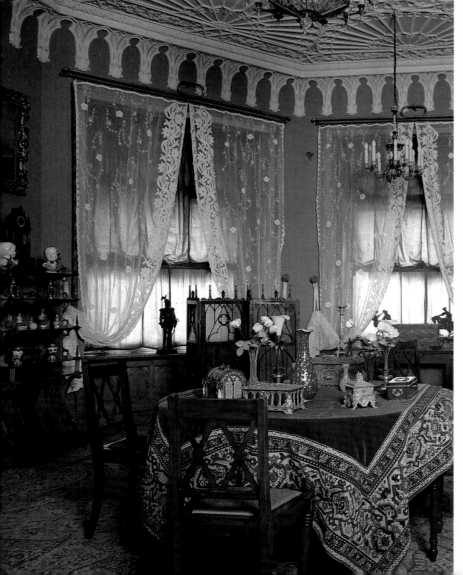

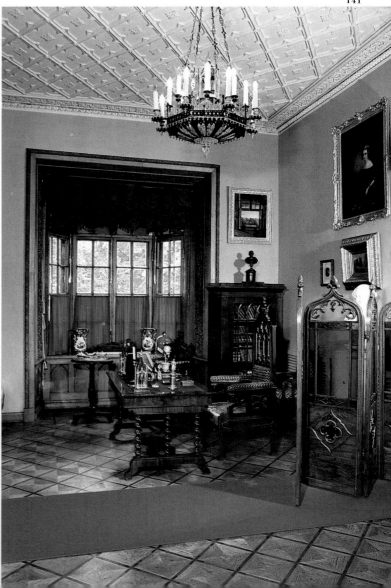

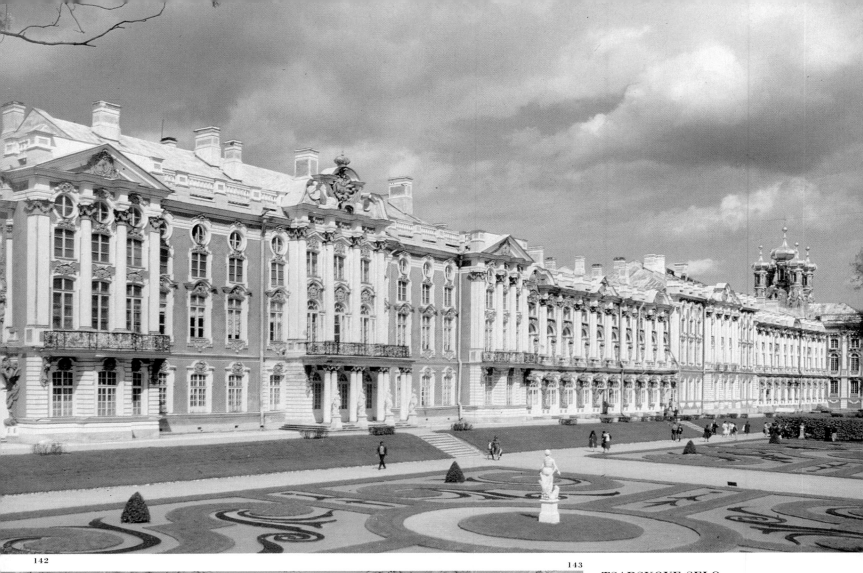

142

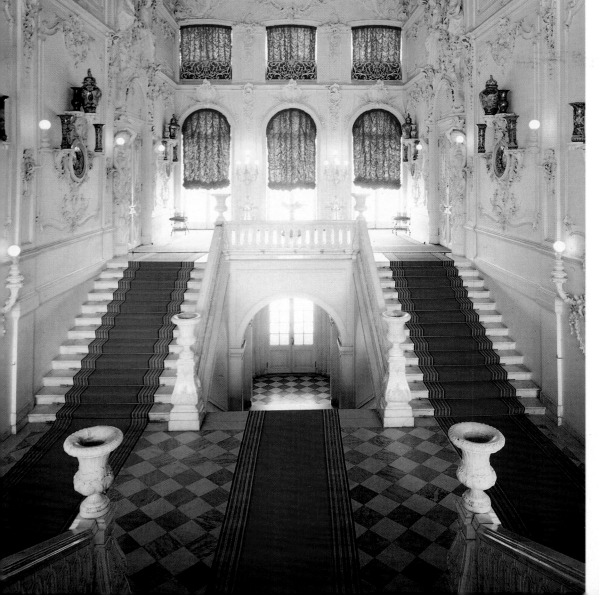

143

TSARSKOYE SELO

142 The Catherine Palace. 1752–56. Architect Francesco Bartolommeo Rastrelli

143 The Catherine Palace. The Main Staircase. 1860–61. Architect Ippolito Monighetti. Originally designed by Charles Cameron in the late 18th century

144 The Catherine Palace. The Central Gate. Detail of the railing

145 Cupolas of the Catherine Palace church

14

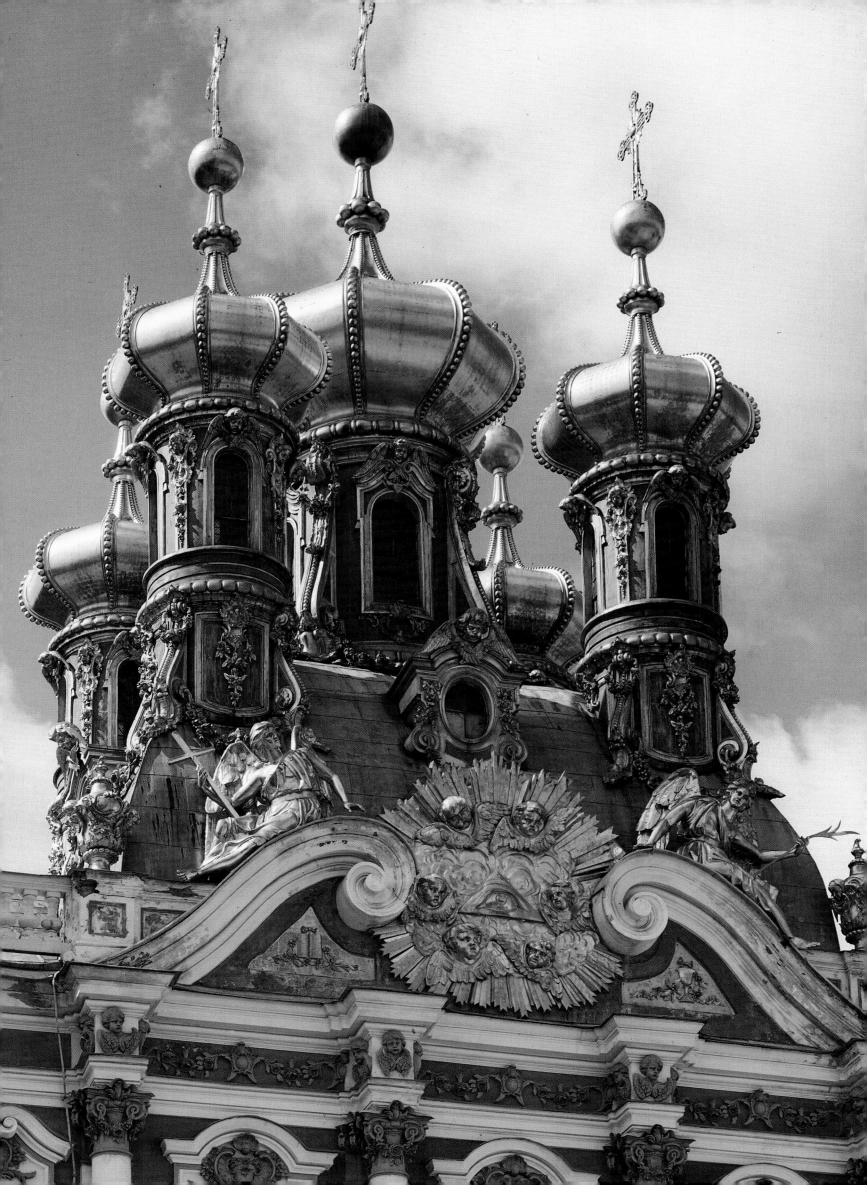

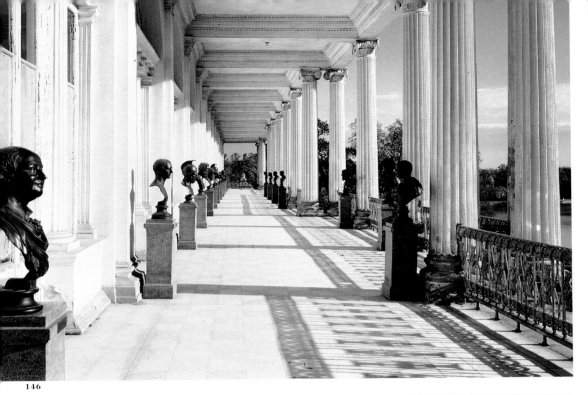

146

147

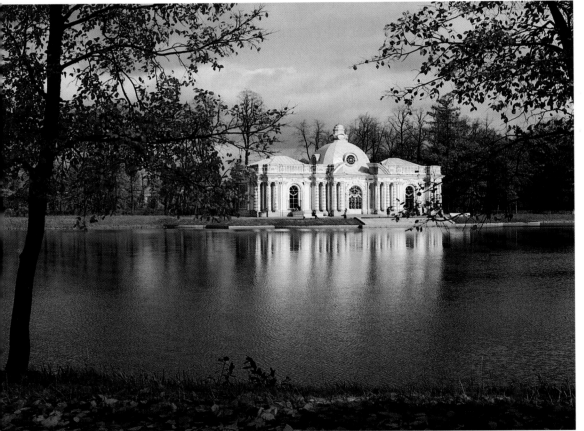

148

149

TSARSKOYE SELO

The Great (Catherine) Palace, a remarkable
monument of Russian eighteenth-century
culture, is the compositional centre of the
architectural and park ensemble of Tsarskoye
Selo. Among those who took part in its
creation were many Russian architects,
painters, sculptors and craftsmen. The palace
was completed by Francesco Bartolommeo
Rastrelli in 1752–56. Its façade, which is
over 300 m long, has a rich and varied
décor. The parks of Tsarskoye Selo rank
among the finest creations of Russian
landscape gardening.

They were laid out at about the time
the Catherine Palace was being built.
Tsarskoye Selo is associated with the life and
work of Alexander Pushkin who studied there
at the Lyceum, and for some 50 years from
1937 the town has borne the poet's name.
In the Catherine Park memories of Pushkin
are evoked by the Lyceists' Walk and the
sculpture *Young Girl with a Pitcher* by Pavel
Sokolov, which inspired one of his poems.
The natural beauty of the park is enhanced
by the Hermitage and Grotto pavilions,
Marble Bridge and other architectural
edifices.

150

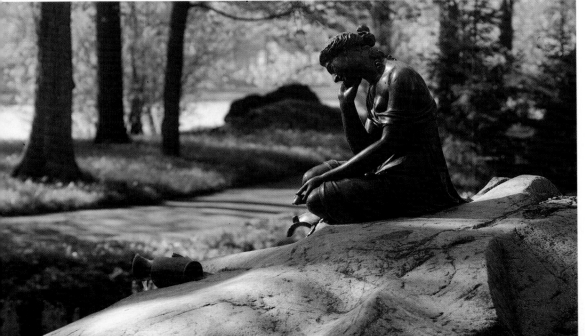

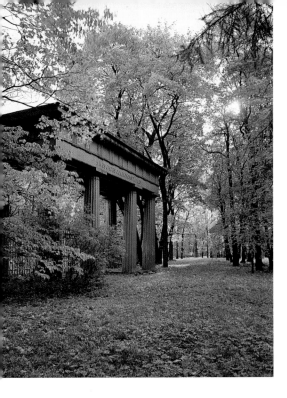

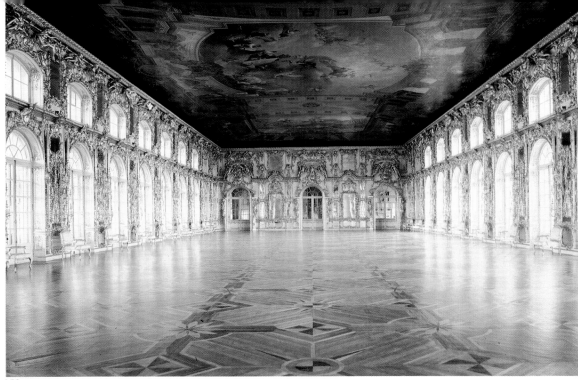

152

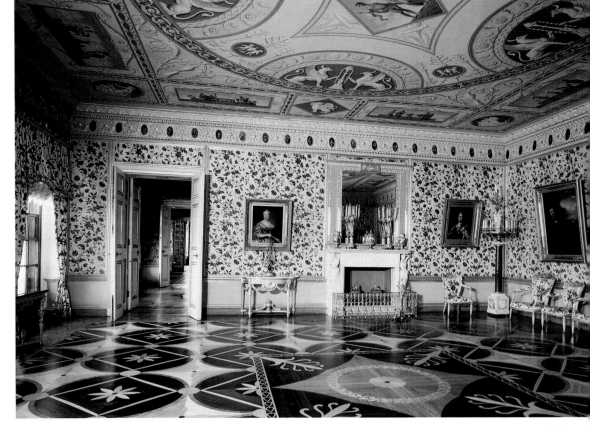

153

154

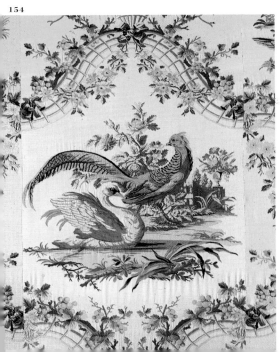

155

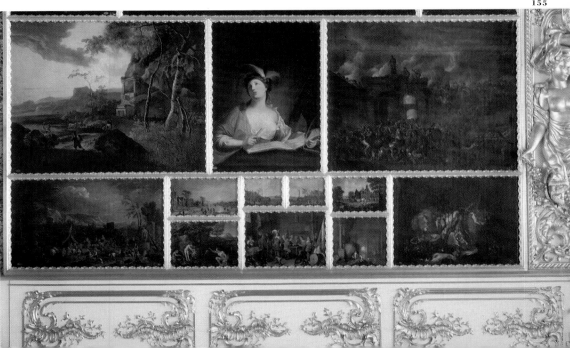

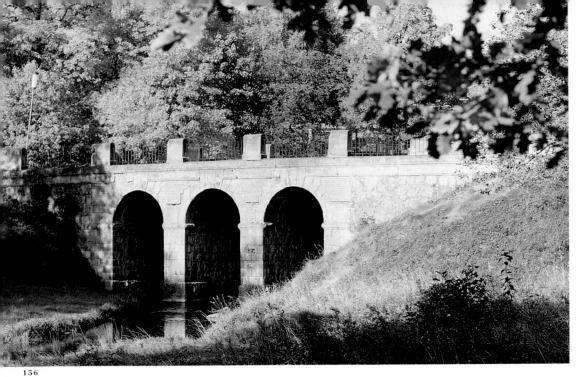

ORANIENBAUM

156 Peter Bridge

157 The Great Palace. The Japanese Pavilion. 1710–25. Architects Giovanni Fontana and Gottfried Schädel

158 The Palace of Peter III. 1756–62. Architect Antonio Rinaldi

159 Stone Bridge over the U-shaped pond

160, 161 The Coasting Hill Pavilion. 1762–64. Architect Antonio Rinaldi. Originally there was a sloping track running from the pavilion down which people rode in special cars for amusement

162 Sculptural group *The Three Graces*

163 Entry Gate to the Peterstadt Fortress. 1756–62. Architect Antonio Rinaldi. The "Toy" Peterstadt Fortress was constructed for the future Emperor Peter III

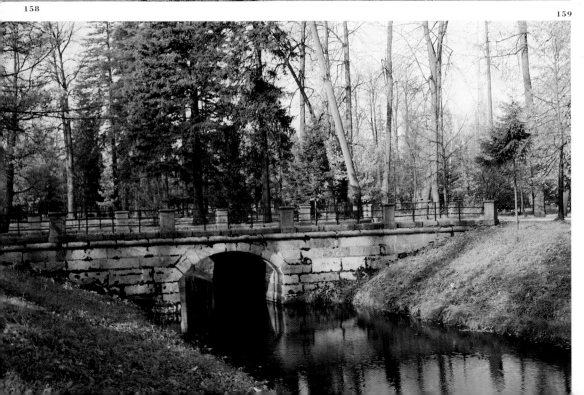

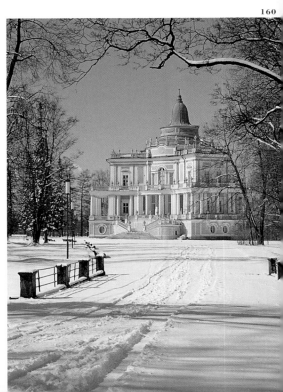

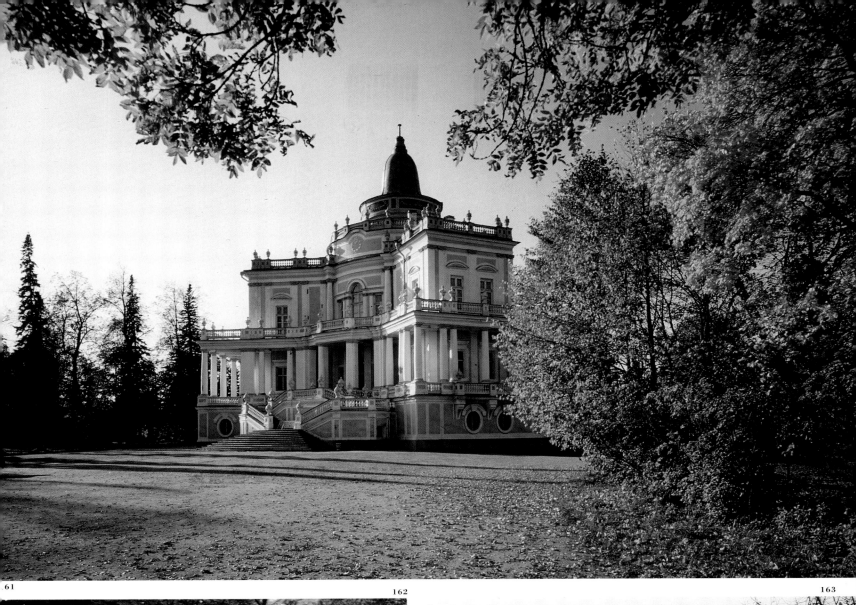

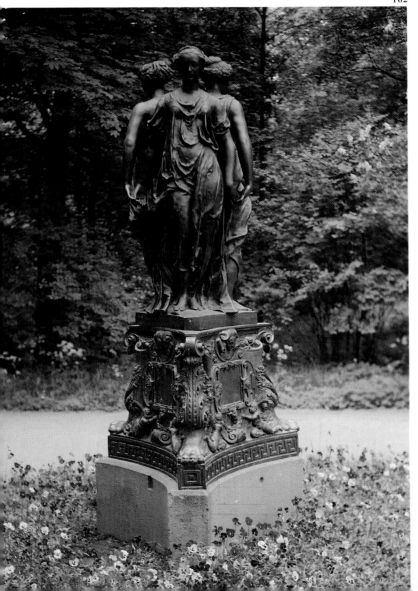

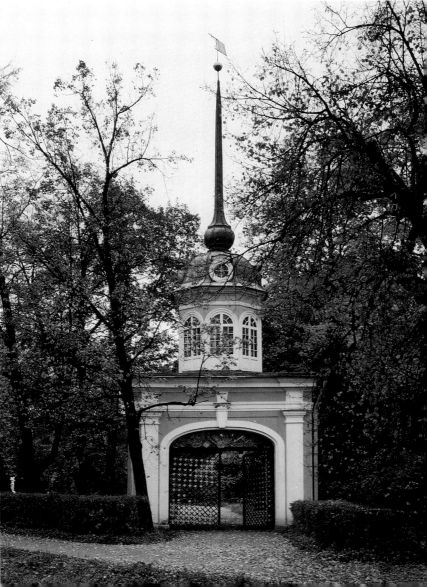

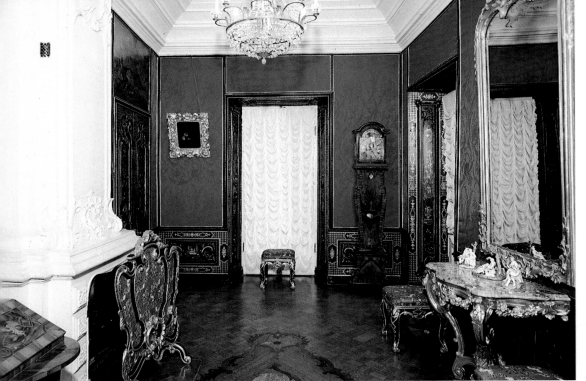

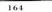
164

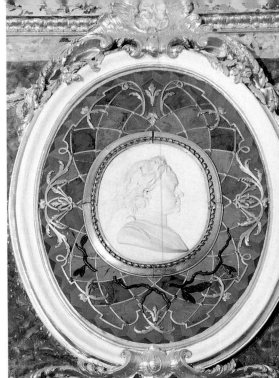

165

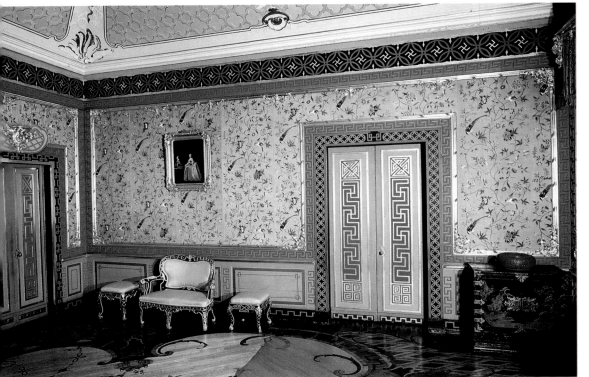

166

ORANIENBAUM

The Upper Park ensemble of Oranienbaum consists of the Chinese Palace, the Palace of Peter III and the Coasting Hill Pavilion. The Chinese Palace was designed by Antonio Rinaldi and built in 1762–68. Rinaldi's project was implemented by talented folk craftsmen — moulders, marblers, mosaicists and wood-carvers. The palace's ceilings were painted by well-known Italian masters of the Venetian academic school. Four Chinese Studies, decorated with lacquered panels, gave the palace its name. The palace's unique parquetry which was executed after Rinaldi's drawings by Russian craftsmen has survived to our day.

In the Palace of Peter III especially interesting are the stuccowork ornamentation of the ceilings and the lacquered panels of the doors. The architectural gem of Oranienbaum is the Coasting Hill Pavilion, which blends harmoniously with the surrounding landscape.

168

167

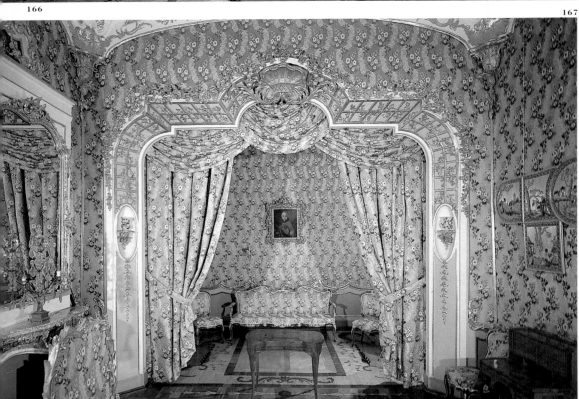

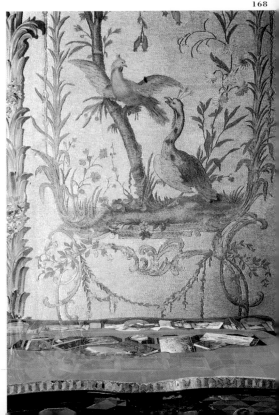

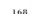

169

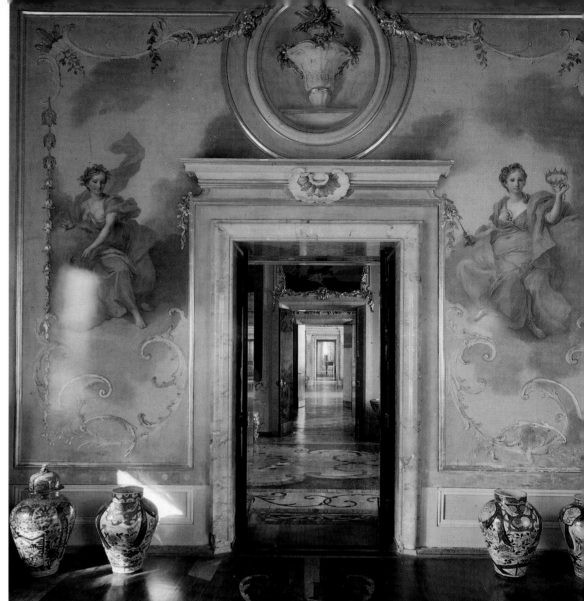

170

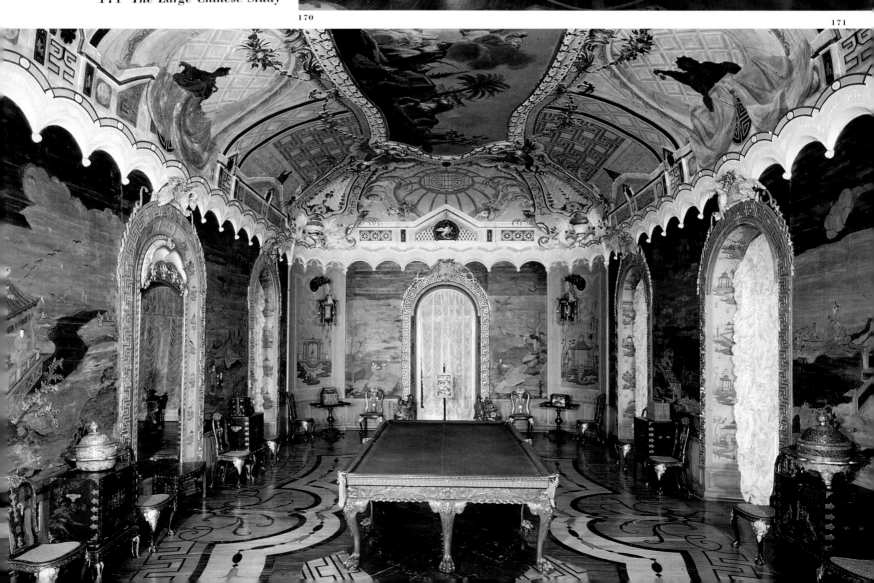

171

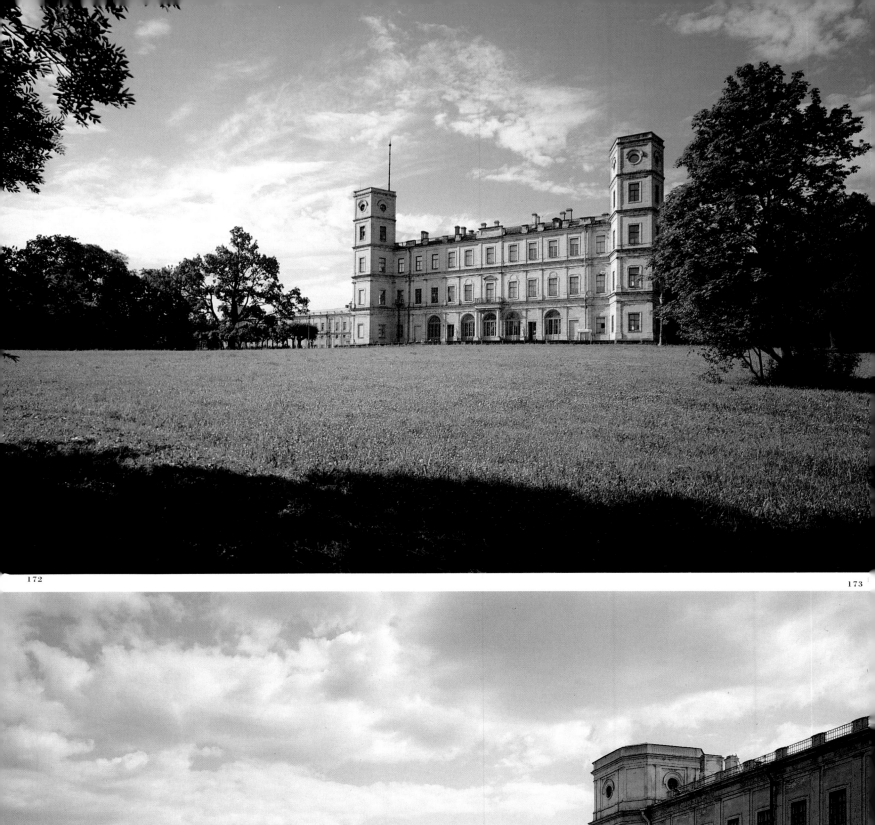

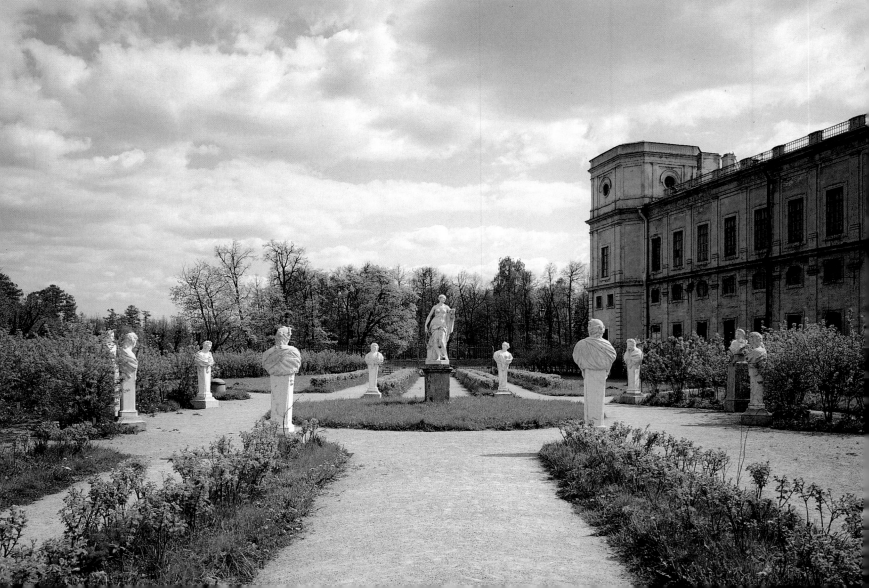

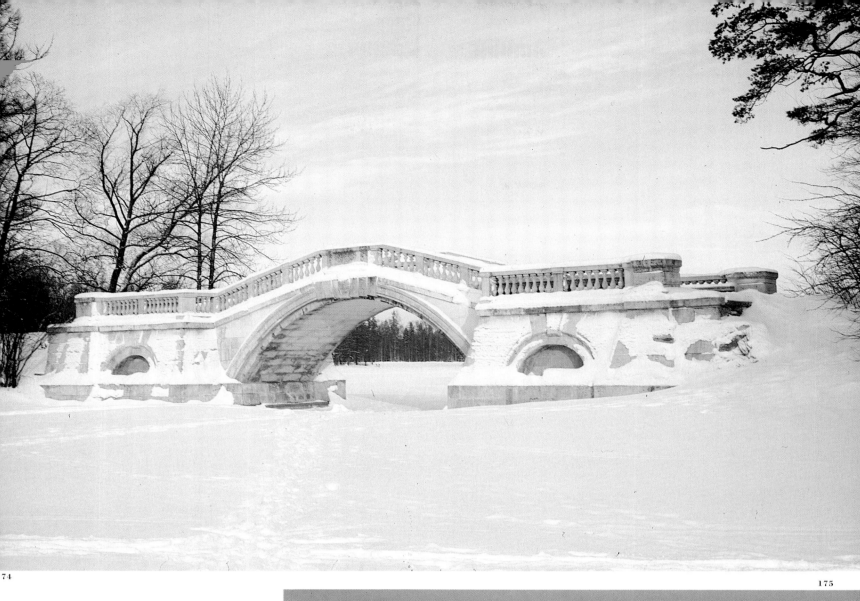

GATCHINA

The history of the palace and park ensemble at Gatchina began in the 1760s when Catherine II gave the estate to Grigory Orlov who was the Empress's favourite and the organizer of the palace coup which brought her to the throne. The outstanding Italian architect Antonio Rinaldi was commissioned to draw up plans for a palace and construction began in 1766. Faced with stone, the palace blended harmoniously into its setting. Under its next owner — Emperor Paul — the palace was reconstructed (1796–98) by the architect Vincenzo Brenna. The greatest changes, however, took place not in the palace but in the park. In 1792 the estate was adorned by a Pavilion of Venus set on a small headland converted into an island and called the Island of Love. An important element in the park ensemble was Adrian Zakharov's Humpbacked Bridge, the only one in the park between two islands (the others connect islands to the lakeshore). The light golden colour of the limestone-faced bridge forms a striking contrast with the lush green banks of the Long Lake.

172 View of the Great Palace

173 Landscape in the park

174 Humpbacked Bridge

175 The Prior's Palace

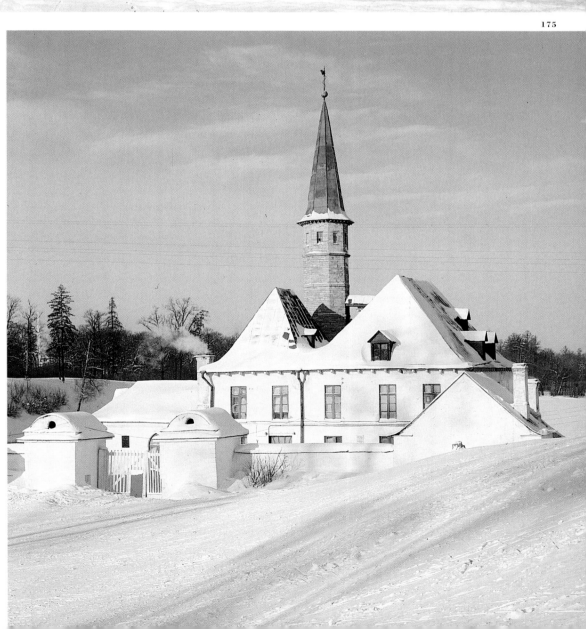

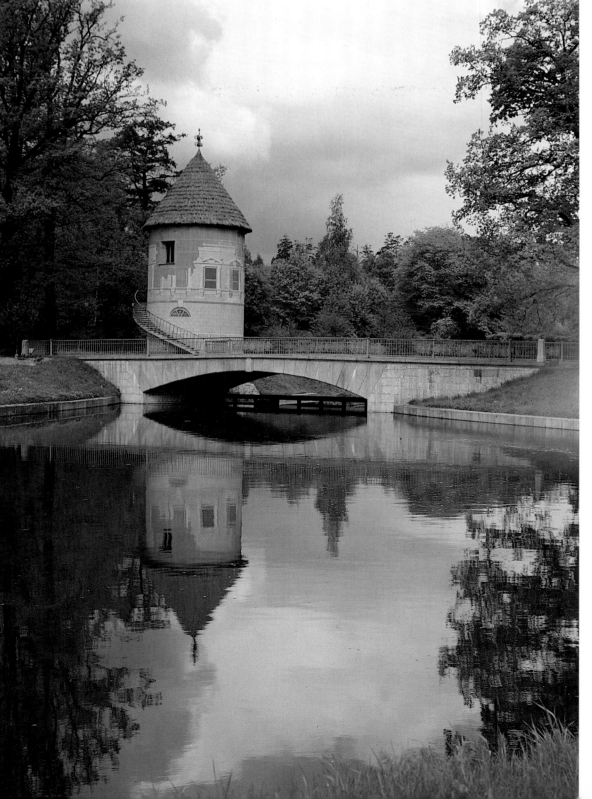

PAVLOVSK

The Pavlovsk Palace is an architectural monument of the late eighteenth and early nineteenth century brought into being by the joint efforts of outstanding architects and sculptors. The museum has on display unique works of art. The collection of antique sculpture housed in the palace ranks among the richest in the country, second only to that of the Hermitage. The picture gallery boasts many canvases by well-known Western European artists of the seventeenth and eighteenth centuries. There is also a superb collection of tapestries and *objets d'art* in bronze, ivory and valuable minerals.

The Pavlovsk Park (600 hectares) was created by famous Russian architects over the course of fifty years, beginning from 1777. In spite of its long genesis, the park is compositionally an integral ensemble, its constituent elements fused together by an original artistic concept in one of the most beautiful landscape parks in the world.

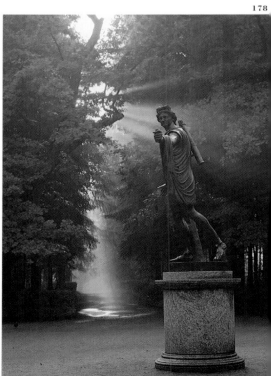

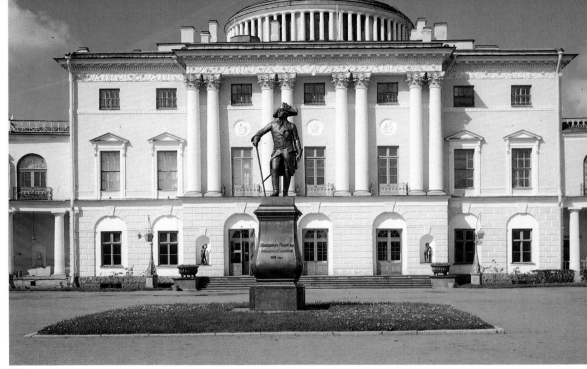

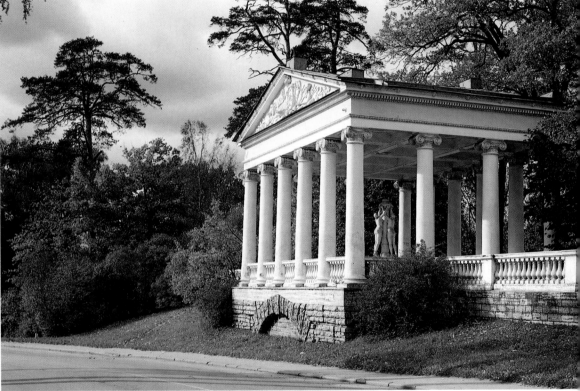

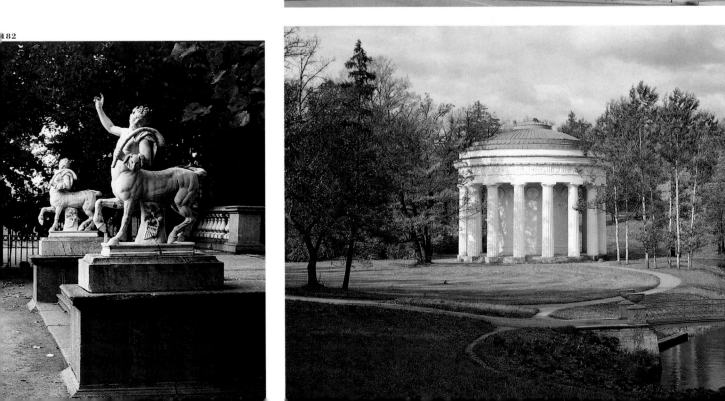

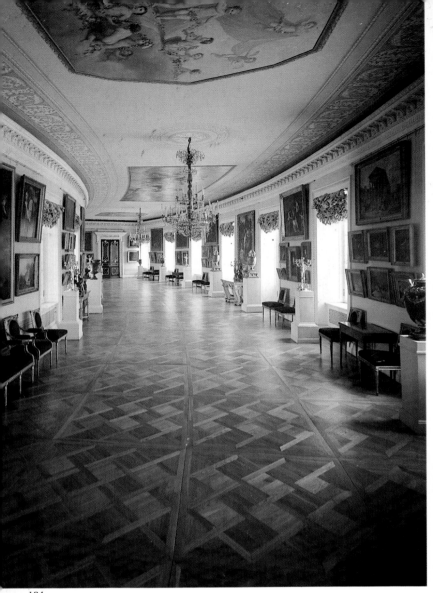

184

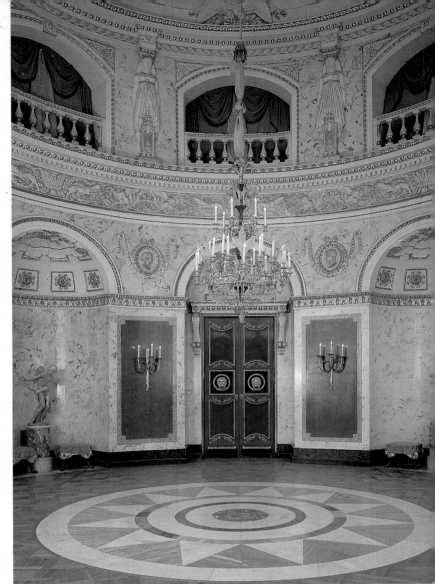

185

186

PAVLOVSK

184–188 **The Great Palace**

184 *The Picture Gallery*

185 *The Italian Hall*

186 *The Greek Hall*

187 *The Tapestry Room*

188 *The Little Lantern Study. Oriel*

187

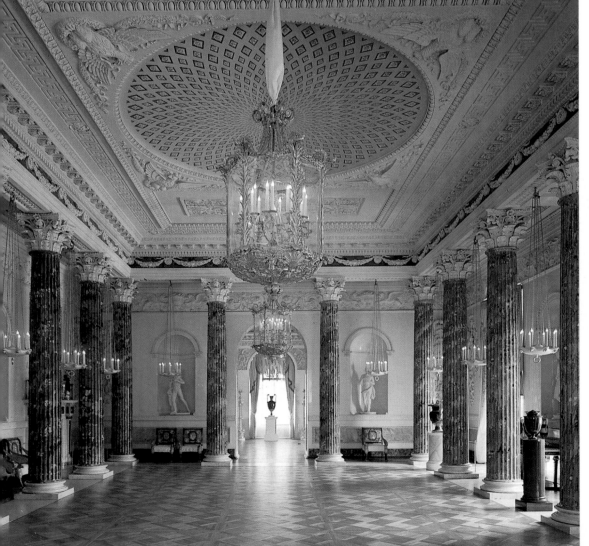

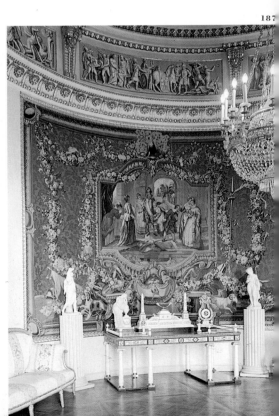

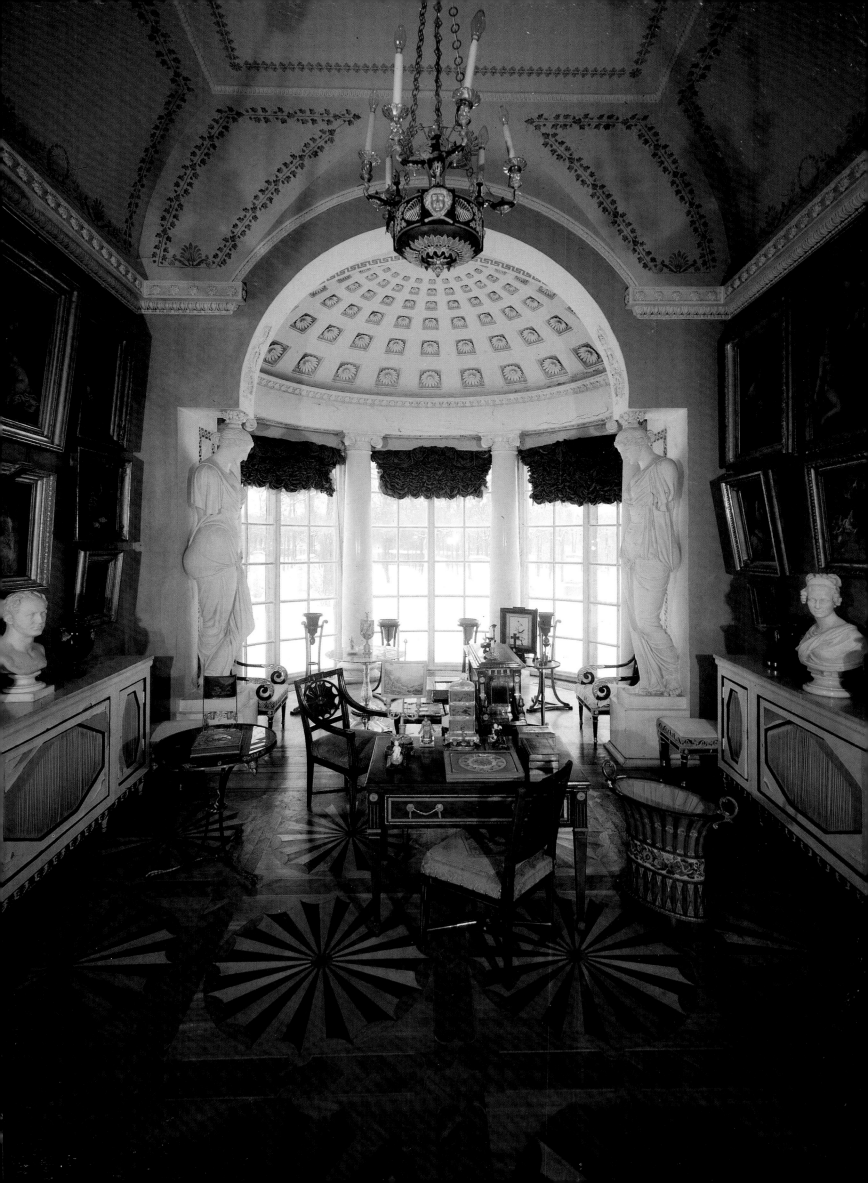

Photographs by:

SERGEI ALEXEYEV and VALENTIN BARANOVSKY — 45;
VALENTIN BARANOVSKY — 12, 32, 34–37, 60, 61, 76, 82;
YURI BELINSKY — III, VIII, IX, 41, 46, 85, 89, 105;
LEONID BOGDANOV — fore-title, I, II, IV, VI, X; VALENTIN BRIAZGIN — 31;
VLADIMIR DOROKHOV and ALEXANDER KASHNITSKY — 48, 56;
SERGEI FALIN — 63, 113, 116; LEONARD KHEIFETS — VII, 22, 27;
ROMUALD KIRILLOV — 108;
ROMUALD KIRILLOV and VLADIMIR SAMOILOV — double-page spreads;
FERDINAND KUZIUMOV — 10, 11, 40, 44, 77, 83, 102, 106, 107;
BORIS KUZNETSOV — 33, 155;
VLADIMIR MELNIKOV — 1, 4, 6, 30, 42, 67, 90, 93, 137–141, 144, 148,
150, 157, 159, 162, 174, 175, 177, 182, 184, 188;
VICTOR SAVIK — 75, 80, 88, 89, 103, 142, 145, 146, 149, 151, 152, 153;
GEORGY SHABLOVSKY — 112, 114; VLADIMIR SHLAKAN — 86, 126, 129, 167, 171;
ANATOLY SIAGIN — V, 53; VADIM SITNIKOV — 160;
VLADIMIR SOBOLEV and KIRA ZHARINOVA — 23, 28, 62, 71, 78, 79, 117, 121;
SERGEI SPETSCHINSKY — 16;
OLEG TRUBSKY and PAVEL DEMIDOV — 9, 15, 19–21, 43, 51, 57, 58,
64, 68, 73, 127, 130–136, 172, 173, 179, 185, 186.

Introduced by MIKHAIL GUERMAN

Designed by SERGEI DYACHENKO

Translated from the Russian by
PAUL WILLIAMS and VALERY FATEYEV

Edited by MARINA GRIGORYEVA
and IRINA KHARITONOVA

Printed in Italy by Stamperia Artistica Nazionale - Turin

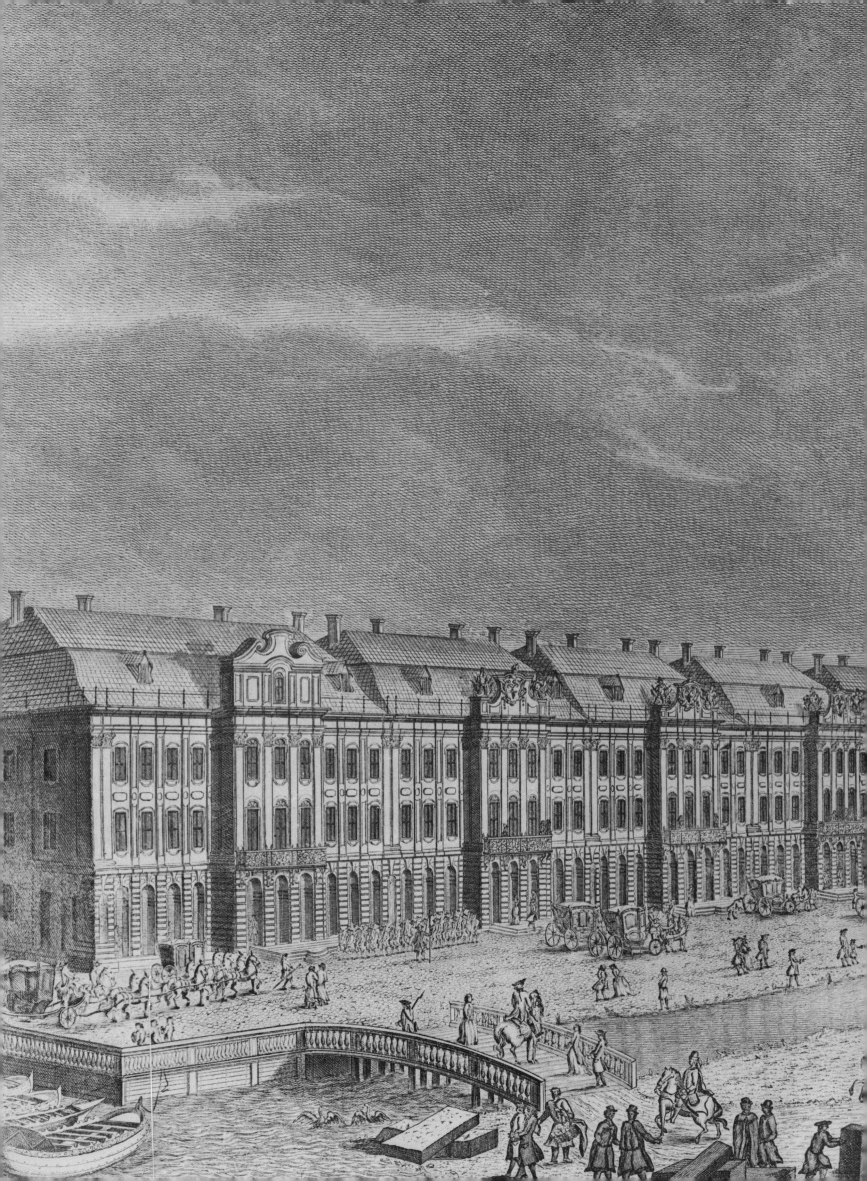